lee frost's simple art of
black and white photography

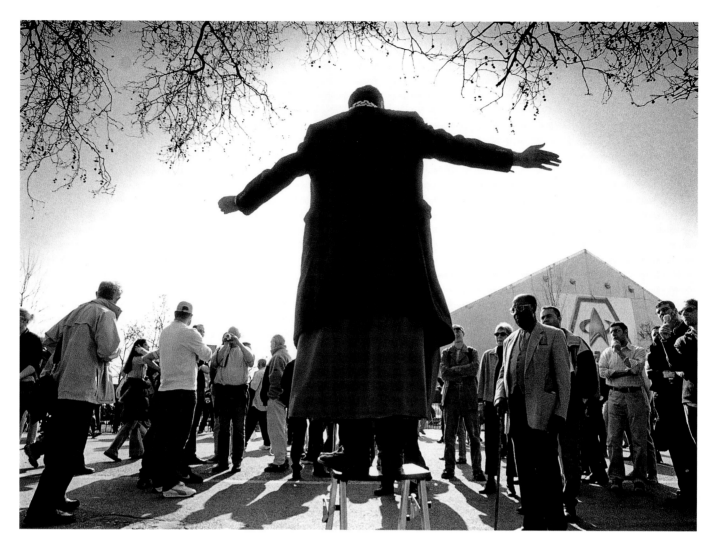

lee frost's simple art of
black and white photography

easy methods for making fine art prints

David & Charles

A DAVID & CHARLES BOOK

First published in the UK in 2004

Distributed in North America
by F&W Publications, Inc.
4700 East Galbraith Road
Cincinnati, OH 45236
1-800-289-0963

A catalogue record for this book is available from the British Library.

ISBN 0 7153 1632 X
ISBN 0 7153 1633 8 paperback (USA only)

Printed in China by Hong Kong Graphics & Printing Ltd
for David & Charles
Brunel House Newton Abbot Devon

Commissioning Editor Neil Baber
Senior Editor Freya Dangerfield
Senior Designer Prudence Rogers
Production Controller Kelly Smith

Visit our website at www.davidandcharles.co.uk

David & Charles books are available from all good bookshops;
alternatively you can contact our Orderline on (0)1626 334555 or write
to us at FREEPOST EX2 110, David & Charles Direct, Newton Abbot,
TQ12 4ZZ (no stamp required UK mainland).

(Previous page) Speaker's Corner, London

It was February 2003, when US and Allied Forces
were gearing up to attack Iraq, and this man wanted
to talk about the imminent war. Unusually for Speaker's
Corner (an area of London's Hyde Park, where, since
1872, people have traditionally gathered to express
their opinions), he did so in a calm and dignified way.
I slipped behind him so I could see the audience's
reaction. There wasn't much space, so I switched to
a 20mm lens and crouched down to hide the sun
behind the speaker. I had exposed three or four frames
when he suddenly outstretched both arms and I knew
I had my shot. The low viewpoint and wide lens
exaggerated the perspective, making my subject
appear to be towering over the audience, like Jesus
addressing his disciples. I'm not religious, but I couldn't
help feeling that the scene was rather biblical.
Camera Nikon F90x Lens 20mm Film Ilford HP5 Plus

Dome of the Basilica, Venice

Venice is one of my favourite places for black and
white photography. I tend to go there in winter, when
the city is much quieter and the light is more
atmospheric. This magnificent view over the Basilica
was taken from the top of the Campanile in St Mark's
Square. Shooting is difficult because you have to poke
the camera through metal grilles and no tripods are
allowed. When I look at this print, which I made
through a soft-focus filter and then partially sepia
toned, I feel as if I'm stepping back in time, even
though the picture was only taken in 2001.
Camera Nikon F90x Lens 17–35 zoom Film Ilford HP5 Plus
Print Filter Soft-focus Toning Sepia

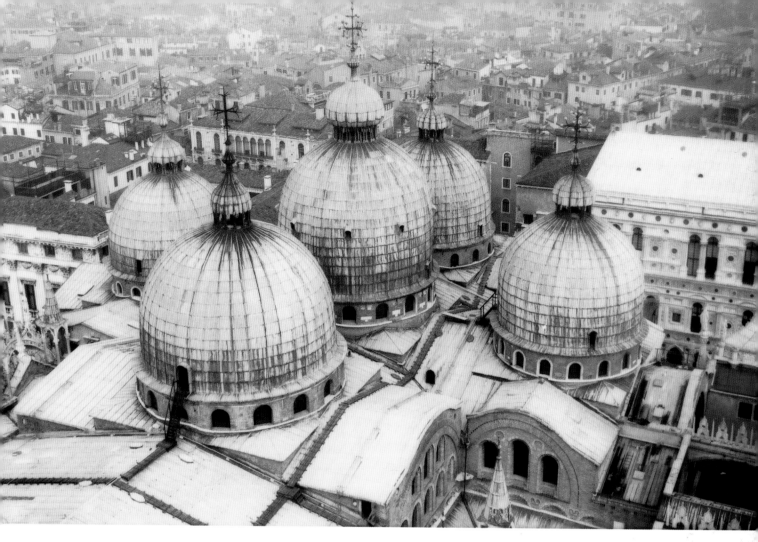

contents

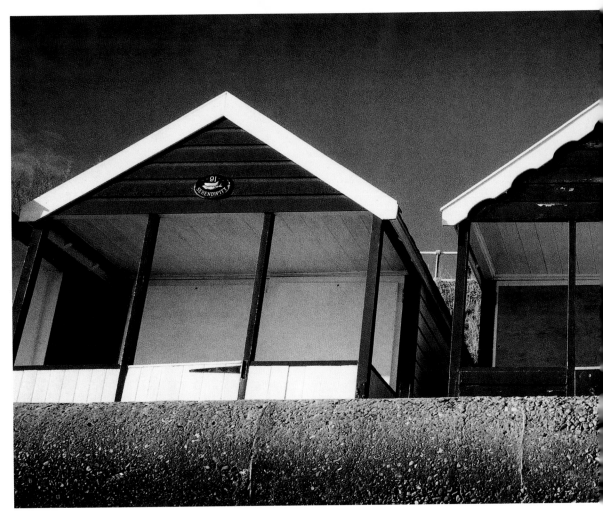

Introduction

In 1982, at the age of 15, I was given a Zenith EM 35mm SLR as a Christmas present from my mother. At the time I had only ever expressed a passing interest in photography, but I was an avid reader of magazines such as *National Geographic*, and had big plans to one day pack a rucksack and travel the world. I guess that my mother, in all her wisdom, decided it would make sense if I had a decent camera with which to record my exploits. Little did she or I know what a profound effect that gift would have on my life.

That very same Christmas I also discovered black and white photography. There was no deep and meaningful reason behind this discovery other than the fact that black and white film was cheaper than colour, and, as I needed to eke out my meagre pocket money, I opted for Ilford HP5 instead of Kodachrome. Fuelled by my new-found interest, I read a beginner's guide to photography that said it was fairly easy to develop and print black and white photographs, so I headed into town and bought a developing tank, some small bottles of developer, stopbath and fixer, and a pack of 7x5in printing paper.

I couldn't afford an enlarger, so initially I made do with contact sheets, and instead of proper developing dishes I used gardeners' seed trays (the ones without drainage holes!).

My grandmother's pantry was hastily converted into a makeshift darkroom (well, I blacked out the window with some black plastic) and it was there, making contact prints using a reading lamp as my light source, that I first witnessed the magic of a photographic image appearing before my eyes on a blank sheet of paper. That magic has never gone away – two decades later I still find making black

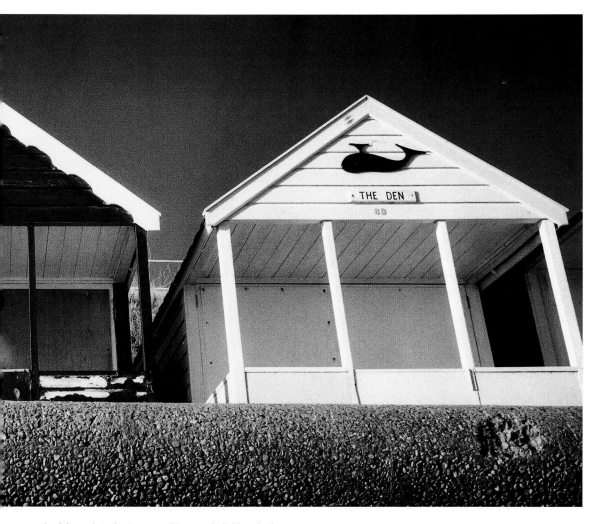

and white prints just as exciting as I did back then.

For me, the most satisfying aspect of black and white photography is the potential it offers for creativity and self-expression. Commercial requirements, however, dictate that most of the pictures I take are in colour, because that's what the market wants. To put things into perspective, in the last ten years I have shot fewer than 300 rolls of black and white film, whereas I might shoot that many rolls of colour film in a good month. Ultimately, however, I gain greater pleasure from the black and white images I produce because they're more personal. When I work in colour I'm trying to say something about a place, but when I work in black and white I'm trying to say something about myself.

Black and white photography feels like a little treat; an occasional indulgence that I look forward to and enjoy every moment of. When I switch from colour to black and white I feel like a hobbyist photographer once more, taking pictures for sheer pleasure with no commercial constraints.

I have always tried to keep my approach to both shooting and printing black and white photographs as simple as possible. There's a

Beach huts, Suffolk, England

I have always enjoyed producing simple, graphic photographs, so when I stumbled across these beach huts while visiting the Suffolk town of Southwold, I knew there was a great picture to be taken. I started out photographing them in colour as the vibrant paintwork and deep blue sky looked amazing. It was only after I had exhausted the colour possibilities that I realized there might be scope for a simpler black and white shot as well. I prefer not to shoot colour and black and white alongside each other as the two require totally different approaches, but sometimes I have no choice. In the darkroom I printed at grade IV to produce a bold, contrasty image with the beach huts standing out against the sky.

Camera Hasselblad Xpan Lens 45mm Filters Polarizer and orange Film Ilford FP4 Plus

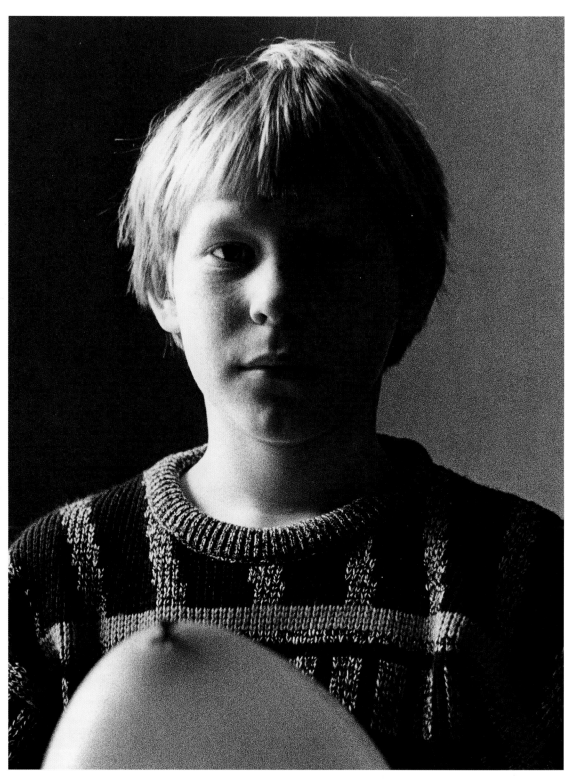

David

When I first became interested in photography, I didn't have children of my own to photograph so I picked on my younger siblings. David, my youngest brother, was often harassed into posing for me, and though he usually protested, I persisted and occasionally managed to take a half-decent picture. When this photograph was taken he was just a boy, full of innocence and wonderment. Today he's approaching 30. I took the picture in my mother's dining room, using windowlight for illumination and a plain, painted wall as the background. That's all I needed. Light levels were low and I didn't have a tripod, so I uprated ISO400 film to ISO1600 and push-processed. This increased grain considerably, which I feel adds to the mood of the lighting and David's sombre expression.

Camera Olympus OM1n Lens 50mm Film Ilford HP5

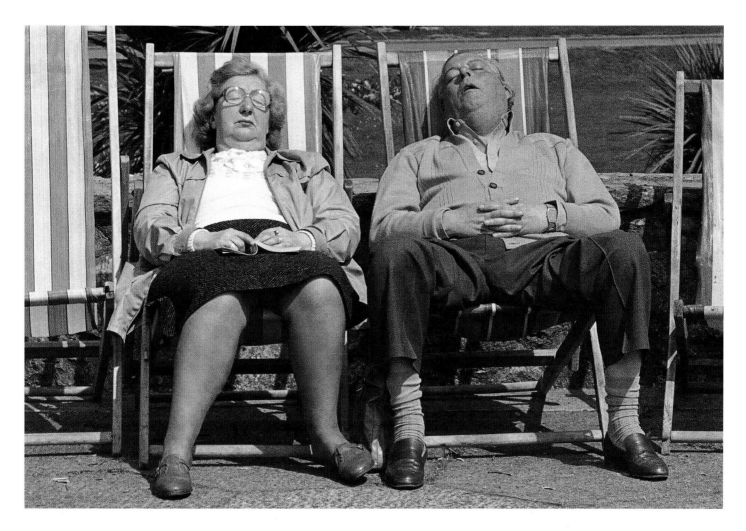

general belief, however, which tends to be perpetuated by the many magazine articles and books on the subject, that unless you have in-depth technical knowledge of topics such as the Zone System, split-grade printing and pre-flashing, you will never be able to produce fine prints. I can say to you here and now that I have never used any of these techniques. Neither have I ever bench-tested a black and white film to establish its true ISO rating when used in my particular camera; increased or reduced development time to change the contrast of the negative; mixed up my own developers or toners from raw chemicals; or done any of the other things that are touted as being prerequisites to success. Some might say that I should, and that if I did my prints would be better. They might be right. But the point is, I don't really care. I work in black and white when I can because it brings me immense pleasure, and most of the time I'm happy with what I end up with. If I'm not, I throw it away.

I also feel that too many photographers become so obsessed with having total control

Sleeping beauties

When I was 16, my family moved from Yorkshire in England where I was born, and settled in Torquay on the south Devon coast. It was there, inspired by new surroundings, that my passion for photography flourished, and I spent many happy hours exploring the town's pier and promenade in search of interesting pictures. I always liked the idea of candid photography, but my nerves tended to get the better of me. This couple made an easier target because they were fast asleep and unaware of what I was doing. A newly purchased telezoom lens also allowed me to get the shot from a safer distance!

Camera Olympus OM1n Lens Tokina 70-210mm zoom Film Ilford HP5

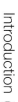

and getting everything absolutely perfect that their black and white photography becomes a technical exercise fraught with problems rather than an art form that's supposed to be fun. The result? Prints that are technically excellent but often creatively dull.

What you need to remember is that black and white photographs communicate on an emotional level first and foremost. The vast majority of people decide whether they like a photograph or not in a split second. Rarely will that decision have anything to do with how you created the picture. Only other photographers are influenced by the technique; everyone else looks beyond it. Therefore, a photograph that has flaws but moves people is infinitely preferable to one that is technically perfect but leaves the viewer cold.

In writing *Simple Art of Black and White Photography* I hope to demonstrate this, and convince you that by taking a simpler, more casual, approach you will free up your mind to concentrate on the creative side of the medium, which is by far the most important.

My intention has not been to produce a comprehensive guide to black and white photography; there are plenty of books already in print that do a far better job than I ever could. Instead, I wanted to put down my own personal thoughts and ideas on paper and explain how I go about producing black and white prints.

The first chapters deal with the basics – equipment and film choice, using filters, metering and exposure, and setting up a darkroom – but only to a level that I feel is necessary for you to produce good work. There is no space in this book for unnecessary detail; I would rather fill that space with photographs.

Next, we look at film development, assessing the results and making fine prints. Having reached the stage where you can produce good-quality prints, you may then wish to experiment with various creative techniques. My favourites are toning, soft-focus and tissue printing, lith printing and using liquid emulsion. All these subjects are discussed, and illustrated with images that show the results you can expect.

Finally, from pages 106 to 143, you will find a gallery containing a large selection of my favourite black and white photographs taken over the years. The subjects covered range from landscapes and architecture to candids, portraits, still-lifes and nudes, but all are united by a

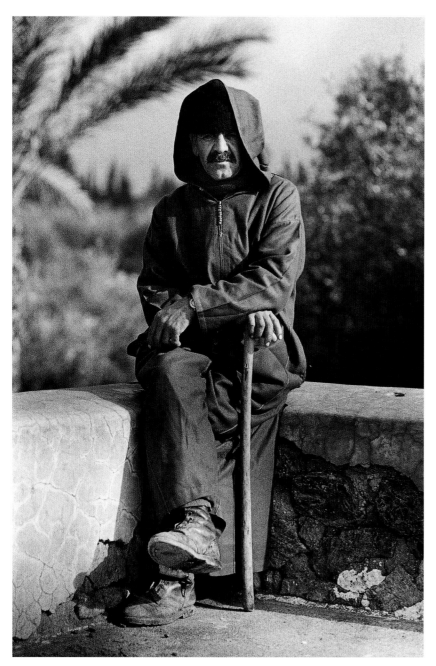

Farmer, Marrakech, Morocco
Travel is an important part of my life as a photographer. I try to organize trips to at least two new destinations each year, as well as visiting some old favourites, such as Morocco. I have visited the country five or six times now, and the more I go there, the more it inspires me. I spotted this farmer relaxing in the Menara Gardens outside Marrakech. I was there leading a photographic workshop, and I think he found the sight of a dozen photographers setting up tripods and playing with cameras rather amusing – worlds away from his own life in the country. After a few minutes, I wandered over and asked if he would mind me taking his photograph. He nodded approval, so I quickly shot half a dozen frames.
Camera Nikon F90x Lens 70–210mm zoom Film Ilford HP5 Plus

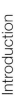

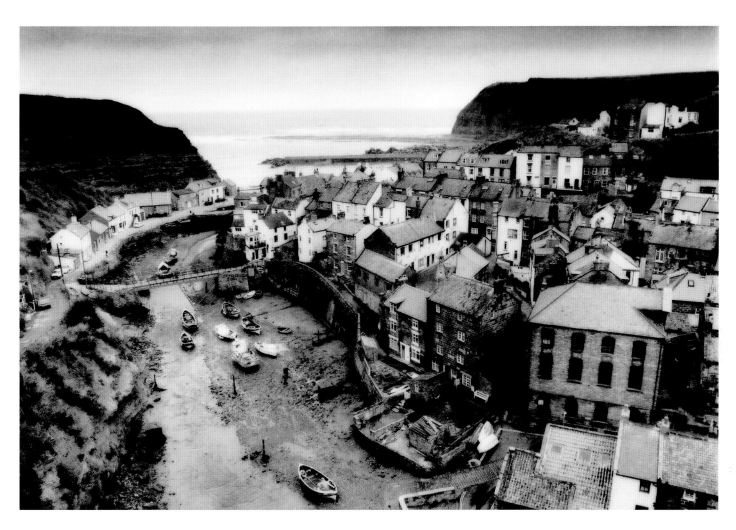

common factor – they were created using simple, accessible techniques.

Writing this book has taken me on a wonderful journey, a journey back to the point in my life where, as an innocent teenager with a head full of creative ideas, I first discovered a passion for photography. That passion grows stronger with each passing year.

Revisiting some of my first black and white photographs has been like studying a map of my creative development over the last twenty years. Looking through the sheets of carefully labelled negatives, I can clearly see how I got from there to here, and though most of my earliest efforts leave a lot to be desired, a few of them can hold their own against my more recent work.

I hope that by reading *Simple Art of Black and White Photography* you gain as much enjoyment as I did in producing it, and that the photographs you see inspire you to go off and create your own fine prints.

Lee Frost

Staithes, North Yorkshire, England

I love this view over the old fishing village of Staithes. It has been photographed many times before, but no other view shows off the village and its setting in quite the same way. The weather was ghastly – dark, grey and damp. But I'm happy to shoot black and white in such conditions, because the soft light is both flattering and revealing and produces negatives with a wide tonal range that can be manipulated during printing. In this case, I chose to make a lith print from the negative (see chapter seven). It was an experiment, really, during one of my first attempts at the technique, and although it doesn't exhibit the usual high contrast of a lith print, it does show that more subtle effects are possible. What makes the picture for me is its steely grey tone, which reflects the true feeling of the light and weather when the shot was taken. This colour was created by gold-toning the print, which was made on Kentmere Kentona paper.
Camera Nikon F90x **Lens** 28mm **Film** Agfapan APX 400 **Toning** Gold

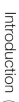

Equipment and film

When I first became interested in photography, I tended to spend more time day-dreaming about owning exotic equipment than putting to good use the camera and lenses I already owned.

Back then, my humble Zenith EM was about as basic as a 35mm SLR could get, so I assumed that if I could save up and buy something more sophisticated, it would help me take better pictures. Of course, I quickly realized that it didn't matter what camera I owned, or whether I had one lens or ten – it's what I did with the equipment that counted. From that point on, I never looked back.

Today, I can profess to owning a veritable arsenal of equipment, in various formats from 35mm to 6x17cm panoramic and 5x4in. When it comes to working in black and white, however, I still prefer good old 35mm, and the vast majority of the pictures in this book were taken with that format. I could go bigger – my Pentax 67 is occasionally pressed into service – but my style of black and white photography is more suited to the speed, size and convenience of 35mm. Also, modern lenses and modern films offer such high image quality that I rarely feel the need to use anything else.

Grand Canal, Venice, Italy

The compactness of 35mm equipment makes it ideal for travel photography, allowing me to carry two or three camera bodies and a range of lenses without feeling burdened by the weight and bulk of the outfit. I also find the 3:2 ratio of the format easy to compose in and usually print my negatives full-frame, as here. This photograph was taken on a dull day from the Rialto Bridge and shows the view along Venice's Grand Canal. The scene has changed little in hundreds of years, so I wanted to create a print that had a timeless feel. This was achieved by exposing the negative through a soft-focus filter before partially sepia-toning the print.

Camera Nikon F90x **Lens** 18–35mm zoom **Film** Ilford HP5 Plus **Print Filter** Soft-focus **Toning** Partial–sepia

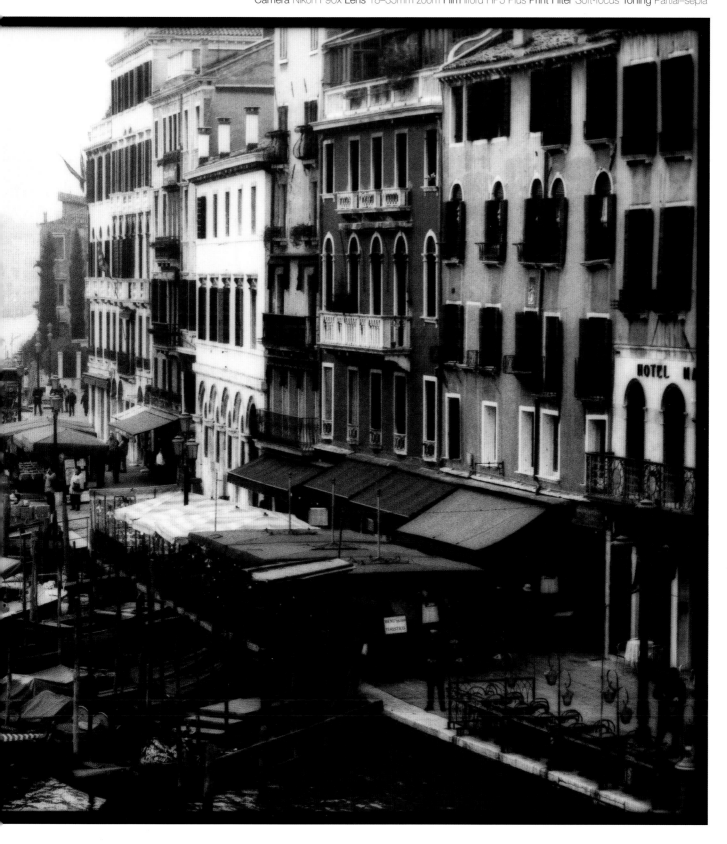

Camera bodies

If I'm shooting 35mm, I carry two Nikon bodies: an F90x and an F5. Both bodies boast a range of exposure modes, but the only ones I use are aperture priority AE (auto-exposure) and manual. Similarly, while I could choose from a variety of metering patterns, matrix metering is more than adequate for most of my needs, and if it isn't I use a handheld spotmeter. I only use autofocus when I'm photographing moving subjects and need to work quickly. The rest of the time, I focus manually so that I can control depth of field.

Lenses

All the lenses I use are Nikon, and most of them are prime (fixed focal length). On a typical shoot, I carry a 20mm f/2.8 AF-D; a 28mm f/2.8 AF-D; a 35mm f/2 AF; a 50mm f/1.4 AF-D; and an 80–200mm f/2.8 AF-D.

I favour prime lenses because they're small, light and easy to handhold. The 50mm f/1.4 lens is particularly useful. We live in an age of zoom lenses, and the 50mm standard lens has been all but abandoned. However, I would advise any photographer to buy one: they are small, light, relatively inexpensive, but offer superb image quality and a fast maximum aperture that makes them perfect for taking handheld pictures in low light. The two or three stops of extra speed that a 50mm lens offers compared to a typical standard zoom can make a massive difference when you're working in extreme situations.

Speaker's Corner, London

35mm equipment comes into its own for reportage photography. This isn't an area that I work in very often, but I do try my hand occasionally. These pictures are part of a larger photo story that was put together during a single three-hour visit to Speaker's Corner in London's Hyde Park. The event takes place every Sunday and it's a superb place to photograph people, especially those who come along to preach and protest. Initially nervous, I soon realized that no one minded being photographed and had a thoroughly enjoyable time capturing some of the characters in action – often with a wide-angle lens from very close range.
Camera Nikon F90x **Lenses** F5, 20mm and 28mm **Film** Ilford HP5 Plus

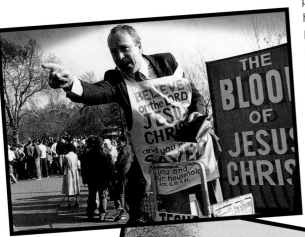

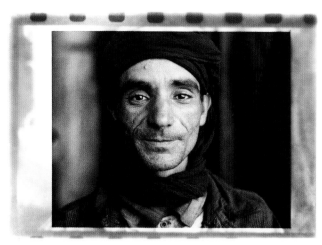

This portrait was taken in the Dyer's Souk (Souk Teinturiers) in Marrakech. Light levels were low, but my 50mm f/1.4 standard lens saved the day by allowing me to select a wide aperture – f/2.8 – and keep the shutter speed high enough to handhold without worrying about camera shake. Depth of field was very shallow so I focused on my subject's eyes – providing the eyes in a portrait are sharp, it doesn't really matter what happens to everything else.

Camera Nikon F90x **Lens** 50mm **Film** Fuji Neopan 1600

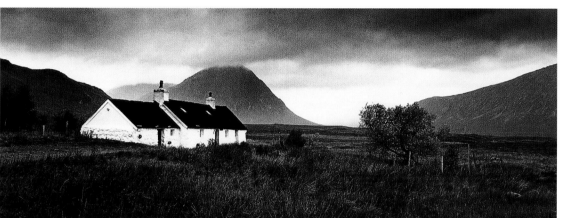

Panoramics

Black Rock Cottage, Rannoch Moor, Scotland

I love panoramic photography, and for the last few of years have been using a 6x17cm panoramic camera for colour work. However, this format is impractical for black and white, simply because I would need a 10x8in enlarger to print the negatives.

However, I also have a dual-format Hasselblad Xpan. Investing in the Xpan has enabled me to shoot black and white panoramics on 35mm film and print them on a standard medium-format enlarger (the negatives measure 24x65mm). I could use my Pentax 67 and crop the images during printing, but the Xpan is much smaller and lighter than the Pentax, so I can use it handheld when necessary, and it's far easier to see and take panoramic photographs when you're using a panoramic camera.

There are two more factors that make the Xpan so desirable. First, it's dual-format. At the flick of a switch, I can go from shooting panoramics to full-frame 35mm, mid-roll, which I find very useful at times. Second, the optical quality is superb. The 30mm, 45mm and 90mm lenses are by far the sharpest for a 35mm-format camera that I have ever seen.

This has to be one of the most photographed buildings in the UK. The cottage itself isn't anything to shout about, but the setting is magical, with the pyramidal peak of Buachaille Etive Mor rising in the background, and miles of empty, boggy moorland stretching in all directions. I photographed the scene on a dull, grey day, during late afternoon. The sky in the far distance was much brighter as the sun tried desperately to break through the clouds. This never happened, but when I printed the negative I decided to emphasize the effect and add drama by burning in the higher clouds and the foreground. Printing to grade IV boosted contrast, recording the cottage walls as a crisp white while reducing its roof to a rich black. Finally, the print was partially bleached so only the highlights and lighter tones were affected, then toned in dilute sepia. This warmed up the highlights while leaving the darker tones unchanged.

Camera Hasselblad Xpan **Lens** 45mm **Filter** Orange **Film** Agfapan APX 400 **Toning** Partial bleach and sepia

Other equipment

There are few other items that I would consider essential. One is a tripod. For 35mm work, I tend to keep this small and light and use a Manfrotto 190 with a Manfrotto Heavy Duty ball-and-socket head.

Another is a cable release, which I almost always use to trip the camera's shutter when it's tripod-mounted. I also carry a Pentax digital spotmeter.

That's about it really – the only other items that merit mention are filters, though to explain their use we need to go into a little more detail.

I generally place any filters that I'm using on the lens and meter through them with my camera's TTL (through-the-lens) metering system so that any filter factor that affects the exposure is compensated for automatically. If you meter without the filter in place, or use a handheld meter, you must compensate the exposure to take into account the light loss incurred by the filter being used. Use the following table as a guideline:

Filter colour	Filter factor	Exposure increase
Yellow	x 2	1 stop
Yellow/green	x 4	2 stops
Green	x 6	2 ½ stops
Orange	x 4	2 stops
Red	x 8	3 stops
Red and polarizer	x 32	5 stops

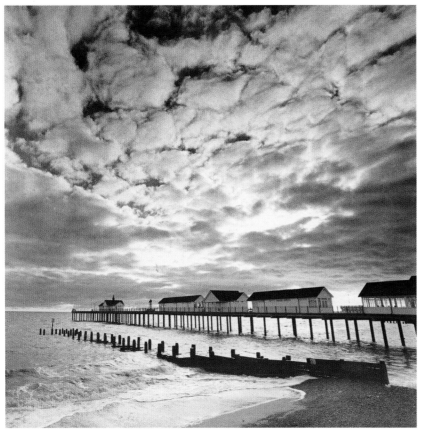

Southwold Pier, Suffolk, England

A deep red filter is the most effective of all coloured filters when it comes to enhancing a dramatic sky. Here you can see how it has darkened the blue of the sky so the cloud formation stands out, as well as generally boosting contrast to give the scene a more sombre feel. The image was printed to grade III and the sky was burned in quite heavily.
Camera Nikon F5 Lens 20mm Filter Deep red Film Agfapan APX 400

Filters

In black and white photography, filters are used mainly to increase contrast and to control the way that different colours translate to grey tones. For example, red and green record as a similar shade of grey. If you photograph a subject where the main elements are red and green in colour, you will end up with a pretty boring picture – these colours look very different to the naked eye, but in a black and white image there will be hardly any contrast between them.

This is where filters come in. By using coloured filters, you can change the way that different colours record in shades of grey by lightening or darkening them. The rule to remember is that the filter you use will lighten its own colour and darken its complementary colour. If you use a red filter, it will record red as a lighter grey tone and green as a darker grey tone. If you use a green filter, the opposite happens.

In reality, I can't ever remember using a coloured filter when taking a black and white photograph to perform this tonal task. However, I do use filters regularly in my black and white work to boost contrast and produce more dramatic results.

Filters for black and white landscapes

My standard choice for landscapes is an orange filter, as it gives a very noticeable effect. I use one in stormy weather to make the sky more dramatic and to increase contrast, and in sunny weather if I want to really emphasize interesting clouds.

A red filter does a similar job, but the effect is even stronger. This filter significantly darkens a blue sky so that white clouds stand out clearly. It also darkens greens. I occasionally use these characteristics to good effect for landscape photography, but for me its main use is in conjunction with mono infrared film (see pages 20–21).

Another filter I occasionally use for black and white is a polarizer. This emphasizes the sky as well as a red filter, but does so without affecting other colours. It will also cut through haze and mist, and eliminate reflections and glare.

I use UK-made Lee filters, not only because they offer excellent image quality, but also because the modular holder can be adapted so it works with all my lenses, including the 20mm wide-angle, without causing vignetting.

Effects of different filters

The following sequence gives you an idea of how different filters can affect a black and white photograph. The shots were all taken using a Nikon F90x and 28mm Nikkor f/2.8 AF-D lens on a bright, sunny morning. The colour shot was taken unfiltered on Fuji Velvia, and the black and white images were shot on Ilford FP4 Plus. I used Lee filters in all cases. The resulting prints were made to grade II on Ilford Multigrade IV RC paper.

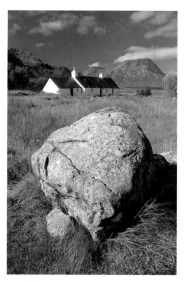

The original scene
This colour shot shows how the scene appeared to the naked eye. The clouds are distinct against the blue sky and the grass is a mixture of greens and yellows. Note how the different filters affect these specific areas.

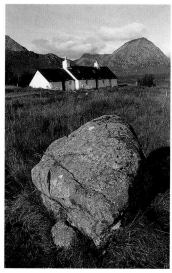

Unfiltered black and white
This unfiltered shot has a fair degree of punch: contrast is reasonably high thanks to the sunny weather. The sky is in need of some help, though, as the white clouds almost merge with the blue. Note that detail has recorded in the shadow cast by the rock.

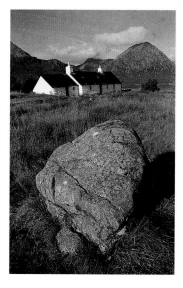

Yellow filter
Here, the most obvious effect of filtration is in the sky, which is noticeably darker and with more pronounced clouds. The yellower grass towards the middle distance has also been lightened and contrast is slightly higher. There is not a great change, however. Generally, this filter is too subtle for my liking.

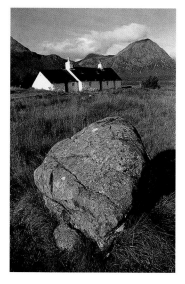

Green filter
The sky has been improved, but not as much as with the yellow filter. The grass is also lighter, and the lichens on the rock, and the rock itself, stand out nicely. This filter is handy if you want to lighten the greens in a scene, or make sure that red and green record as different tones.

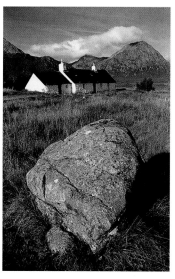

Orange filter
The difference is obvious now. The blue sky is much darker, and the clouds emphasized. More detail has been revealed in the distant mountains; the bushes and cottage roof are darker; and contrast is higher. This is a good filter for landscapes if you like punchy prints.

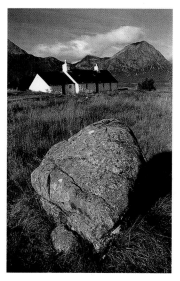

Red filter
The sky looks strong, contrast is much higher, and the grass and the cottage roof are darker. Note that the shadow of the rock is darker. This is because it's lit by blue sky, and red darkens blue. There has been a dramatic transformation, but you must use this filter with care for landscapes.

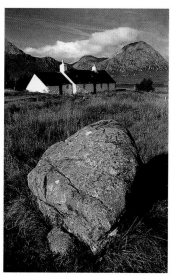

Red and polarizer
Combining a red filter and a polarizer will give you the most extreme effect of all. I generally like to use this combination when I work in infrared photography. With conventional black and white film it provides a significant increase in contrast, which is most noticeable in the sky.

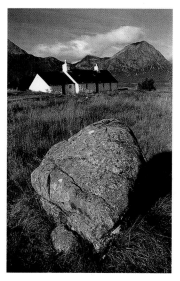

Equipment and film

Film choice

I've never been one for using lots of different black and white films. I prefer to keep to a small selection that I can get to know and use in different situations. This not only makes life easier when I'm deciding what to pack for a shoot, but also makes film processing more convenient because I can batch-process to save time.

Over the years, I have tried most brands of black and white film. I have never felt that the difference between any two films with the same ISO rating was significant enough to reject one in favour of the other, or to use a specific film in one situation, such as contrasty light, and another brand with the same ISO in different conditions, such as dull weather.

It's a matter of how technical you want to get. As far as I'm concerned, all modern black and white films are capable of superb results for their given speed. The fact that one might be slightly grainier or a little more contrasty than another is not important – at least, not for my style of photography, anyway.

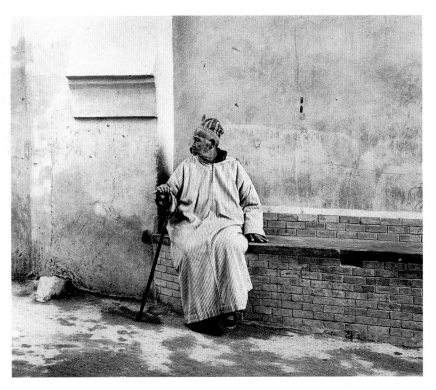

Old man, Marrakech, Morocco

Travel photography tends to involve working in extremes, especially when it comes to light. One minute I might be shooting in the open where light levels are high, but minutes later I might be in a shady alley, or inside a building, so I need a film that can cope with pretty much any situation. For general use, I find ISO400 stock ideal. This portrait was taken in an alleyway outside the Ben Youseff Medersa (Koran School). I was waiting to buy a ticket in the entrance to the Medersa and happened to glance behind me. This old man was quietly watching the world go by from the other side of the alley, so I quickly raised a camera and fired a single frame before people started crossing his path and the moment was lost.
Camera Nikon F90x **Lens** 50mm **Film** Ilford HP5 Plus

Film speeds

For general use, I find ISO400 to be an ideal speed. It's fast enough to enable me to take handheld pictures in relatively low light, but not so fast that exposures go off the scale when I'm working outdoors in brighter conditions. Grain is generally fine, though on 16x12in prints and bigger I can make a feature of it. If I need more speed, I can uprate to ISO800 or ISO1600 and push-process (see page 41).

These days, I tend to stick to Ilford HP5 Plus. It's inexpensive, easy to get hold of, offers excellent image quality and is a tried and tested film. HP5 Plus also responds well to uprating and push-processing, and, because it's such a popular film, just about every brand of black and white film developer on the market has a development time for it.

If I want higher-quality images, then I tend to use a slower film. There are numerous brands to choose from, including Ilford Delta 100, Kodak T-Max 100, Kodak Plus-X, Fuji Acros 100, and Agfapan APX 100. I've tried them all, but my usual choice is Ilford FP4 Plus, for the same reasons that I use Ilford HP5 Plus.

I also tend to carry a few rolls of ultra-fast film. I rarely need a film that's faster than ISO400 to cope with low light levels, but I do like to create gritty, grainy prints and for this I find Fuji Neopan 1600 is ideal. It's a naturally grainy film, which can be uprated to ISO3200 or ISO6400 for more extreme results.

There are faster films available – Kodak T-Max 3200 and Ilford Delta 3200. I have used both and find them excellent. Ilford Delta 3200 can be uprated as far as ISO25000 when necessary and still yield surprisingly good image quality.

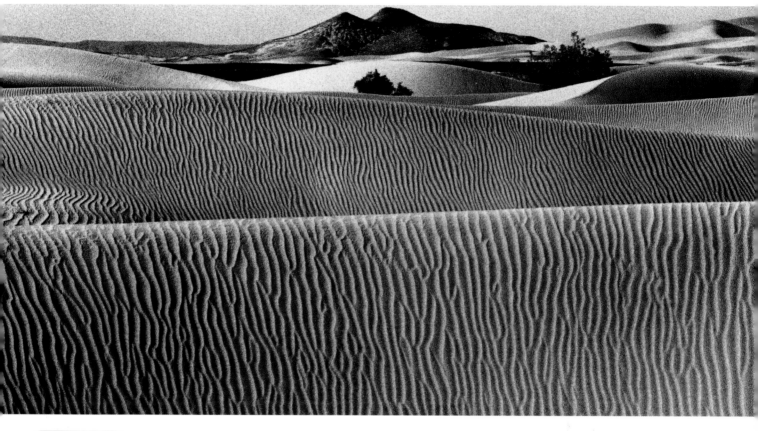

rating film

I'm not one for bench-testing films to establish whether I can obtain better negatives by adjusting the ISO rating. I know photographers who do, and I'm sure it works for them. I like to keep things simple, however, so I always rate the film at the ISO recommended by the manufacturer – apart from when I intentionally want to uprate for a speed increase (see page 18).

As far as I'm concerned, if a manufacturer makes a film and recommends that you rate it at ISO400, then that's good enough for me. After all, they're the ones who have spent a fortune creating and testing the emulsion.

Also, I'm fairly certain that many of the photographers who do test and tweak films to achieve optimum results still bracket exposures most of the time. In a way, this defeats the object because it means they may not end up printing the 'optimum' negative anyway.

Sahara Desert

Ultra-fast film has two main uses: its speed can be invaluable in low light, and the coarse grain characteristic of these films also has creative applications. When I use ultra-fast film, it tends to be for the latter reason. I have a great fondness for stark, grainy images. To make the most of the effect I develop the film in Agfa Rodinol, which emphasizes grain; enlarge the 35mm negatives to a good size – usually on 16x12in paper; and print hard at grade IV or even grade V. The photograph here was made from a rather flat negative – probably caused by a processing error on my part – so I needed to work at grade V to create the stark effect I had visualized when the photograph was originally taken.

Camera Nikon F90x Lens 80–200mm zoom Filter Red Film Fuji Neopan 1600

Infrared film

Mono infrared film is one of my favourite materials for black and white photography and I feel it deserves a special mention.

Because infrared film is sensitive mainly to red and infrared light, it records the world in a way that's completely different to how we see it with the naked eye. Blue sky and water goes almost black; white clouds stand out boldly; and foliage records as a ghostly white, as do skin tones. These characteristics allow you to produce surreal images, especially in bright, sunny weather when levels of infrared radiation are high.

At the time of writing, there are five makes of mono infrared films available: Kodak High Speed, Konica 750, Ilford SFX, Maco 750C and Maco 820C. I have tested each of these over the years, and all are capable of good results, but two stand out particularly – Kodak High Speed and Konica 750 – and these are the two that I use.

Kodak High Speed, available only in 35mm, is the best-known mono infrared film. It has been around the longest and gives the strongest infrared effect. It's also a fast, grainy material and, when used correctly, can create wonderfully stark, gritty images.

Konica 750 is completely different. It is a much slower emulsion (and this means that you will need to mount your camera on a tripod even in bright sun), and it boasts very fine grain and much smoother tones than the Kodak film. The infrared effect is also slightly less marked, though it is still very obvious.

Filtration with infrared

All mono infrared films are partly sensitive to the visible spectrum, so you need to filter it out to get the strongest effect. This can be done using a visually opaque infrared filter such as the Kodak Wratten 87 and 87C. They're fiddly to use, though, because once on the lens you can't see anything. Instead, I prefer to use a deep red filter, such as the Cokin 003, B+W 092 or Lee Red 25. You can compose, focus and meter through a red filter, and the difference in effect is hardly any different from using an opaque filter.

ISO rating and exposure with infrared

Levels of infrared radiation vary according to lighting and weather conditions, and this changes the effective ISO of infrared film. As a guide, if you

Peter

I occasionally use mono infrared film for portraiture. Dark eyes and ghostly skin tones don't exactly make for flattering results, but on the right subject such an effect can work well. For this portrait, I lit my subject with a single studio flash unit and softbox placed at almost 90 degrees. The negative was printed to grade IV, though it required very little work to achieve this result. The ragged border was created by filing out the masks in my negative carrier so the rough-edged aperture extended beyond the image area and allowed me to include the film rebates.
Camera Olympus OM4-Ti Lens 85mm Filter Deep red Film Kodak High Speed

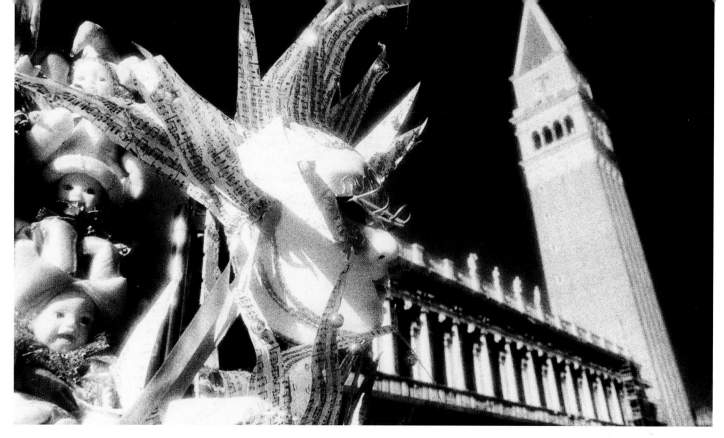

Venetian masks
The dark sky and glowing highlights in this photograph are typical of mono infrared film. To achieve such effects, I tend to print hard, to grade IV, so contrast is increased. This may mean that I have to spend some time dodging shadow areas and burning in highlights, but it's well worth the effort because the results can be stunning.
Camera Nikon F90x Lens 28mm Filter Red Film Kodak High Speed

take TTL meter readings with a deep red filter on your lens, rate Kodak High Speed at ISO400 and Konica 750 at ISO50. Your camera's TTL metering system automatically accounts for the three-stop light reduction caused by the red filter.

If you're taking an exposure reading with a handheld meter, or using your camera's TTL metering without the filter in place, you need to compensate the exposure obtained. Do this by rating the Kodak film at ISO50 and the Konica film at ISO6 and don't change anything when the filter is fitted to the lens.

When I'm using infrared film, I set my Nikon to aperture priority AE mode and meter through the filter. As well as taking a shot at the metered exposure, I take a second with the exposure compensation set to +1 stop; a third at +2 stops; and a fourth at −1 stop. From this set of four negatives, I can usually be sure that one will give me a good print.

I use this same procedure for shooting on normal film too – see page 25.

Loading and unloading infrared film
Great care must be taken when loading and unloading Kodak High Speed infrared film as it's prone to fogging. I use a changing bag to do this on location. Konica 750 isn't as sensitive and can be loaded and unloaded in subdued light. I still tend to use a changing bag, but occasionally have just stepped into the shade and covered my camera with a jacket to load and unload.

Camera compatibility
Some modern SLRs and compact cameras use an infrared sensor to count the film's sprocket holes, which can fog infrared film. Often the fogging is limited to the film rebate and barely affects the image area, but not always. If in doubt, consult your camera instruction manual, speak to the manufacturer, or test a film.

Focusing with infrared
Infrared radiation focuses on a different point to visible light. If you're using a wide-angle lens and an aperture of f/8 or smaller, you can focus normally as there will be enough depth of field to cope with the difference. If you're using a telephoto lens, focus normally then adjust the lens so the required focusing distance falls opposite the infrared index – this is a small red marker next to the main focus index on the lens barrel.

Taking the picture

Cameras and lenses are vital tools in the picture-taking process, but ultimately that's all they are – tools of the trade, like the spanners and wrenches a mechanic uses to fix a car. The same goes for film. You can load any brand or speed of black and white film into your camera these days and be confident that it will produce high-quality results.

What you do with these tools and materials is by far the most important thing. You can own the most sophisticated SLR in the world, but if you have no imagination or motivation, your pictures are unlikely to be inspiring. However, in creative, enthusiastic hands, even the most basic camera can be used to produce wonderful works of art.

Practice counts for a lot. The more time you spend behind a camera and the more pictures you take, the better you will become. Looking through my collection of black and white negatives during the writing of this book, I saw how my photography slowly evolved. I became more selective about the pictures I took, and my compositional skills also improved. Exposure disasters became fewer, as did processing errors, and the number of good, printable negatives per roll of film increased.

This didn't come about because I have some natural gift or talent, but through hard work,

determination and dedication. I spent every available minute either taking photographs or printing them. When I wasn't doing that, I had my head buried in a photography book or magazine, reading about technique and admiring the work of other photographers. I wanted to become a better photographer (and still do, as there's always room for improvement), so I did everything in my power to make that happen.

The purpose of this chapter is to explore some of the basic techniques behind taking and making successful black and white photographs.

Mow Cop, Cheshire, England

Once their interest is ignited, photographers tend to proceed in one of two directions: the pursuit of technical excellence or creative expression. I have always taken the latter path, preferring to develop ideas and techniques that allow me to bring my imagination to life and keeping the technical side as simple as possible. The prints I make generally come from the heart rather than the head, and though they are not always perfect I hope the feelings they encourage in the viewer overcome any technical inadequacies. The main element in this photograph is an 18th-century folly known as Mow Cop. The location had quite an unsettling feel about it, and I wanted to convey this in my print by giving it a spooky, ghost-like appearance. This was achieved by printing through a soft-focus filter, burning in the corners to create a vignette effect, and then toning the print in sepia and gold. **Camera** Nikon F90x **Lens** 17–35mm zoom **Filter** Orange **Film** Agfapan APX 400 **Print Filter** Soft-focus **Toning** Sepia and gold

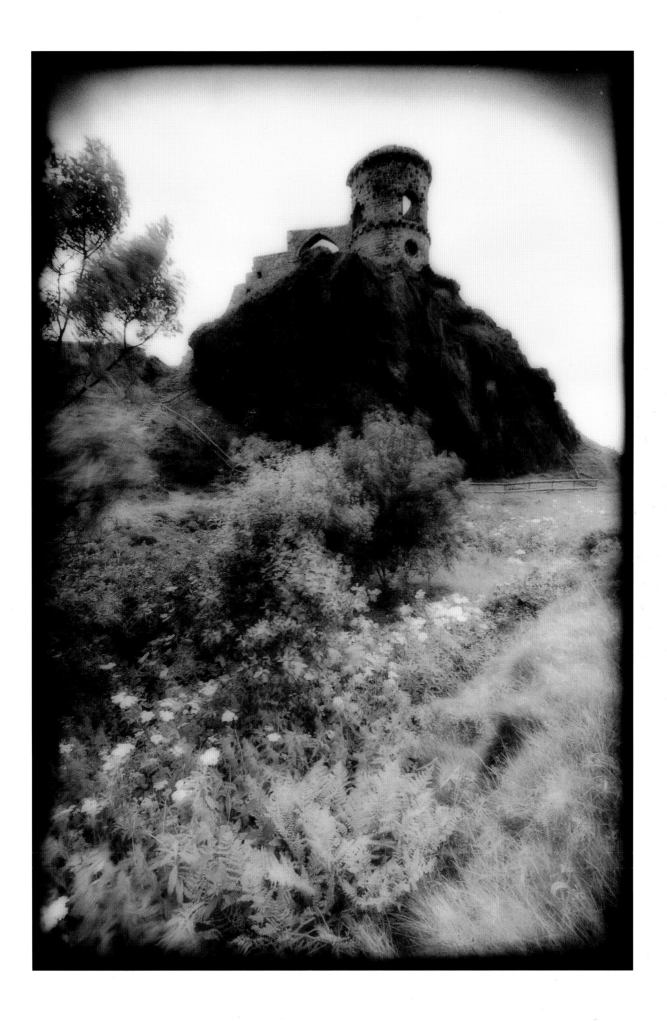

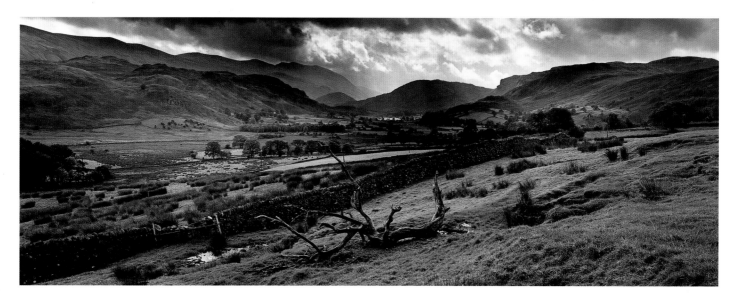

Exposure

The first step in producing fine black and white prints is making sure you have a decent negative to work with. That provides the foundations on which everything else is built.

To create a decent negative, you need to take care of exposure. The basic rule you should apply is to expose for the shadows and develop for the highlights. This first step is advised because, ideally, you need to record shadow detail on the negative – if you don't, it can never be revealed on the print. The second step follows the first in order to ensure that you have a negative that contains a full range of tones and is easy to print.

The basic principles are:
• If a subject is of normal contrast, expose and develop the film as normal.
• If the subject is of high contrast, when you expose for the shadows the highlights may go off the scale and be heavily overexposed. In order to prevent this, increase the exposure by one stop and increase development time by 20 to 25% to reduce the contrast of the negative.
• If the subject is of low contrast, you may end up with rather flat prints, so you need to boost the contrast of the negative. This can be done by reducing the exposure by one stop and increasing the development time by 20 to 25%.

Determining contrast

To determine whether contrast is normal, high or low, take one meter reading from the highlights and another from the shadows and work out the difference between the two. (A spotmeter is the

St John's-in-the-Vale, Lake District, England

I discovered this scene while walking near Castlerigg Stone Circle. The light was too flat to take a decent picture of the stone circle itself, so I decided to spend some time exploring. Within a few minutes, the sun began to break through the stormy sky and I could see the potential for an interesting panorama, using the old tree branch on the ground as foreground interest. To determine correct exposure, I simply tilted my camera down so the sky was excluded and took a meter reading from the grassy foreground. I knew this would correctly expose the midtones, of which much of the scene was comprised, but overexpose the sky – a problem easily remedied in the darkroom by burning it in. Finally, the print was partially bleached and sepia toned.
Camera Hasselblad Xpan **Lens** 45mm **Filter** Orange **Film** Agfapan APX100 **Toning** Partial bleach and sepia

best tool for assessing brightness range because you can meter from very small areas without leaving the camera position.) For example, if the highlight reading is 1/60 sec at f/16 and the shadow reading is 1/60 sec at f/2.8, the difference is five stops. Contrast is normal if the difference is between three and five stops; high if it's more than five stops; and low if it's less than three stops.

Practical exposure problems

The principle for determining exposure for contrast may seem straightforward enough. However, applying it isn't always practical because you need to expose the whole film to subjects of similar contrast – if you don't, adjusting the exposure and development time to control contrast will benefit some pictures but ruin others.

This is a particular problem with 35mm

equipment because you will have a minimum of 24 exposures per roll of film and a maximum of 36. If you use part of the roll to photograph a scene where contrast is normal, and the next scene is either low or high in contrast, you either have to waste the rest of the film and load a new one, or remove the film and reload it the next time you encounter a scene that falls into the same contrast category. Either way, it's a fiddly, confusing and time-consuming business that is bound to lead to mistakes.

If you have a medium-format camera that accepts interchangeable film, you are in a better position because you can use three different film backs – one marked 'normal contrast'; a second marked 'high contrast'; and a third marked 'low contrast'. Having assessed the contrast range of the scene that you're about to photograph, you can decide which film back to attach to the camera so that each roll only contains images that are normal, low or high contrast. That film can then be developed accordingly.

A simple exposure solution

As I use 35mm film for most of my black and white work, I don't bother with complex exposure procedures. I prefer just to go out and take pictures, and I avoid anything that gets in the way of me concentrating on composition and light.

Therefore, I have developed a 'quick and dirty' exposure routine when shooting black and white. I set my Nikon SLR to matrix metering and aperture priority AE mode, and, having composed the picture, I let the camera take a meter reading. In normal situations, I use the exposure that the camera sets as a starting point. I then shoot

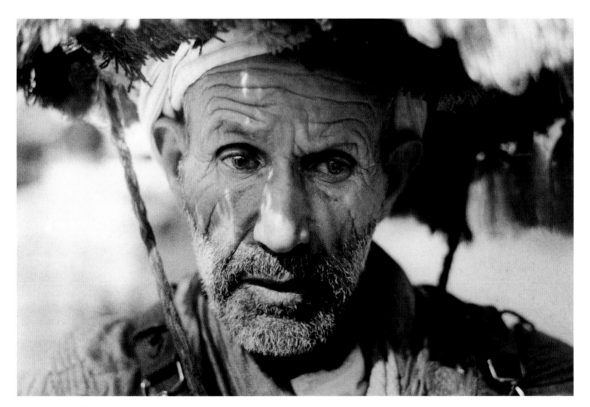

Waterseller, Marrakech, Morocco

When I'm shooting a landscape, I'm happy to spend a little time taking meter readings and thinking about how best to expose the scene. But when a fleeting opportunity presents itself such luxuries must be abandoned, or the moment is likely to be lost. In this case, I had only a few seconds to get the shot before my subject moved on, so I set my camera to aperture priority mode and fired away. Some serious dodging and burning in was necessary to produce a decent print, but at least I'd got the shot.

Camera Nikon F90x Lens 50mm Film Ilford HP5 Plus

another frame with the exposure compensation facility set to +1 stop, a third at +2 stops, and a fourth at –1 stop. That gives me four negatives of the same scene, each at a different exposure. I don't vary exposure in increments smaller than a stop because I don't feel it's necessary to do so with negative film.

This method usually gives me a decent negative to print from. If not, I have to work a little harder in the darkroom. But so what? My

preferred style of printing doesn't require me to have such stringent control over image contrast, and even if I did, I doubt that I would notice any difference in the quality of my prints.

The only time I change this technique is when I decide to expose a scene with a particular effect in mind, or when the lighting is so extreme that I know the camera's meter will be fooled into giving an incorrect reading and I need to help it.

For example, if I photograph a snow scene, I know the predominance of light tones will cause the camera to underexpose, so I miss out the metered exposure and instead shoot at +1, +2 and +3 stops over the metered exposure. I use the same exposure sequence if I'm shooting into the sun and I want to record lots of detail in the

shadows, or I may shoot all the way from –1 stop to +3 stops so I have a sequence of negatives that range from little or no shadow detail to well-exposed shadows and burned-out highlights. This allows me to produce both low-key and high-key prints of the same scene if I wish, just by varying the camera exposure when the pictures are taken.

More technically minded photographers might break into a sweat on reading this, but the system works for me and I hope the photographs in this book support the argument that you can produce high-quality prints by adopting a simple approach. Technical knowledge is important, but it's no match for creativity, so let the camera deal with the former – that's what it's designed for – while you concentrate on the latter.

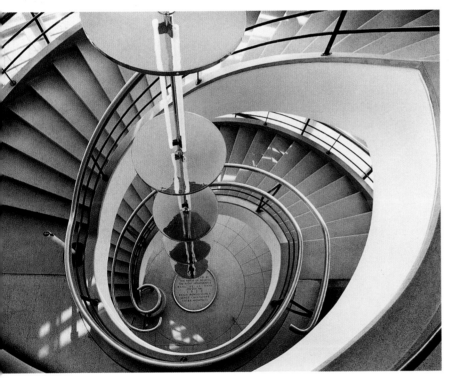

De La Warr Pavilion, Sussex, England

I like to use bold lines and shapes in my photographs and create simple, graphic compositions. This shot was taken inside one of England's best examples of modern architecture, the De La Warr Pavilion in Bexhill-on-Sea. Climbing the open spiral staircase, I had a hunch that there would be a great view from the top looking down. I was right: the staircase, handrails and walls created a wonderful spiralling effect, while the Art Deco chandelier suspended in the central well of the staircase provided a contrasting shape. By using a wide-angle lens, not only was I able to include all the main elements in the scene, but the way it stretched perspective also enhanced the effect.
Camera Nikon F90x Lens 20mm Film Ilford FP4 Plus

Composition

Composition is the first creative step in the picture-taking process. Everything that comes before it is essentially a mechanical task that enables you to record an image on film, but once you raise a camera to your eye and start making decisions about what to include in that image, you are starting a journey towards making your vision a reality.

If the negative forms the foundations of a great print, composition is the bricks and mortar with which the image is constructed. It provides the bare bones that you can manipulate and embellish in the darkroom until your vision is satisfied, in the same way that a house is just an empty shell until you furnish and decorate it and add the personal touches that make it your home.

When I compose a photograph, I always try to make sure that what I capture on film is what I want to see on the final print. Negatives can be cropped in the darkroom, and I am more than happy to do this if it improves the end result, but where possible I print full-frame. Working in this way forces me to get the composition right first time, whereas if you have the philosophy that it can always be improved later there's a tendency to become lazy and adopt sloppy practices.

Follow the rules or break them

There is no right or wrong way to compose a photograph – the most important factor is that what you produce works for you and helps you to communicate a certain message or feeling. Ideally,

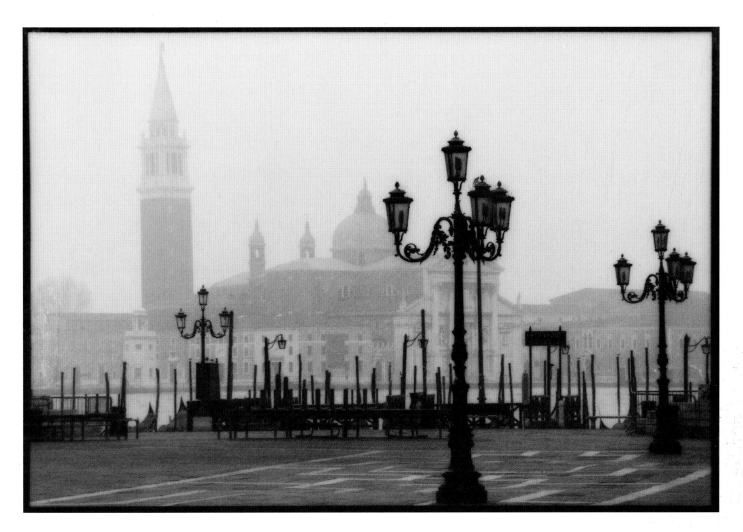

composition should become an instinct born out of your personal way of seeing the world and an understanding of how you can use certain tricks and devices to your advantage.

I never set out with preconceived ideas; I prefer to just go with the flow and see what happens. Often I compose a photograph instinctively, but there are some situations where I know I can take a great picture but I have to work hard to get the composition right, adjusting the camera position until all the elements fall into place or using lenses to alter perspective.

The key is to think about what you're doing. Be positive and confident. A lot of enthusiast photographers don't assess their actions before tripping the shutter. You really need to get into the habit of questioning why you're composing in a certain way, and whether you could improve on what you see.

Look all around the camera's viewfinder. Let your eye drift through the composition. If it collides with something, consider excluding the offending element. Look into the corners and make sure

Venice, Italy

The way you compose a photograph depends partly on what kind of message and feel you wish the final print to communicate, and also the nature of the subject or scene. For this picture of Venice, I wanted a balanced composition that was easy on the eye and captured a strong sense of place. Having decided on the key elements that would be included, and which lens would best allow me to capture them in a single picture, I spent a few minutes adjusting the camera position until I felt those elements worked well together. I have a particular dislike for wasted space, so I always try to keep my compositions tight. Printing full-frame is a good discipline to adopt because it forces you to think about the composition when the picture is taken – you can also create an attractive border using the edges of the film rebate.

Camera Nikon F90x Lens 80–200mm zoom Film Ilford HP5 Plus Print Filter soft focus Toning partial bleach and sepia

that nothing is creeping into the picture that shouldn't be there. If there is wasted space in the composition, ask yourself if it plays a role or should be filled. A tight composition generally works better than a 'windy' one.

There are various 'rules' of composition that can be used to point you in the right direction. I favour the 'rule of thirds' when I want to create balanced compositions. These days, I instinctively divide the viewfinder into an imaginary grid to make sure that key elements fall on the thirds. I don't necessarily take the picture that way, but it provides a handy starting point. I also like to use diagonal, vertical, horizontal and converging lines to shape the composition, and when I'm shooting wide-angle landscapes I always look for foreground interest to provide a sense of depth and scale and to lead the viewer's eye into the scene.

Your compositions need not always obey convention, however. If I feel that placing the main

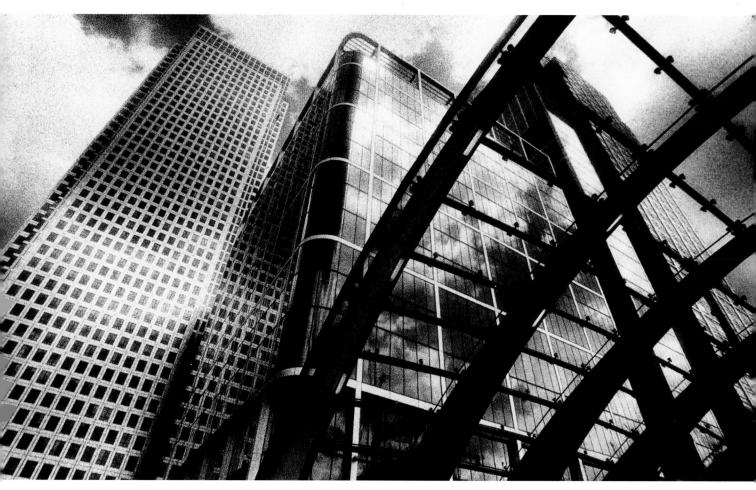

Docklands, London

Don't be afraid to experiment with composition. You don't have to commit yourself and take a picture unless you're happy with what you see through the viewfinder, but often you will be surprised by what does appear when you try something different. For this shot of Dockland's towering office buildings, I knew there was no way of avoiding converging verticals, so I decided to exaggerate them by using an ultra-wide-angle lens from a low viewpoint. The bold arches on the right side of the picture form the entrance to Canary Wharf subway station. By stepping under them, I added an extra element to the composition. **Camera** Nikon F5 **Lens** 18–35mm zoom **Filter** Deep red **Film** Kodak High Speed mono infrared

element in the centre of the composition is the best option, then I do it. If I want to shoot from a low viewpoint, or use the camera at an angle, then I do so. Basically, when I am happy with how a picture looks through the camera's viewfinder, I take it, and if I have to break the so-called 'rules' to reach that point, I don't hesitate.

Depth of field

Having invested time and effort in composing your picture, you need to have an accurate idea of what's going to be in and out of focus in that picture when you finally trip the shutter and expose the film to light. That means you need to be able to control depth of field.

There are three factors that determine how much, or how little, depth of field you get:
1) Most important of all is the aperture (f-number) you set the lens to. For any given lens focal length, the smaller the aperture (that is, the higher the f-number), the greater the depth of field. If you want to maximize depth of field, set a small aperture such as f/11 or f/16; if you want to minimize it, set your lens to its widest aperture (that is, the lowest f-number).
2) The focal length of the lens makes a big difference. The bigger it is, the less depth of field you get at any given aperture setting, and vice versa. So, a 200mm lens set to f/16 will give far less depth of field than a 28mm lens set to f/16, and so on.
3) The final factor is focusing distance. The closer

Lindisfarne, Northumberland, England

Being able to control depth of field is particularly important when you're taking scenic photographs and require everything to be in sharp focus. I achieve this using hyperfocal focusing, which allows me to maximize depth of field without stopping the lens down to a smaller aperture than is absolutely necessary. For this infrared photograph, I wanted to fill the foreground with one of the boats around the harbour while including the landmark of Lindisfarne Castle in the background to give the picture a sense of place. I used the hyperfocal focusing technique to ensure that everything in the scene recorded in sharp focus.
Camera Nikon F90x Lens 20mm Filter Deep red Film Kodak High Speed mono infrared

the point of focus is to the camera, the less the depth of field will be. For example, a 50mm lens set to f/11 and focused on ten metres (33 feet) will give you more depth of field than the same lens set to the same aperture but focused on a point two metres (seven feet) away.

Depth of field for landscape photography

Controlling depth of field is especially important when you're shooting landscapes and want everything to be recorded in sharp focus, from the

immediate foreground to infinity. The problem with SLRs is that the lens is always set to its widest aperture for viewing purposes to give you a bright, crisp viewfinder image, and it's only when you trip the shutter to take a picture that the diaphragm stops down to the aperture set and the true depth of field is created. Consequently, when you look through your camera's viewfinder, you're seeing depth of field as it would record if the picture were taken with the lens set to its widest aperture, when depth of field is minimal. That's why areas will appear out of focus, especially when using telephoto lenses.

Pressing the stopdown preview button on your lens barrel or camera body will mimic this effect by closing the aperture down to the f-number set. This helps you assess what's going to be sharp or not in the final picture. At small apertures such as f/16 or f/22, the viewfinder image goes dark though, so it's not easy to make an accurate judgement and more concrete evidence is necessary. Ironically, it tends to be these smaller apertures that you are more likely to use for landscape photography.

Users of rangefinder cameras (my Hasselblad Xpan is a good example) have an even greater problem because you're not even looking through the lens, so there's no way of assessing depth of field visually.

Fortunately, there is a solution: a technique known as hyperfocal focusing.

Hyperfocal focusing

If you look at a typical lens barrel (shown below), you'll see that there is a series of f-numbers on either side of the main focusing index. This is the lens's depth-of-field scale.

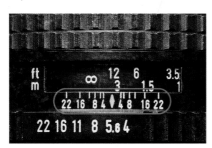

To maximize depth of field, focus the lens on infinity and then check along the depth-of-field scale to see what the nearest point of sharp focus will be at the aperture set –the distance on the lens's distance scale opposite the relevant f-number on the depth-of-field scale. This distance is the hyperfocal distance for that particular aperture setting.

In the picture below, of a 45mm wide-angle lens for a Pentax 67, you can see that at f/16 with focus set to infinity, the nearest point of sharp focus is just under three metres (ten feet). This is the hyperfocal distance. If you left the lens focused on infinity and shot at f/16, you would therefore achieve sharp focus from just under three metres (ten feet) to infinity.

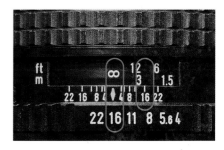

By refocusing the lens on the hyperfocal distance, depth of field will extend from half the hyperfocal distance to infinity. In the example below, you can see that by refocusing the lens on a point just under three metres (ten feet) away, depth of field now extends from around one and a half metres (five feet) to infinity. That extra one and half metres (five feet) of depth of field can make all the difference when you're shooting wide-angle landscapes with lots of foreground interest.

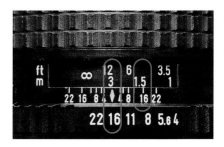

Another important factor to consider is that not all depth-of-field scales are particularly accurate, so don't be tempted to follow them too closely. I always set infinity well inside the f-number I'm working at on the depth-of-field scale as a precaution and always assume that the nearest point in sharp focus won't be quite as close to the camera as the scale says. This avoids relying on the scales too much, only to find that the nearest or further points (or both) aren't pin-sharp when you process the film and examine the negatives.

If I were shooting at f/16 with the lens pictured top right, for example, I would set the infinity marker closer to f/11 than f/16, as shown, and assume that the nearest point of sharp focus was a little over one and a half metres (five feet).

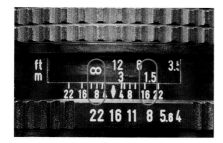

Note: If you look through your camera's viewfinder after refocusing the lens on the hyperfocal distance, pretty much everything appears to be out of focus. Ignore this – the final shot will be sharp from front to back, as you will soon realize once you have used the technique a few times and examined the results.

Finding the best compromise

Having read this advice, you may well be thinking that you could take the easier option of stopping the lens right down to f/16, f/22, or whatever the minimum aperture of your lens is, and either focusing on infinity or on a point roughly a third into the scene.

This latter suggestion will work most of the time with a wide-angle lens, where depth of field is extensive anyway, because depth of field extends twice as far beyond the point of focus as it does in front. However, for once I would advocate a more controlled approach, because if you stop your lens right down to its minimum aperture you may still not achieve the desired result, and, even if you do, other problems will be created in the process.

Lenses give their best optical performance in the middle of the aperture range – usually around f/8 or f/11 – so by stopping down to f/16 or beyond you're reducing image quality when you may not need to.

Also, the more you stop down, the slower the shutter speed will be that you need to set in order to achieve correct exposure. If you're

handholding the camera this may result in unsharp pictures due to camera shake – especially when using slow film. Subject movement can also be a problem.

For these reasons, I never stop the lens down further than I need to. If there's no option but to use f/16 or f/22 in order to obtain sufficient depth of field then I will do so, but equally, if I can achieve the depth of field required by shooting at f/8 or f/11 then I would never stop down further. Using the hyperfocal focusing technique allows you to juggle the two variables and find the best possible compromise.

Calculating hyperfocal distance

In order to use the technique, you must have a decent depth-of-field scale on your lens. Unfortunately, this is something a lot of modern autofocus lenses for 35mm SLRs tend to lack – especially zooms.

If your lenses let you down in this respect, all need not be lost because you can calculate the hyperfocal distance using this simple equation:

Hyperfocal distance = F (squared)/(f x c) where:

F = lens focal length in mm
f = lens aperture used, e.g. f/16
c = Circle of confusion (a constant value is used for Circle of confusion – 0.036 for 35mm-format lenses and 0.127 for medium-format)

For example, if you're using a 28mm lens set to f/16, the hyperfocal distance is 28 x 28/(16 x 0.036)
= 784/0.576
= 1.361 metres, rounded up to 1.4 metres (four and a half feet)

By focusing the lens on roughly 1.4 metres (four and a half feet), depth of field will extend from half that distance (0.7 metres/two feet) to infinity.

hyperfocal distance

Aperture (f-stop)	Lens focal length (mm)								
	20mm	24mm	28mm	35mm	50mm	70mm	100mm	135mm	200mm
f/11	1m	1.5m	2m	3m	6.3m	12.3m	25m	46m	100m
f/16	0.7m	1m	1.4m	2.0m	4.3m	8.5m	17.5m	31.5m	70m
f/22	0.5m	0.7m	1m	1.5m	3.1m	6.2m	12.5m	23m	50m
f/32	0.35m	0.5m	0.7m	1.0m	2.2m	4.2m	8.5m	16m	35m

This is too fiddly to do every time you take a picture, of course, so to save you the bother, the table on page 31 shows the hyperfocal distances for lenses from 20 to 200mm and apertures from f/11 to f/32. These values apply for zoom lenses set to the relevant focal lengths, as well as prime (fixed focal length) lenses.

To use the chart, simply find the focal length you're using along the top, the aperture you want to use down the side, then read across to find the hyperfocal distance.

For example, if you're using a 28mm lens set to f/22, the hyperfocal distance is 1.0m. By focusing

the lens on 1.0m, depth of field will extend from half the hyperfocal distance (0.5m) to infinity.

To check that this is sufficient, focus on the nearest point you want to include in the picture and then look at the distance scale on the lens barrel to see how far away that point is.

If it's more than the nearest point of sharp focus that you've just determined, you can fire away safe in the knowledge that you will get front-to-back sharpness. If it's less than the nearest point of sharp focus, there's a danger that the immediate foreground won't be sharp, so refer back to the table and then stop your lens down to a smaller aperture.

This probably sounds very complicated right now, but if you read through the information several times, and refer to the table while handling your own lenses, it will soon become clear and you will never again take a landscape picture that suffers from a fuzzy foreground.

Even better, why not copy the table onto a sheet of white card, or photocopy the previous page, then slip it into a clear plastic wallet so you can refer to it in the field?

Note: The figures in the table only apply to lenses in 35mm format. If you are using medium-format and you want to compile a similar table of

Venice

When there's very little distance between the nearest and furthest points in a scene you want to photograph, you don't need lots of depth of field because most of it will be wasted. Having composed this picture of masks in a Venetian shop window, I simply focused on the mask of the crescent moon, stopped the lens down to f/8, then used the depth-of-field preview to check that everything would be in sharp focus. If carrying out this check tells you that more depth of field is required, stop the aperture down to the next biggest f-number (f/11 from f/8; f/16 from f/11, etc) and check again.
Camera Nikon F90x **Lens** 80–200mm zoom **Film** Ilford HP5 Plus

hyperfocal distances, you must do so by replacing the constant for the Circle of confusion, 0.036, with a new figure – 0.127 – and then recalculate all the distances.

Limiting depth of field

In some situations, of course, you will need to minimize rather than maximize depth of field in order to isolate just one element in the scene or throw a distracting background out of focus when shooting portraits or candids. Minimal depth of field can be a valuable creative tool. Close-ups of flowers and other subjects can work particularly well when very little is recorded in sharp focus.

The two main controls at your disposal here are lens focal length and the aperture you set that lens to. The rule to remember is this: the longer the focal length, and the wider the aperture, the narrower the depth of field will be, so a 300mm lens set to f/4 will give less depth of field than a 100mm lens set to f/4, and so on.

You can reduce depth of field further by moving closer to your subject or by focusing on a point that is closer to the camera – the closer that point is, the less depth of field you will record for any given lens and aperture setting.

Assessing limited depth of field is actually easier than assessing extensive depth of field. If you're shooting with your lens at its widest aperture, the effect you see through your camera's viewfinder is exactly the effect the film will record. If you're working at a slightly smaller aperture, all you need to do is use the depth-of-field preview button on the camera or lens so the aperture stops down to the f-number set. If this is only two or three stops smaller than the lens's maximum aperture, the viewfinder image won't be too dark and you will gain a clear impression of what will be in and out of focus when the shutter release is finally depressed.

Again, experience counts for a lot. The more you experiment with depth of field, the more you will understand how to control it, and, more importantly, use it to your creative advantage.

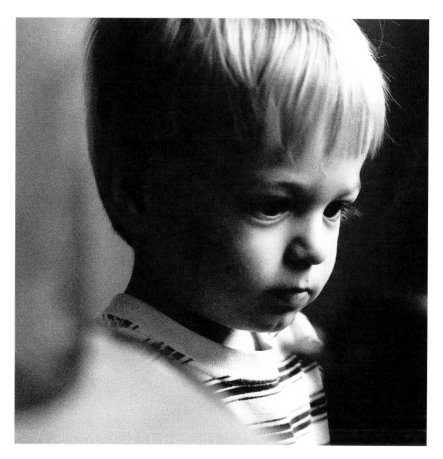

Noah

Depth of field is dramatically reduced if you use a telephoto or telezoom lens set to its maximum aperture. This can be used to great creative effect, allowing you to isolate your main subject from the background, though in low light you may have no choice but to work at this extreme in order to make it possible to continue taking pictures. Either way, you need to focus carefully as there is little room for error. The longer the lens and the wider the aperture, the less depth of field there will be. Autofocusing can help, though I tend to focus manually if my subject is static. For this candid shot of my son, I set my telezoom lens to its longest focal length (200mm) and widest aperture (f/2.8).
Camera Nikon F90x Lens 80–200mm zoom Film Ilford HP5

Developing the film

Having exposed the film, the next step is to develop it to create the negatives from which you will make prints.

To be honest, this is the least interesting part of the photographic process for me. You can't see what's happening because the film is enclosed in a lightproof tank until the fixing stage is complete, so it becomes little more than a means to an end. That said, it's a vitally important task that must be taken seriously. Any mistakes made here could ruin your chances of making a good-quality print and important pictures could be lost forever.

You could take the lazy option and send your black and white films away to a commercial lab for development, and I have done this from time to time. However, home development is relatively quick and very easy. You don't need expensive equipment or even a darkroom, so you might as well do it yourself. At least that way you have total control over the whole process, from taking the picture to making the final print.

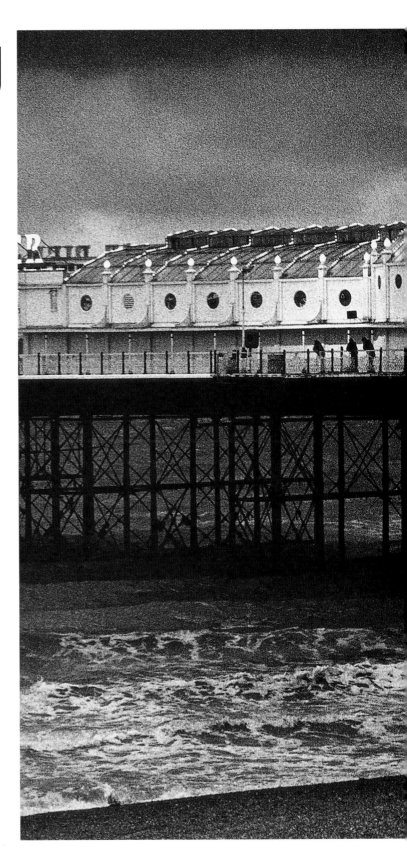

Brighton Pier, Sussex, England

If you want the best possible prints, then you must have a high-quality negative to work from in the first place. Achieving that isn't as difficult as it sounds: modern cameras make getting the exposure right in the first place relatively straightforward, and actually developing the film is easy if you stick to a consistent working routine and think about what you're doing. This photograph was taken on a cold winter's evening in the midst of a hailstorm. To recapture this effect in the darkroom, I printed hard to grade IV to increase contrast, burned in the sky to enhance the stormy effect and selenium-toned the print.

Camera Olympus OM4-Ti **Lens** 85mm **Film** Fuji Neopan 1600 **Toning** Selenium

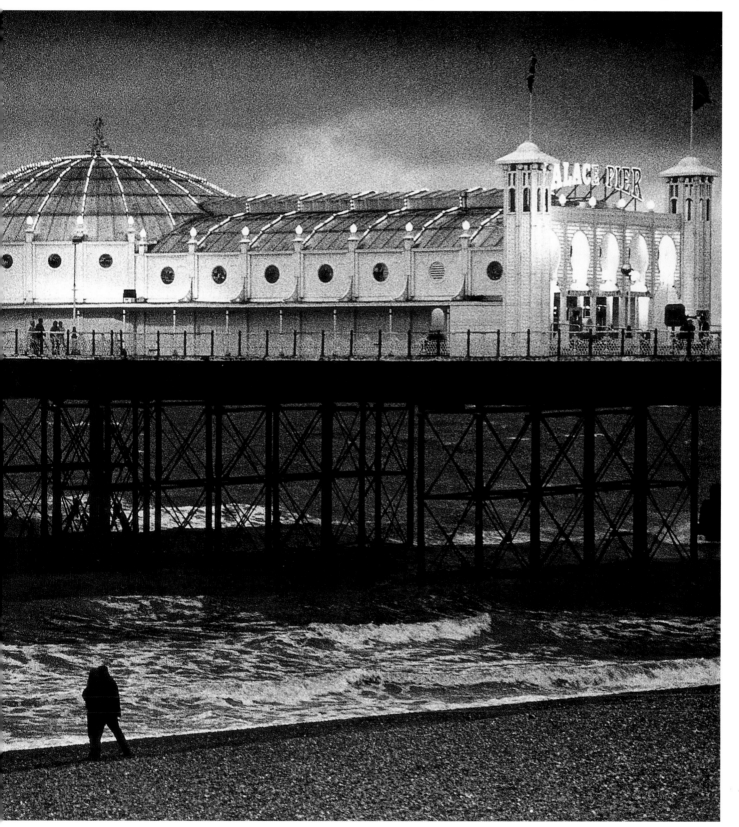

Film-developing chemicals

There are three chemicals that you need to be able to process black and white film: developer, stopbath and fixer.

Developer

The developer is the most crucial of the three chemicals because the type you use can affect the contrast and graininess of the negative. There are many types of developer to choose from. If you go to a specialist darkroom supplier, you will find all kinds of weird and wonderful concoctions, including some that have been invented by individual photographers.

I've never really got into experimenting with developers – it doesn't suit my style of working. Instead, I buy standard brands off the shelf – always liquid concentrates as they're easy to work with – and use them as recommended by the manufacturer.

The two developers that I use most often are Ilford Ilfotec LC29, which is a fine-grained, general-use brew, and Agfa Rodinol, which is a high-acutance developer that produces crisp negatives with enhanced grain. I tend to use the former when I want to obtain finer grain and the latter when I want coarser grain from fast film. Both can be used at different dilutions to vary image contrast, though I tend to use Ilford Ilfotec LC29 at 1:19 and Agfa Rodinol at 1:25.

There are many other brands of developers I could use that would work just as well, but I prefer to stick with what I know to make for a more consistent working practice and to reduce the risk of making mistakes.

Liquid concentrates are more convenient if you don't shoot a lot of film because you only have to mix up what you want as and when you need it. I buy small bottles (LC29 in 250ml/half-pint quantities and Rodinol in 125ml/quarter-pint bottles) so I don't have partially used bottles lying around for long periods.

Once a bottle of concentrate is opened, the remainder has a limited life – usually only a few months. I purchase small bottles because I know that I will use the contents before they need to be discarded due to oxidization, so waste is minimized. To slow down the deterioration, I place glass pebbles in the partly used bottles so the level of liquid is brought back up to the neck and all oxygen is expelled. Another option is to buy bigger bottles of concentrate and then decant them into small storage bottles that are full and tightly capped. This can be more cost-efficient, as larger bottles of developer, and other chemicals, cost less pro rata than small bottles.

Most liquid concentrate developers are known as 'one-shot'. This means that when you dilute a quantity of concentrate to make a working solution it must be discarded after single use. Other liquid developers can be reused by extending the development time for each subsequent use, though I avoid this and prefer to use fresh stock each time.

Stopbath

When the development time is up, the developer solution is poured out of the film tank and then replaced with dilute stopbath. This is a weak acidic solution that neutralizes the alkaline developer so that development is halted.

Any brand of stopbath can be used. I prefer those that contain an indicator dye that changes the colour of the solution when it is exhausted – this tells me when I need to make up a fresh batch. After each use, the stopbath is poured into a storage bottle.

You don't have to use stopbath at all – clean water poured into the tank once the developer has been removed can be used instead. However, the benefit of using stopbath is that it will make your fixer last longer: fixer is also acidic, so if you don't neutralize the developer with a stopbath its alkalinity will reduce the effectiveness of the fixer.

Fixer

The final stage is to pour a solution of fixer into the tank. This makes the image on the film permanent and no longer light-sensitive by removing any remaining undeveloped or unexposed silver halide from the emulsion.

You can reuse fixer until it reaches exhaustion, though I recommend that you test it before each use. You can do this by dropping an undeveloped piece of film into the fixer solution (the film leaders you cut off prior to loading the film onto a spiral for development are ideal). If it clears in half the recommended fixing time – usually two or three minutes – then the fixer is safe to use. If it doesn't,

Developing the film

discard the solution and make up a fresh batch.

There are various types of fixer available, and it doesn't really matter which you use. Most can be used for both film and prints at different dilutions. I keep film fixer separate from print fixer.

Other equipment for developing

Listed below are the other items that you will need to be able to develop black and white film.

Lightproof developing tank and film spirals

I use standard Paterson System 4 developing tanks and film spirals. They're widely available and relatively inexpensive. You can also buy the tanks in different sizes to take varying numbers of films. I use two tanks: a Universal to process two rolls of 35mm films or one roll of 120/220 film; and a second that holds up to five 35mm films or three 120/220 films.

Thermometer

A thermometer is vital to ensure that the developer is maintained at a temperature of 20°C. If you deviate more than 1°C above or below this, the development time should be adjusted to compensate (the instructions that come with the developer will say by how much).

Timer/clock

A timer enables you to control development time accurately. If you develop for too long or not long enough, the quality of the negatives will be affected. Any timer or clock that can be set to count down for a specific time will suffice – I use a digital clock from the photo dealer Jessops.

Film squeegee

This is used to remove excess water from the surface of the film once it has been fixed and washed so it dries evenly and streak-free. This item isn't essential – you could run the film between your fingers – but I find it useful.

Water bath

To keep the developer temperature constant, you will often need to partially immerse the developing tank in a water bath. A plastic washing-up bowl or any large container will be suitable. Alternatively, use your kitchen sink as a water bath.

Near Aira Force, Lake District

Although there are many different film developers available, some offering special characteristics, I mainly stick with well-known 'universal' brands that can be used for all types of black and white film – in this case Ilford Ilfotec LC29, diluted 1:19 with water. I also prefer developers that are supplied as liquid concentrates as they're easier to use than powdered developers that must be mixed with water to make a stock then diluted further to make a working solution.
Camera Nikon F5 Lens 28mm Film Ilford HP5 Plus

Measuring graduates/jugs

You will need a small measuring graduate for each of the three developing chemicals, and a larger measuring jug to hold the diluted chemicals.

Wetting agent

Wetting agent is a very dilute detergent. If you put a few drops in the film tank after the washing cycle, fill the tank with water and then drop the film spirals back in, the detergent will break down surface tension on the film and allow excess water to run off. Combined with a quick squeegee, this will aid even drying and should give you spotlessly clean negatives.

Film clips

You need to hang up freshly developed and washed film overnight to dry. Film clips are available for this purpose. They come in pairs, one heavier than the other. The weighted one is clipped to the bottom of the film to hold it down and prevent curl during drying. I don't bother with them; I just use plastic clothes pegs. Two pegs clipped to the bottom of the film are just as effective as a weighted film clip that might cost fifty times as much!

Loading the film

Film must be loaded onto a spiral in complete darkness to avoid fogging. If you have a darkroom, load the film in there; if you don't, use a lightproof changing bag or black out a room or cupboard in your house.

As I don't have a permanent darkroom, I tend to wait until late at night and load films for development in the guest shower room on the top floor of my house. This room doesn't have a window and, with all lights turned off both inside and outside, is pitch dark.

The main thing when loading film is to lay out all the items you need so you can find them in the dark without any problems. I also complete as many stages as I can with the lights on.

Modern film spirals are quick and easy to use. However, you must make sure that they are completely dry as moisture in the grooves can cause jamming. If the film jams, remove it carefully – trying to force it will buckle and damage the film.

To prevent this, I drop the spirals into hot water from a kettle (not boiling) after use to wash them. After a vigorous shake and towel-dry, they are lined up on a central heating radiator for an hour or so to ensure that all the moisture evaporates.

When I have needed to reuse spirals straight-away to develop a large batch of film I have even placed them in a warm oven for a few minutes to speed up total dry-out. If you do this, I recommend leaving the spirals to cool down before use, as the warm plastic will increase the temperature of the developer when you pour it into the tank.

Only mix film types and speeds if you have already checked that they need the same development time. This is rarely the case, so I tend to develop each type individually, using the small tank if there are only one or two rolls to develop and the bigger tank when I have between three and five rolls of the same type. The standard plastic reels can usually be set

controlling negative contrast

In keeping with my 'simple' approach to the art of black and white photography, I always develop films according to the times recommended by the developer manufacturers. This works fine for me. However, some photographers adjust development time as a means of controlling the contrast of the negative: reducing it lowers contrast; extending it increases contrast.

This technique only works if you also adjust the exposure when the picture is initially taken, though. If the light is flat and low in contrast and you want to make the negative more punchy, reduce the exposure by one stop and then increase the development time by 20 to 25%. Conversely, if contrast is really high (more than five stops' brightness between highlights and shadows) increase the exposure by a stop then reduce the development time by 20 to 25%.

As outlined in chapter two, this is only practical if you shoot a whole roll of film in the same low-contrast or high-contrast conditions. Also, you need to mark the film cassette for increased or reduced development, because otherwise you're likely to forget.

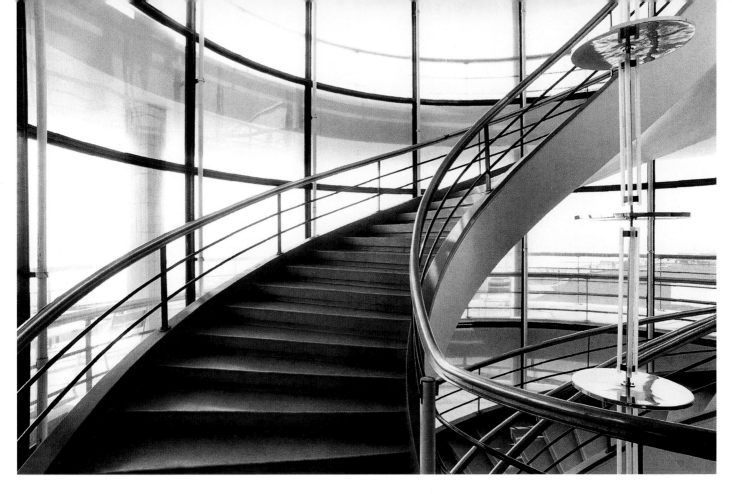

De La Warr Pavillion, East Sussex

By over or under-exposing a picture, then altering the devopment time, you can change the contrast of the negative. Instead, I rate and develop the film as recommended then vary the contrast grade of the paper. In this case I printed at grade 1 so I could record a full range of detail in the interior without burning-out the windows.
Camera Nikon F90x Lens 20mm Film Ilford FP4 Plus

with the sides wider apart to accept 120 or 220 film. This is trickier to load because it's wider and more flexible than 35mm. Also, rollfilm isn't contained in a cassette so you can't feed the end onto the spiral in daylight – it is essential that everything is done in complete darkness.

Your best bet with rollfilm is to sacrifice a roll and use it to practise in daylight until you get the hang of feeding the end onto the spiral when you can't actually see anything. Having tried it while watching what you're doing, try again with your eyes closed, then eventually in complete darkness.
1) First of all, if your camera pulls the whole of the film back into the cassette when it's rewound, you need to pull the leader back out again using a leader retriever – or set a custom function on your camera, if possible, that tells it to leave the leader out.
2) Cut off the leader with a pair of scissors and feed the end of the film onto the spiral until the ball-bearings in the spiral pick up the film sprocket holes.

This is much easier to do in daylight than in total darkness. I repeat this for each roll of film before switching off the lights.
3) Once the lights are off, pick up the first spiral, pull the film cassette down to reveal a length of film, then rock the sides of the spiral back and forth until the film cassette touches the spiral. Then pull the cassette down again to reveal more film, and repeat until all of the film is loaded onto the spiral.
4) Cut off the cassette using scissors, put the spiral into the film tank and secure the lid. Repeat this process for the second and subsequent films until all spirals are loaded and are placed inside the tank.

The developing process

Once the spirals are inside the tank and the tank lid is secure, you can complete all the other stages with the lights on.

I tend to do this on the draining board in my kitchen, where any splashes and spills are easily wiped up. If the fixer and stopbath are already mixed, they are placed in measuring jugs ready for use. I then check the instructions that come with

Storm over Loch Levan, Scotland

All black and white films can be uprated and push-processed. In this case, I rated ISO400 film at ISO1600, not because I needed extra speed, but to make the image grain coarser. I felt that this effect would enhance the stormy nature of the scene.
Camera Olympus OM2n Lens 300mm Film Fuji Neopan 400 rated at ISO1600

the developer to determine the recommended development time for the particular film that I want to develop.

Finally, I mix up the developer. This stage is left until last so I can get the correct working temperature and use the solution straightaway. For each roll of 35mm film I prepare 300ml (half a pint) of solution; for 120 film I prepare 500ml (one pint) of solution.

To speed up the process, I make up a jug of water at 20°C by mixing hot and cold water together and checking it with a thermometer until the correct temperature is reached. I then use this water to make up the required volume of developer solution.
1) After a further temperature check, if the developer is still at 20°C I start the timer and then carefully pour the developer into the tank.
2) Once the solution has settled down, I secure the lid, tap the base of the tank a couple of times

on a worktop so as to dislodge any air bubbles, then invert it for ten seconds.
3) Next, I remove the lid and check the temperature to make sure it's still at 20°C. If the temperature has risen or fallen more than 0.5°C, I place the tank in the sink and run a few inches of either warm or cool water to adjust the developer temperature.
4) The tank must be agitated according to the manufacturer's instructions. With some developers, this involves inverting the tank once every 30 seconds; with others you must invert several times over a ten-second period every minute.
5) 20 seconds before the recommended development time is complete, I pour the developer from the tank into a measuring jug and then quickly pour in the stopbath to halt further development. You don't have to be accurate to the second here, so don't panic!
6) The tank is inverted several times for about a minute. Then the stopbath is poured back into its measuring jug, the fixer is poured into the tank, the timer is reset to three minutes and I hit the start button.
7) During fixing, the tank is inverted two or three times every minute. After three minutes, the solution is poured out of the tank and clean water, at about

20°C, is poured in. After inverting the tank a few times, the water is poured out and more clean water is put in. I repeat this process four or five times to flush out as much of the residue fixer as possible.

8) With the top lid removed, the tank is placed under a running cold-water tap so fresh water runs down the hollow tube that holds all the spirals. This forces water already in the tank back up through the film spirals. You can buy a special hose known as a force-film washer that connects to a tap at one end and is pushed into the film tank at the other to provide more efficient washing, but my method works fine.

9) After 20 minutes of continual washing, the tank is emptied, the spirals are removed, and I add a few drops of wetting agent before running more water into the tank and dropping the spirals back on. The spirals are then sloshed around in the 'soapy' water.

10) Finally, the films are removed in turn from their respective spirals, passed once through a clean squeegee, and then hung up to dry. I use a Durst UT100 film-drying cabinet for this, which acquired many years ago, though a shower cubicle can be just as good if you fix a line up inside it.

11) Once the films are dry, cut them into strips of five or six negatives with a pair of sharp scissors and store them into file sheets. I favour glassine paper pages as they are inexpensive, non-abrasive, and information such as date, location/subjects, developer and a film number can be written on the top of the sheet.

12) Finally, the negative file sheets are stored in an archival ring-binder box. Each box can hold around 150 films and provides a safe environment for long-term storage, as well as keeping everything organized.

push-processing

A technique popular with black and white photographers is to rate film at a higher ISO than is recommended (this is known as uprating) and then to increase the development time to compensate. This technique is known as push-processing.

The most practical reason for doing this is to provide faster shutter speeds in low light so you can freeze movement or take handheld shots without worrying about camera shake. However, there are side-effects to uprating and pushing that have creative benefits too – image contrast increases and grain becomes coarser, allowing you to produce stark, gritty images.

When a film is uprated, the normal practice is to double or quadruple the recommended speed. For example, ISO100 film could be rated at ISO200 or ISO400; ISO400 film could be rated at ISO800 or ISO1600, and so on. Each time the ISO rating is doubled, the film must be push-processed by an extra stop, so ISO100 film rated at ISO200 must be pushed one stop; ISO1600 film rated at ISO6400 must be pushed two stops, and so on.

Some black and white developers, such as Ilford Microphen and Kodak X-Tol, are designed for use with film that has had a speed increase, but you can experiment with any developer. As a general rule, increase the development time by 20 to 25% for each stop you uprate. Alternatively, refer to the suggested speed increases and development times for various films listed below.

Film	Original ISO	New ISO	Developer	Dev time 20°C
Fuji Neopan 400	400	1600	Kodak T-Max (1:4)	10 mins
Fuji Neopan 400	400	3200	Ilford Microphen (stock)	16 mins
Agfapan APX 400	400	1600	Kodak X-Tol (stock)	12.25 mins
Agfapan APX 400	400	3200	Kodak X-Tol (stock)	14.5 mins
Kodak Tri-X 400	400	1600	Kodak X-Tol (1:1)	11.75 mins
Kodak Tri-X 400	400	3200	Kodak X-Tol (1:1)	13.5 mins
Kodak T-Max 400	400	1600	Kodak X-Tol (stock)	8.5 mins
Kodak T-Max 400	400	200	Kodak X-Tol (stock)	10 mins
Ilford HP5 Plus	400	800	Kodak T-Max (1:4)	8 mins
Ilford HP5 Plus	400	1600	Kodak T-Max (1:4)	9.5 mins
Ilford HP5 Plus	400	3200	Kodak T-Max (1:4)	11.5 mins
Fuji Neopan 1600	1600	3200	Kodak T-Max (1:4)	10 mins
Fuji Neopan 1600	1600	6400	Kodak X-Tol (stock)	7.25 mins
Kodak T-Max 3200	3200	6400	Kodak X-Tol (stock)	12.5 mins
Kodak T-Max 3200	3200	12500	Kodak X-Tol (stock)	15.25 mins
Kodak T-Max 3200	3200	25000	Kodak X-Tol (stock)	18.5 mins
Ilford Delta 3200	3200	6400	Kodak T-Max (1:4)	11 mins
Ilford Delta 3200	3200	12500	Ilford Microphen (stock)	16.5 mins
Ilford Delta 3200	3200	25000	Ilford Microphen (stock)	22 mins

The darkroom

The darkroom is the heart of any black and white photographer's operation. It's where the magic happens: where images on strips of film are turned into successful photographic prints and creative ideas become reality.

It is important to realize that your darkroom need not be a space permanently set aside solely for the purpose of processing film and making prints. Neither do you need expensive equipment and running water to produce high-quality results.

In an ideal world, it would be good to have such amenities, and we can all strive to have a permanent darkroom where everything is on hand and all we have to do is close the door and turn off the lights. But it's a myth that you must have such luxuries in order to produce high-quality work, just as it's a myth that you must have state-of-the-art cameras to take successful pictures.

Aln Estuary, Northumberland, England

Good printing is as much about your attitude and enthusiasm as it is the facilities you have at your disposal. I taught myself the art and craft of black and white printing with the most basic equipment available in a number of temporary darkrooms, from a garden shed to a freezing basement. Even today, my darkroom is a temporary space that has to be set up whenever I wish to make prints. However, I never let this fact put me off, or affect my motivation – I love printing and within reason will do it anywhere! I wanted to add atmosphere to this photograph, which was taken just down the road from my home, so I printed the negative through a soft-focus filter and subjected the print to partial bleaching and split-sepia toning to create its delicate warmth.

Camera Nikon F90x **Lens** 28mm **Film** Ilford FP4 Plus **Print Filter** Soft-focus **Toning** Partial bleach and sepia

My darkroom set-up

Throughout the writing of this book, and the making of all the photographs featured in it, I have used the utility room at the back of my house as my darkroom. The only item of equipment on display when you enter the room is an ageing enlarger that lives on top of the washing machine; everything else is packed away and has to be set up whenever I want to make prints. I share the space with a toilet, a sink, a central heating boiler, my son's bicycle, and often a basket of laundry.

Eventually this room will become a permanent darkroom. It will boast workbenches; shelves and cupboards for bottles of chemicals; boxes of printing paper; and the myriad accessories that black and white printers need to practise their art. But the room will never be mine exclusively; it will always be a utility room that is in daily use and that therefore must be kept clutter-free.

Meanwhile, I spend 30 minutes blacking out the window and door with board and lightproof sheeting before I start work, then as long again at the end of the session returning the room to its original state. My print trays have to be placed on the floor and I have to kneel down when I'm developing and fixing prints – a procedure that always plays havoc with my knees, especially when lith printing!

When I have a set of prints ready for washing, I carry them up two flights of stairs in a large print tray to the bathroom, where they are deposited in an archival print washer set up in the bath. When the prints are washed and ready for drying, I hang them on lines stretched across the bathroom using plastic clothes pegs.

Taking over the bathroom as well as the utility room means that I usually have to print late at night when those rooms aren't required by my family. I don't mind doing this because I find it much easier to work when the house is quiet and I have the place to myself. The only snag is that, come the next morning, I have to be first out of bed (no matter how late I got into it) so I can take down the prints before the kids emerge and start complaining that they can't use the bath or shower!

This isn't an ideal situation to be in, and I would dearly love a permanent darkroom. But you don't really need one. Fancy darkrooms are an asset, but the key to great printing is enthusiasm, commitment and creativity. If you have that, you can make magic happen anywhere.

Suitable darkroom areas

Any room that can be blacked out is suitable for use as a darkroom, whether on a temporary or a permanent basis.

Understairs cupboards, cellars, garden sheds, garages, lofts, spare bedrooms, basements and utility rooms can all be suitable. Bathrooms are often ideal, as they offer running water and practical, wipe-clean surfaces. A sheet of board over the bath will create a suitable surface on which to place your print trays; fixed prints can be dropped into the partially filled bath ready for washing; and your enlarger can be positioned on a small table or cupboard (you need to make sure that this is stable as vibrations will result in unsharp prints).

One drawback with bathrooms is that they don't have power points for electricity for safety reasons, so you have to trail an extension lead under the door. It can also be inconvenient to your family if the bathroom is occupied for long periods of time. That said, I have used bathrooms as darkrooms and they're perfectly functional.

Bathroom darkroom
An average-sized family bathroom can be turned into an effective temporary darkroom if you get yourself organized. Turn the bath into a wet bench with a sheet of board and position the enlarger well away on a small table or cupboard. You can wash prints in the bath, and power the safelight and enlarger by trailing an electrical extension lead under the door. Safety must be paramount – water and electricity don't mix.

Understairs darkroom

If space is really cramped, an understairs cupboard can serve as a compact darkroom – and if you're lucky it can be set up for permanent use. Position your enlarger at the highest end and the developing trays at the lower end. If space is tight, construct a series of stepped benches, each holding one tray, with a fourth on the floor tucked away and containing water to receive fixed prints. Prints can be transferred to the bathroom for washing.

Darkroom safety and comfort

Whichever area in your house you decide to use as a darkroom, the key is to make sure that it's damp-free, well-ventilated and safe.

Cold and damp environments are unsuitable; as well as being uncomfortable to work in, they make it difficult to control the temperature of chemicals and can damage equipment and ruin materials such as printing paper. If you decide to convert a loft, a basement or a cellar into a darkroom and it lacks any form of heating, make sure you install some to maintain a suitable temperature and keep damp at bay – especially during the winter. A radiator tagged on to the central heating system for the rest of your house is ideal, though independent heaters with timer switches can work too.

Ventilation is necessary because the fumes from developers, fixers, stopbath and toners aren't pleasant and in some cases can be dangerous. If you can ventilate the room that you're working in simply by opening a window, that's fine. If not, install an extractor fan. There are models available that are designed for darkrooms that are light-tight, though you could use a standard extractor fan and make some kind of baffle arrangement that would allow it to operate without admitting light into the room (if you're printing at night this won't be an issue anyway).

Safety is paramount. Printing involves the use of electricity to power enlargers, timers and

safelights, and the use of liquids. Put the two together and you have a recipe for disaster. I have never heard of a photographer being electrocuted in his or her darkroom, but there's always a first time. Make sure it's not you by keeping liquids well away from electricity.

The ideal design for a darkroom takes this potential danger into account by having separate wet and dry areas at opposite sides of a room. Chemicals and print trays live in the wet area and enlargers and timers in the dry. This may not always be possible if space is limited, but use your common sense.

You should also think about safety when it comes to storing chemicals. If you have children, make sure all darkroom chemicals are stored either in cupboards that can be locked or that are located high off the ground and only accessible to adults. If you use empty household bottles to store chemicals, these should be clearly labelled.

Finally, try to keep clutter to a minimum, or you will get into a muddle when fumbling around in the dark, and remove any obstacles that could cause problems. When I prepare my utility room for printing, I clear the floor and pack away anything that I won't need.

Blacking out a darkroom

The key to creating an effective darkroom is making sure that it's totally lightproof, so the only light present is that generated by a safelight.

In my case, I have one window and one door to deal with. As the room can only be used for printing on a temporary basis, it has to be returned back to normal once I'm finished.

For the window, I attach a sheet of plywood on the outside (the room is on the ground floor) that has been cut to size and painted black. On the inside, I tape a sheet of blackout material (available from most darkroom equipment suppliers). This two-sided approach makes the window completely lightproof, even in the middle of the day.

For the door, I have a curtain made from blackout material that I pull across once the darkroom door is closed behind me. This in itself wouldn't block out all traces of light, but there's a second door between the utility room and kitchen which, when closed, provides a further barrier against light.

An alternative method of blacking out is to fix black Velcro strips around all windows and door frames and use it to hold sheets of lightproof material in place. This is a quick and efficient method, though with windows you may need to do this on the outside as well as the inside. Doors can be made more light-tight by fixing strips of draught-excluder around the inside of the frame so the door closes against them and forms a seal. This, along with a sheet of blackout material, should work well.

If you are creating a permanent darkroom, special darkroom doors are available that are completely lightproof; they're also expensive. For windows, darkroom blinds can be used. These are similar to normal roller blinds, but the edges are contained inside grooved strips, so that all light is blocked out as you pull the blind down. For temporary darkrooms in bathrooms or spare bedrooms, this method is ideal because the blinds can be left in place; they're certainly not unsightly; and the windows can be blacked out effectively within seconds.

Whatever methods you use to black out your darkroom, you need to check that they work. Do this by going into the room and sitting in darkness during the middle of the day, when light levels outside are high. After a few minutes, your eyes will sensitize to the low light levels and you will be able to detect any light leaks. These could be caused by small gaps around waste pipes going through the wall, a gap under the door, and so on. You can usually sort these out quite easily.

It doesn't really matter what colour your darkroom is painted. White is fine because it will reflect the light from the safelight and provide better visibility without causing fogging. However, the area behind the enlarger should ideally be a darker colour so that any unsafe light leaks from the head aren't reflected back to the paper. If your darkroom is temporary, a sheet of black card or fabric suspended from the wall behind the enlarger will be fine.

Permanent darkroom
The ultimate in printing luxury: a permanent and well-equipped darkroom with everything you need to hand. A spare bedroom can be converted if you have the space. Alternatively, you could buy a high-quality garden shed, insulate it, install heating, power and running water. The main basis of the design should be to keep wet and dry benches as far apart as possible and lay everything out so walking is minimized. Such a facility isn't essential, but it might be something to aim for.

Safelights

Safelights are important because they allow you to handle light-sensitive materials and see what you're doing, without causing fogging.

The colour you need will depend on the type of paper being used. Normal graded black and white printing papers can be handled in either red or yellow light. Variable-contrast papers vary, so check the box for safelight recommendations.

I use a dome-type mains safelight that can be fitted with different-coloured domes. I have red, amber and orange domes, which work with every type of printing paper, plus liquid emulsion.

As my darkroom is small, I use only one safelight. This is fixed to the wall at least two metres (seven feet) from both the enlarger and developing trays. For bigger rooms, you may need one safelight over the wet area and a second over the dry area.

To test your safelight, lay a sheet of printing paper on the enlarger baseboard, place a few coins on top and leave it for a few minutes. If, on developing the sheet of paper, you can see where the coins were, then the paper is being fogged by the safelight. It may be too close to the enlarger or it might be that the colour is wrong for the paper being tested.

Equipping your darkroom

If you like to spend money on equipment and accessories, then the darkroom is one place where you could really go to town. That said, it's surprising how little you really need to make successful prints, or how little you need to spend to set up a functional darkroom that will at least get you started.

I haven't made a major purchase in the last decade, and I could fit the entire contents of my darkroom in two or three cardboard boxes. I sometimes think that I should treat myself to a new enlarger, or buy a fancy exposure timer, but as the results I achieve using my existing equipment are perfectly fine, I spend the money on printing paper, film and other materials that allow me to experiment with new ideas and techniques – and make more mistakes!

The enlarger

The enlarger (and its lens) form the heart of your printing set-up, so make sure that the model you buy is suitable for you on a long-term basis.

One good thing about enlargers is that new technology doesn't really affect them in the same way it does camera design, so there's no real need to upgrade unless the model you currently have breaks down (which rarely happens) or you start using a film format that it can't handle. I have used the Durst M670K model for almost 20 years now. It is not particularly expensive or sophisticated, but it does everything I want it to.

If you want to buy a new (or secondhand) enlarger, here are the key features to consider:

• Maximum print size on the baseboard
Mine goes up to 16x20in, and though I have never printed bigger than 16x12in, the extra enlargement possible means that I can crop negatives and still make 16x12in prints. If 16x12in were the maximum print size, I would have to print full-frame at all times, or make smaller prints when I needed to crop the negative. Where big prints are possible, make sure that the baseboard is a decent size too. If it's much smaller than the maximum print size, you may have problems keeping a masking frame steady. Enlargers with a vertical column can also cause problems when making big prints because the base of the column gets in the way of the masking frame. Some models overcome this by having an angled column so that as you raise the enlarger head it moves over the baseboard.

• Film format
If you can afford it, buy a model that allows you to print 35mm and medium format. Even if you only shoot 35mm now, you may progress to medium format in the future. I can print negatives on my enlarger up to 6x7cm, including panoramic negatives made using my Hasselblad Xpan camera. If your budget is tight and you shoot only 35mm, buy a basic 35mm enlarger and a high-quality lens – you can always upgrade the enlarger at a later date.

• Colour head
You may never make a colour print, but a colour enlarger is still preferable, as you can use the dial-in filters to control the contrast grade with variable-contrast papers. This is more convenient than placing individual gel filters in a drawer in the enlarger head.

• Stability
Make sure the enlarger is stable and doesn't have any wobbles or loose fittings, or you could end up with unsharp prints. This is especially important when buying a secondhand model.

• Light source
When it comes to providing illumination, there are three main types of enlarger: condenser, diffusion and cold cathode.

Condenser enlargers focus the light by passing it through glass condensers. This produces crisp, sharp prints with emphasized grain – though downside is that any scratches or dust spots on the negative will be highlighted.

Diffusion enlargers produce a softer, less contrasty form of illumination by passing the light through a mixing box and opal perspex screen. They're the most popular type (my Durst is a diffusion enlarger) and are more forgiving when it comes to hiding blemishes on the negative.

Cold-cathode enlargers use fluorescent tubes to provide illumination and don't get hot like the other types do. The light is also very diffuse, but exposure times are briefer. This type of illumination is mainly found in the more expensive enlargers.

Enlarger lenses

The quality of your enlarger lens is important because it determines the sharpness and crispness of your prints, especially once you start making big enlargements. My advice is to buy the best you can afford. Look at models from Nikon, Fuji, Durst, Rodenstock and Schneider.

Buy a lens with a click stop for the aperture; ideally, one that can be adjusted in half-stops. An illuminated aperture scale is handy too, plus a wide maximum aperture – f/2.8 is ideal – so you get a brighter image on the baseboard to aid composition and focusing.

The focal length you need depends on the film format. For 35mm, a 50mm lens is standard (I use a Durst Neonon 50mm f/2.8). For 6x6cm, 80mm is recommended, and for 6x7 and 6x8cm a 100–105mm (though I use an 80mm Rodenstock lens for 6x7cm and Hasselblad Xpan negatives and it works fine).

Optimum image quality is usually obtained two or three stops down from the maximum aperture, so an f/2.8 is best used at f/5.6 or f/8, and an f/4 lens at f/8 or f/11.

Masking frames

Also known as an enlarging easel, this item holds your printing paper flat and in position on the enlarger's baseboard during exposure. The easel has blades to allow you to adjust the print size; most also have an adjustable border. I use two fairly budget-priced LPL easels, one for prints up to 10x8in and one for prints up to 14x17in. It's necessary to have two because bigger easels aren't practical for small prints – the enlarger column usually gets in the way.

Enlarger timers

Being able to control the print exposure is vital if you want to produce high-quality results that are repeatable, and for that an enlarger timer is required. The least expensive are mechanical, but it's worth spending some extra money and buying an electronic timer that can be wired into the enlarger so it turns the light source on and off automatically at the touch of a button.

I use a fairly basic Paterson electronic timer. I'm sure it's capable of far more than I'm aware of, but when I bought it secondhand many years ago there were no instructions with it. The main thing is that it does what I want it to do.

More and more printers now use f-stop timers that allow you to adjust exposure in fractions of stops, but I'm happy to work with seconds.

Print washer

Thorough washing of prints is essential if all traces of chemicals are to be removed from the fabric of the paper and avoid staining and fading of the image long-term. This is particularly important with fibre-based papers, as they are more absorbent than resin-coated papers. If you don't wash all traces of fixer from a print before toning it, streaks and stains are likely.

The most efficient way to wash fibre-based prints is using an upright archival washing unit. This houses prints individually in their own slots to avoid damage and cross-contamination and continually forces clean water over the prints. These washers aren't cheap, but the 16x12in Nova model that I purchased many years ago has proved to be one of the wisest investments that I have ever made.

If your budget won't stretch to a dedicated print washer, you can improvise your own version. Simply place prints in a developing tray in the bath and run a length of hose from the cold tap into the tray. Angling the tray slightly will allow water to drain away and, if the hose is placed at the higher end, clean water will wash over the prints continually. This system works best if you only wash one print at a time. This is no problem with resin-coated paper, as it only requires a few minutes' washing, but fibre-based paper should ideally be washed for at least 45 minutes in running water.

Developing trays

I started out using gardeners' seed trays because I couldn't afford real developing trays, though proper chemical-resistant trays aren't expensive and are worth buying – and they should last a lifetime. I use two sizes: 30x25cm (12x10in) for smaller prints and 40x50cm (16x20in) for bigger prints. I have five of each. I know some printers who have dozens of trays, but unless you have lots of storage space this is unnecessary. Trays that are slightly bigger than the print size you mainly work at are ideal.

If darkroom space is really tight, you could buy an upright deep tank processor where chemicals are housed in individual slots and you move the print from one slot to the next as required. These units work well, minimize mess and can be left set up to save time – a thermostat will maintain the

correct chemical temperature. However, it is nice to watch an image appear before your eyes, which you can't do if the print is in a deep tank. Neither can you make lith prints in this way, because you need to watch the image form and snatch it at the critical moment (see chapter seven).

Other useful darkroom items

Focus finder
This piece of equipment magnifies part of the projected image on the masking frame so you can focus on the image grain to ensure a sharp print. I have used the same Paterson Major Focus Finder for many years.

Jugs/graduates
You can never have too many measuring and mixing vessels. I have a pair of graduates for developer, fixer and stopbath and then extra ones for toners. One holds up to 100ml (one-fifth of a pint) and is used for measuring out concentrates; the other holds up to one litre (two pints). I also have a set of two-litre (four-pint) mixing jugs. All are marked 'dev', 'stop' or 'fix', and I use them only for those chemicals to avoid cross-contamination.

Storage bottles
I rarely keep developer or fixer that has been mixed up for prints; I usually make enough prints during a session to exhaust the diluted chemicals and prefer to mix a fresh batch at the start of the next session. I do keep stopbath in a concertina bottle, however. I also retain the empty one-litre (two-pint) bottles that the developer and fixer concentrates are supplied in, wash them out thoroughly with boiling water, and use them to store toners, bleaches, 'Old Brown' for lith printing (see chapter seven) and so on, making sure that each bottle is clearly labelled.

Tongs and gloves
I've never liked print tongs because they can easily damage the paper – particularly fibre-based paper, which is heavy when wet. Instead, I handle the prints using my fingers but wash my hands in hot water after each contact, mainly to avoid contamination of the printing paper and my skin. Latex gloves are another option; you can buy a box of disposable gloves and keep them handy near your wet bench.

Towels
I make sure that I have several small hand towels and paper towels dotted around the darkroom – it is essential to have clean, dry hands when handling printing paper.

Cleaning aids
To minimize the need for re-touching, each negative should be carefully cleaned before printing. I do this using an anti-static brush designed for cleaning lenses. I have used jet-air cleaners in the past, but ruined too many negatives when icy liquid residue was ejected from the can.

Thermometer
I have a couple of mercury thermometers and use them religiously when developing film, but I don't bother with them when printing. I'm aware that chemicals should be maintained at a constant temperature, especially print developer, but I don't feel that the results are affected adversely if it's a few degrees out either way.

Contact printer
You can buy purpose-made units for making contact prints, but I just lay the strips of negatives on a sheet of printing paper and contact them with a sheet of clean glass.

Dodging and burning aids
Dodging and burning is covered in more detail in chapter five. It is worth making up a set of dodging masks and burning-in aids. All you need are pieces of card cut into different sizes and shapes (circles, ovals, stars, sausages, squares, and so on) and some lengths of wire. I attach the pieces of card to the wire using blobs of Blu Tac. I also keep a sheet of black card handy with holes of various sizes cut through so I can give additional exposure to specific parts of the print while holding the rest back.

Notepad and pen
It is a good idea to have a notepad and pen to hand to jot down how a particular print was made – dodging and burning information, exposure, contrast grade, and so on.

Making fine prints

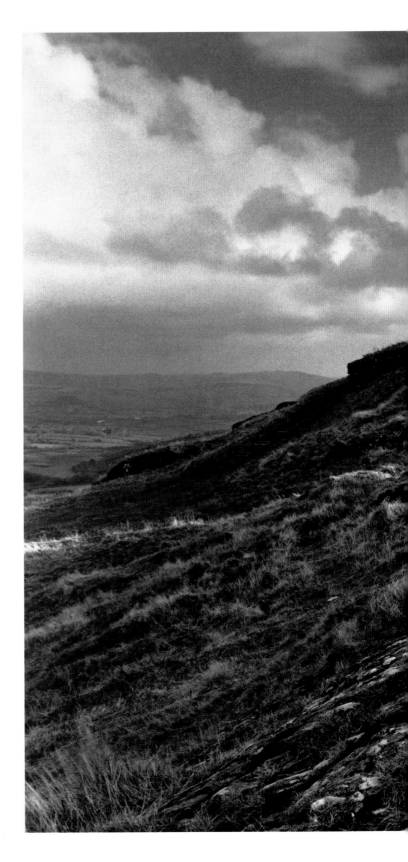

When I step into my darkroom, I like to think that I am embarking on a journey into the unknown. Okay, I'd be lying if I didn't say that I tend to start a printing session with some idea of what I want to achieve. But, like all great journeys, you must be willing to deviate off the well-worn path if you want to discover something new, so I keep an open mind and avoid trying to force myself in a specific direction.

According to many of the books and magazine articles I have read, this approach is asking for trouble: the consensus is that good printing practice relies on pre-planning and pre-visualization.

Pre-visualization can be a benefit, but you also have to be realistic. In my case, it might be a year or more before I make a print from a negative, by which time I might not be able to remember what I wanted to achieve when I first exposed it, and, even if I can, I may well have changed my mind.

I also gain a great deal of satisfaction from seeing where my imagination and creativity take me rather than having too many preconceived ideas. That's why I sometimes print the same negative in a number of different ways, and why, when I reprint old negatives, I often come up with something better than I imagined when the shot was taken.

Printing is a scientific process, but it is also deeply creative and personal, and that's what makes it special. If you handed the same negative to half a dozen printers, chances are that they would all come up with half-a-dozen different prints, made using different materials, different techniques and with different visions, but all successful in their own right. This tiny, centuries-old church was photographed on a stormy day. I composed the scene to show the church perched high on an isolated hilltop. I used filters to produce a more contrasty negative, with particular emphasis on the sky. In the darkroom, my aim was to bring out the drama captured on the film, which I feel has been achieved.

Camera Pentax 67 Lens 45mm Filters Red and polarizing Film Agfapan APX 400

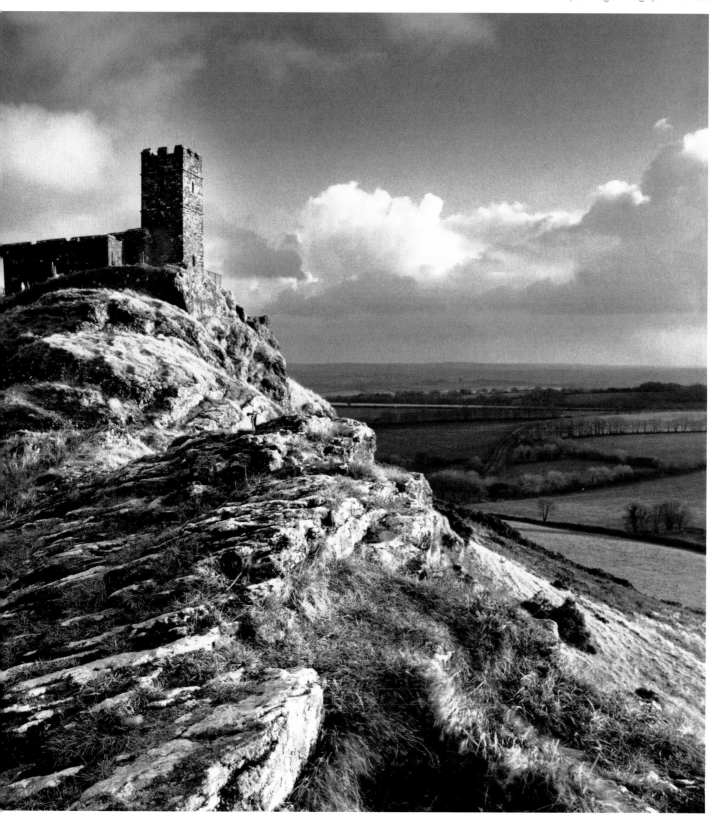

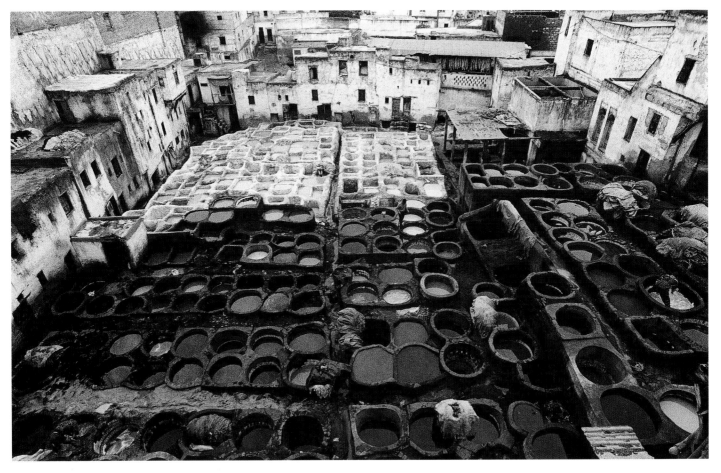

Tanneries, Fez Morocco
Watching a photographic image appear on a sheet of printing paper is an amazing experience, yet the procedure involved is straightforward and high quality results are possible providing you establish a sensible working routine. This shot of the ancient tanneries in Fez required no manipulation and was printed straight at contrast grade II, though most prints require some localized exposure control to achieve best result.
Camera Nikon F90x **Lens** 20mm Illford HP5 Plus

Chemicals for printing

As with developing a black and white film (see chapter three), you need three chemicals to process a print: developer, stopbath and fixer.

Developer

This is the most important of the three chemicals, as you can vary the appearance of the print by using different types.

A warm-tone developer used on chlorobromide printing papers will produce a warmer print than if you use a standard developer, for example. Some developers are 'softer' than others and will reduce print contrast, while 'hard' developers increase contrast. Further variations are possible by changing the dilution so the solution is stronger or weaker than recommended.

My standard choice – and usually the only developer that I keep in the darkroom – is Ilford Multigrade, which I buy as one-litre (two-pint) bottles of concentrate. I dilute the concentrate at the recommended 1:9 with water to make a working solution. It works well with the limited range of papers I use, and I have not felt the need to use anything different in the last ten years.

That's not to say you shouldn't experiment, of course, but if you are new to printing my advice is to simplify and standardize as much as you can. It can be a good idea to use different developers for their unique characteristics, but initially you should concentrate on producing prints of a consistent high quality before you start complicating your life.

I always make up fresh developer at the start of a printing session – usually one litre (two pints) if I'm making 16x12in prints – and discard the solution before the recommended number of prints have been passed through it rather than waiting until it is exhausted.

Development time varies from brand to brand. I usually develop fibre-based papers for 90 to 120 seconds and resin-coated papers for 60 seconds in Ilford Multigrade developer diluted 1:9.

To prevent the remaining concentrate in the bottle from oxidizing, I drop glass 'pebbles' into the bottle to force out any air. This is particularly important if you go for long spells between printing. Another option is to decant the developer concentrate into smaller bottles that are filled to the brim and tightly capped.

Stopbath

Stopbath is a weak acid that is used to arrest development by neutralizing the alkaline developer. You don't have to use it – a tray of water can be used instead – but stopbath ensures that you don't contaminate the acidic fixer with developer and shorten its working life.

I always have one or two litres (two or four pints) of stopbath diluted and ready for use. Most brands now have an indicator dye in them that turns the solution from its characteristic yellow to another colour when the solution is exhausted, so you know when another batch has to be prepared. I use the same solution for both film and print processing and return it to a concertina storage bottle at the end of a session.

Fixer

The third stage in print processing is to immerse the print in a tray of fixer to dissolve any remaining silver halide and make the image permanent. Once fixing is complete, which usually takes two or three minutes with fibre-based papers, the darkroom lights can be turned on.

Don't be impatient at this stage. There are no indicators to tell you that the print is fully fixed, so stick to the manufacturer's recommended time. If you reduce the fixing time, you may find that the print fades or discolours in the long term, or you get problems with staining if you tone the print. The same applies when it comes to discarding fixer. I always make up a fresh batch at the start of each printing session and I discard it before the recommended number of prints have been fixed, just to be on the safe side.

A further safety measure with fibre-based papers is to use two separate fixer baths. The first bath will do most of the work, but then if the print is passed into a second, fresher solution, you can be absolutely sure that it is going to be fully fixed. As the end of the working life of the second bath approaches, you can use it as the first bath and make up a fresh batch for the second. This ensures that the second bath is always fresher than the first.

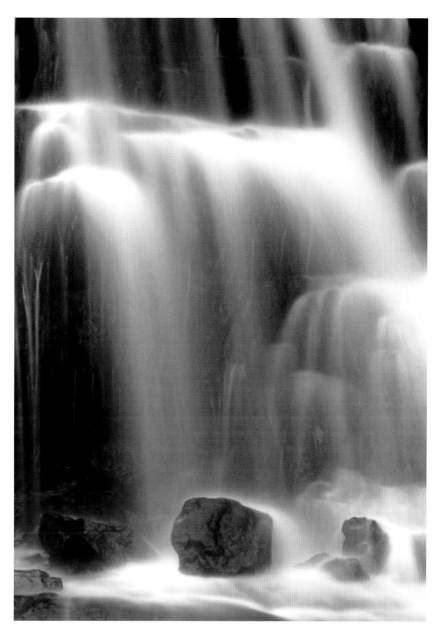

East Gill Force, Yorkshire, England
There are lots of weird and wonderful materials out there, but my advice is to stick with the same chemicals and paper until you can produce consistently high-quality prints. My standard paper is Ilford Multigrade FB Glossy. Having exposed thousands of sheets I know what it's going to give me and I can therefore control each print with a fair degree of precision. Here, I wanted to retain the rich blacks in the rocks without burning out the highlights in the water. As the negative was quite flat due to being exposed on a dull, grey day, this meant careful selection of contrast grade. I made several test strips, with the contrast being progressively increased until the desired balance was achieved. This is one of the benefits of variable-contrast printing paper – contrast can be adjusted in fractions of grades rather than full grades for more subtle control.
Camera Nikon F5 **Lens** 80–200mm zoom **Film** Ilford FP4 Plus

Choosing printing paper

There are many different types of printing paper available to the black and white photographer. Each has its own unique characteristics, but the first decision you need to make is whether to use resin-coated (RC) or fibre-based (FB) paper.

RC paper tends to be favoured by novice printers because it's quicker and easier to use than FB papers. The paper base is coated in a resin or plastic that makes it less absorbent and faster-acting, so development, fixing and washing times are reduced. It also dries quickly and perfectly flat (you can speed this up with a hairdryer if necessary), whereas FB paper takes hours to dry and tends to curl.

FB paper has no resin layer: the emulsion is literally coated onto the paper, though most FB papers have a substance known as baryta applied first to stop the emulsion soaking into the paper. As a result, the chemicals used to process the print are absorbed by the paper. This means that the prints must be washed for much longer to make sure that all traces – particularly of fixer – are removed. If fixer remains in the fabric of the paper, it will eventually cause staining.

Like most printers, I started out using RC paper – as well as being more convenient to use, it also costs less than FB – then, as my experience and confidence grew, I moved on to FB.

The quality of my prints improved literally overnight when I switched to FB paper, mainly because it was more expensive and, as I couldn't afford to make mistakes, I slowed down, thought about what I was doing and took fewer silly risks.

It worked, and I have never looked back. I also found that making bigger prints resulted in better results. This is partly due to the cost factor, but also because the bigger the print is, the easier mistakes are to see and you therefore take more care to avoid them.

These days I use resin-coated paper to make contact sheets or quick test and comparison prints, but for everything else it's fibre-based paper.

I prefer FB papers because they feel more substantial and handmade compared to the plastic, factory-made feel of RC. Fibre papers are also more suited to bleaching and toning, as well as techniques such as lith printing; there are many more to choose from, including 'art' papers with wonderful surface textures; and they're much better for hand-colouring or re-touching.

For the last 12 to 15 years, my standard paper size has been 16x12in (40x50cm). This is an ideal compromise between cost and size. Any bigger and the prints start to get too cumbersome, but any smaller and they're too small for mounting and framing – in my opinion, anyway.

Fixed grade or variable contrast?

Another factor to consider is whether you use graded papers or variable-contrast paper.

Graded paper has a single contrast grade of between 0 and V. Grade II is considered normal contrast for general use. As the number increases, so too does contrast and as it drops, so does contrast – so a grade I paper would be considered 'soft' and grade IV or V 'hard'.

Variable-contrast paper allows you to achieve any contrast grade from a single sheet of paper. This paper is much more economical to use because you only need one box, instead of having a different box for each grade. It is also more versatile because you can obtain different grades on a single sheet and achieve localized contrast control when printing difficult negatives. The contrast is changed simply by adjusting the magenta or yellow and magenta filtration on your enlarger's colour or Multigrade head.

If you don't have a colour enlarger, filter kits are available for variable-contrast papers that are used either above or below the lens. However, a colour head is preferable as you can make small adjustments to contrast grade rather than working in half or full grades.

As you might imagine, variable-contrast papers are the most popular these days. I use Ilford Multigrade IV FB Glossy paper for 95% of my black and white printing. I only use graded papers when I want a specific effect, such as the surface texture and creamy base colour of Fotospeed Tapestry or the reaction of Kentmere Kentona to lith printing. I used to be a big fan of Agfa Record Rapid, a graded chlorobromide (warmtone) paper that responded well to sepia and selenium toning. Sadly, this paper is no longer available, but Ilford Multigrade FB Warmtone is an excellent alternative – and it's variable contrast as well.

In other words, although there are many different types of paper available, you can survive quite happily with one for general use and one or two for specific applications: you don't need to have cupboards (or better still, refrigerators) full of printing paper.

Storing printing paper

A good reason for not keeping too much paper in stock is that it doesn't last forever. If it is stored wrongly it can deteriorate in a short space of time – sometimes just months.

If you want to store paper long term – perhaps you hear that your favourite is going out of production, so you buy a dozen boxes – a freezer is the best option. Place each box in a thick, sealed polythene bag. Let it thaw overnight before use, with the box laid flat. For mid-term storage, a refrigerator will do, though if you keep small quantities of paper and tend to use it fairly quickly, your darkroom drawer will be fine – providing the room isn't damp and doesn't get too hot.

Handling paper

Many years ago, when I was working for a photographic magazine, a box of printing paper arrived for test purposes from Ilford or Agfa and, not knowing what she was dealing with, the editorial secretary opened the package and took out the pile of unexposed paper in broad daylight.

The entire contents were ruined because (and I don't wish to state the obvious here) printing paper must not be exposed to daylight, or any kind of light other than the recommended safelight, until it has been fully fixed, otherwise its light-sensitive emulsion will be fogged.

During a printing session you should also make sure that your hands are clean before you pick up a sheet of printing paper, otherwise chemical staining will occur. I have to admit that this is a problem my prints occasionally suffer from, because I prefer not to wear gloves during processing, and a quick wash and dry doesn't always do the trick. However, I only ever handle the printing paper by the corners, so if I do mark it, the stain will be well outside the image area and can be trimmed off if necessary – though it's better to have a stain-free print in the first place.

Fibre-based paper requires more careful handling when wet than resin-coated paper because it absorbs a lot of liquid. This makes it heavier and soggier – and prone to tearing, in the case of large (16x12in or bigger) sheets.

Covent Garden contact sheet

Although I find it rather laborious to make them, contact sheets provide an effective way of assessing the photographs from a roll of film before deciding which frames deserve closer inspection and enlargement.

Making contact sheets

If you hold a sheet of negatives up to the light, deciding which ones will make great prints is difficult, simply because you're seeing the image in a negative form and the brain struggles to convert that image into a positive one. Eventually this skill will come, but in the meantime I advise you to make a contact sheet of each film, so you can examine the photographs properly.

This isn't something I enjoy doing, because when I go into the darkroom I want to make 'real' prints. However, it is time well spent. I sometimes lock myself away for an hour or two and just make contact sheets from newly processed films so that I can assess them carefully before enlarging any of the images.

Covent Garden, London

These two guys were performing a comedy double-act out on the Plaza, so I joined the crowd to see if I could get any decent pictures. Within minutes, I was spotted, and without warning they interrupted their act and posed for my camera. It was all over in literally two seconds – so quick that I fired off only a single frame and had grave doubts that it would even be in focus. In the darkroom I decided to darken the background down so my subjects stood out – especially their white shirts. This was achieved by printing to grade IV and dodging their faces for a few seconds. The print, made on Agfa Multicontrast Classic, was then selenium toned. **Camera** Olympus OM2n **Lens** 135mm **Film** Ilford HP5 rated at ISO1600 and pushed two stops **Toning** Selenium

To make a contact sheet, all you do is lay the strips of processed negatives, emulsion side down, onto a sheet of printing paper, contact the negatives and paper with a sheet of clean glass, expose the paper and then process it. A sheet of 10x8in paper will take a full 36-exposure roll of 35mm film. I use glossy resin-coated paper at contrast grade II so I can record as much information about each image as possible.

Your enlarger head should be raised so that the pool of light produced on the baseboard is a little bigger than the paper size you are using to make the contact sheet. To establish the correct exposure, make a test strip using half a sheet of paper with two or three strips of negatives laid on it.

In reality, one contact sheet per film is rarely enough. If you expose a roll of film to different subjects and lighting, and bracket exposures, you may need to make two or three sheets to obtain a decent image from each negative. Similarly, if you shoot a whole roll of landscapes, you may need to make one contact sheet exposed for the foreground (which will have washed-out skies) and a second exposed for the sky (which will have very dark foregrounds) so you can assess both the light and dark areas of the print.

If you get into the habit of making more than one sheet per film, it's worth investing in a proper contact printer. This holds the strips of negatives in place so you don't have to keep arranging them for each contact sheet.

Another way of making contact sheets is to scan the negatives into your computer. I'm not a great fan of digital black and white printing, but at the same time I'm not against using the technology for practical applications.

If you have a flatbed scanner, you can lay the negative strips from a whole film side by side and scan them in one go. My flatbed (a Microtek ScanMaker 8700) also has a film holder that takes strips of negatives and allows me to batch-scan a whole roll of film.

Having scanned the negatives it's then quick and easy to view them individually on screen. You can enlarge each image to get a better idea of what you've got on the film and make proof prints with an inkjet printer for further reference.

Once you have your contact sheet in front of you, early decisions can be made about which frames you would like to enlarge; if you need to crop an image; if you need to use a hard or soft paper grade, and so on.

The exposure test

Having decided that you want to enlarge a particular negative, the first stage is to produce a test strip so you can determine the correct exposure and other information such as which is the most suitable contrast grade, and whether any localized exposure control will be required.

When I first started printing, I would sometimes guess the exposure and then simply pull the print from the developer when it looked okay. However, this approach rarely works (except with lith printing – see chapter seven) because, to achieve consistent high quality, you must develop the print fully – and that means getting the exposure right in the first place.

To make a test strip, I usually cut a sheet of printing paper into two or three strips along the length, unless I'm making 10x8in prints, in which case I use a whole sheet. I know photographers who try to get five or six test strips from a single sheet of paper. However, if the strip is too narrow you won't be able to record enough information on it and you'll probably end up wasting whole sheets of paper as a result. This defeats the object of trying to be economical in the first place.

Having placed the (clean) negative in the enlarger, set it up for the final print size and stopped the lens down to f/5.6 or f/8 (optical quality tends to be optimized two or three stops down from the widest aperture), I then decide where to place the test strip paper so that it covers an area of the image that contains a full range of tones and the most important subject matter – horizontally, vertically or diagonally.

Sometimes it's impossible to do everything in one strip so two have to be made. With a landscape, for example, I usually make one exposure test for the landscape and a second test for the sky so I know how much longer I need to burn in the sky after making the base exposure for the landscape.

Test strip printers are available to help you make strips, but I just use a printing paper box or a sheet of thick card as a mask and use it to expose the strip bit by bit.

The increments used vary depending on the density of the negative, the brightness of the enlarger light source, the paper type being used, and how big the final print will be. I try to keep them as small as possible so I can see the effect of making small changes to the exposure – often just two or three seconds – and record around ten different exposures on the strip. If this first strip

Castle Stalker, Scotland
The way you make an exposure test strip depends on the content of the negative. In this case, I needed to determine the 'correct' exposure for the castle (which was the most dominant element), the sky and the foreground, knowing that to get what I wanted some localized exposure control would be essential. The first test (top) was made by exposing the print from left to right in one second increments so the darkest strip received ten seconds and the lightest just one second. I then made a second test (bottom), exposing right to left in two-second increments so the darkest strip received 14 seconds and the lightest two seconds. These two test prints gave me all the information I needed to make the final print (see page 61).

doesn't give me the information I need then I make a second, perhaps using bigger or smaller increments for the exposure.

It's vital that you develop the strip for the recommended time. If the instructions with your developer give a time range – say one to one and a half minutes – go for the longer time.

Ideally, you should also examine the test strip when it's dry, rather than wet, to determine correct exposure. This is because as a print dries it goes darker – a phenomenon known as 'dry down'. Resin-coated paper can be dried quickly with a hairdryer, and some printers put fibre-based test strips in a microwave oven for a minute or two.

I don't bother doing this. Having produced the test strip I want to get on with making the final print immediately, so I build in a dry-down factor when I determine the final print exposure. Reducing the 'correct' exposure on the wet test strip by about 10% usually does the trick.

Controlling contrast

Contrast is a common photographic term. It refers to the difference in brightness between the brightest tones (the highlights) and the darkest tones (the shadows).

The main factor governing the contrast of a picture is the lighting under which it's taken. In bright sunshine, contrast is high, so pictures tend to have dark shadows and bright highlights and the gap between the two is high. On a dull, overcast day, however, contrast is low because the difference in brightness between highlights and shadows is much lower.

This contrast can be controlled when the picture is taken by adjusting the exposure, then adjusting the development time of the film to compensate (see panel at bottom of page 38). In the darkroom you can also control it by varying the contrast grade of paper you use.

A negative with average contrast – around a five-stop difference between the brightest and darkest areas – should print on grade II paper, which is considered 'normal', and yield a good range of tones from white through to black.

If you have a high-contrast negative where the brightness range is wider and you print it on grade II paper, you may find that either the shadows 'block up' and come out too dark so little or no detail is visible, or the highlights 'burn out'. Sometimes this effect can work well, but often you will want to avoid it.

To do that, print the negative on a lower or softer grade, such as grade I or even grade 0. Doing this reduces contrast so you can record a wider tonal range and more information in the print – primarily in the highlights and shadows.

Similarly, if you have a low-contrast negative and you print it on normal grade II paper, you may find that the highlights come out grey and the shadows don't exhibit any rich blacks. This problem is solved by printing on a harder grade of paper, such as III or IV. This gives increased contrast so you get rich blacks and crisp whites.

This is where variable-contrast printing papers are so versatile: no matter what the contrast range of the negative is, you can simply dial the required filtration into your enlarger's colour head to achieve the necessary contrast grade.

Contrast can also be used creatively; a high-contrast image can be made more graphic and dramatic by printing it hard to grade IV or V so you eliminate most of the midtones and produce a print that mainly consists of black and white.

Initially, deciding which contrast grade to use can be tricky but, like everything, it will come with practice and experience. I tend to use grade III as my standard rather than grade II simply because it suits the way I work, and the fact that I often shoot black and white landscapes in dull weather when the light is soft and contrast low. By printing on a higher grade than II, I can increase contrast to produce more punchy prints. I also shoot a lot of infrared film, which I tend to print on grade IV as it gives very stark results with glowing, ghostly highlights and deep shadows.

I don't print on softer grades very often, but if a negative requires me to do so in order to produce a satisfactory print then I will. For example, the Venice photograph on page 27 required grade I to record detail in the buildings in the background – on grade II virtually nothing recorded.

This, really, is as far as I take contrast control when making black and white prints. There are other techniques available, but I have never become involved in using them.

For example, if you place a partially developed print in a waterbath, the development of the shadows will be suppressed but the lighter tones will continue to emerge so you can lower contrast. Pre-flashing the paper with white light prior to exposing it will also help you deal with really high-contrast negatives.

With the advent of variable-contrast printing paper, a new technique also emerged – split-grade printing. This involves using more than one contrast grade on a single sheet of paper so you can apply localized contrast control – perhaps printing the landscape on one grade and the sky on another, for example, or using softer or harder grades to control how specific elements in a print appear. Another approach is to partially expose the whole print using a hard grade first so you get enhanced shadows, then complete the exposure using a soft grade to give finer gradation in the lighter tones.

Some printers use this technique all the time while others feel that if you produce a decent negative in the first place you shouldn't need to use more than one contrast grade.

Having never tried it, I'm going to sit on the fence, though I would say that it's worth trying if you want to fine-tune the contrast of your prints.

David and friend

This photograph was taken many years ago – my brother, the one with the big grin on his face, is heading towards 30 now! However, I thought it would be a good shot to illustrate how varying the contrast grade during printing can make a big difference to the appearance of the final picture. All six prints were made on Ilford Multigrade RC paper, and the contrast grade was controlled by adjusting the filtration on my enlarger's colour head.

Camera Olympus OM1n **Lens** 28mm **Film** Ilford FP4

Grade 0

The softest grade and one that I rarely use. Here it's too soft for the negative, resulting in a flat, grey print.

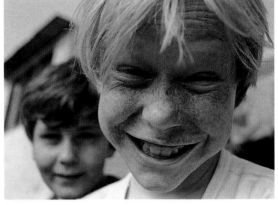

Grade I

Contrast is slightly higher, but still not high enough to produce blacks and whites.

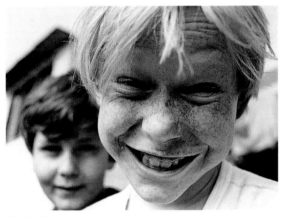

Grade II

The 'normal' contrast grade for black and white printing produced the best print in this set.

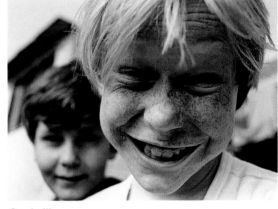

Grade III

This print is still acceptable, though you can see how the highlights are beginning to lose detail and the shadows are blocking up.

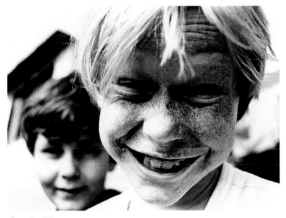

Grade IV

I use this grade when I want to boost contrast, but in this case it's too high, producing a hard effect with dark shadows and bright highlights.

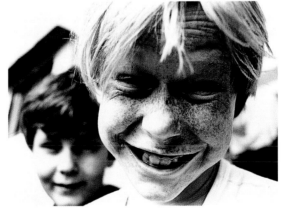

Grade V

The hardest contrast grade is best reserved for very low-contrast negatives that need a boost, or for graphic effects.

Making the print

After making a test strip to determine correct exposure, many photographers then produce a proof print at the required size so they can establish what needs to be done in terms of dodging and burning and adjustment of contrast grade to achieve a high-quality final print. Sometimes they live with this proof print for a week or two before going back into the darkroom, so they have time to consider it.

In my case, I'm impatient and I like to get on and make the final print immediately. In effect, the first print is always going to be a proof print. However, as your experience grows, you will be able to make certain decisions about how the image might need to be manipulated just by assessing the test strip. You can then carry out certain steps – such as burning in the sky in a landscape – when the first print is made. You may not get it just right at this point, but any work you can do on the proof print will take you closer to the desired result.

Having developed and fixed this print, the darkroom lights are then turned on, and I decide what – if anything – else I need to do to improve it. More often than not, print two is 90 to 95% there, and by print three I've usually got what I want. In the early days, I went through much more paper before this stage was reached and occasionally I still do because it's easy to make a silly mistake when you have various dodging and burning-in exercises to do on a single print.

What you shouldn't do is accept second best just for the sake of saving one or two sheets of paper. If you don't take things to the next level you will never know what could have been achieved and your printing will suffer as a result. Printing paper is a raw material and sometimes you need to use more of it than usual to get what you want.

Having produced a print that I'm satisfied with, I tend to make another two or three identical copies. This is done so I can maybe leave one or two untoned and tone the others. I also do it as a safety measure in case one print is damaged or lost in transit, or I want to frame one for the wall.

My time in the darkroom is limited, so I rarely have the opportunity to go back to old negatives – I've always got new ones to work on anyway. I've never been one for filing exposure test strips for future reference or making notes about each print either, so if I did reprint a negative I would have to start from scratch. Making several prints at the same time overcomes this, and on the rare occasion when I do reprint a negative, I come up with something different anyway.

This approach doesn't suit everyone, but it's the way I like it – I concentrate on the art of printing rather than the science. Accountants keep records. Photographers make pictures. I'm a photographer.

Quality control

Consistency is the key to success with printing – establish a way of working and stick to it. I'm fastidious about cleaning my negatives before they go into the enlarger because I don't like the idea of spending ages re-touching.

I also like to print negatives full-frame, and often use the film rebates to create a black border around the image. I've got nothing against cropping an image to improve the composition, and will happily do so if necessary. However, composing in-camera as you want the final print to look is a good discipline because it forces you to take your time and think more about each picture.

It's also worth pointing out that if you want to produce an inspiring print, the content of the photograph itself must be inspiring too. There's little point in being the best printer in the world if you don't have a good eye for a picture. I like to think that I fall somewhere in the middle – I can take a decent picture and I can make a reasonable print. I could improve in both areas, and I am always striving to do that, but if I never get any better I won't die an unhappy photographer, or printer.

Having exposed the print, I develop it for the maximum period recommended by the manufacturer. I use an inexpensive timer for this, and ten or 15 seconds before the development time is up I lift the print by one corner, allow it to drain, and then slide it into the stopbath. After 20–30 seconds in the stopbath, it's drained again and fully fixed, usually for three minutes, before the lights are turned on and I can inspect it.

Fixed prints are stored in a print tray filled with water, and every couple of hours I transfer them to the archival washer set up in the bathroom upstairs. This in effect creates a rotation of prints – by the time the second batch is ready for washing, the first batch can be drained and hung up to dry.

In a good session, I would make prints from up to ten negatives, which means that I could have upwards of 30 sheets of 16x12in printing paper to

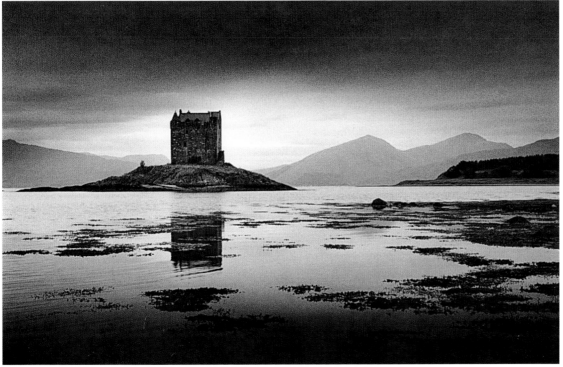

dry overnight. On one occasion I overdid it and the weight of the wet fibre-based prints pulled the line down. Luckily, this occurred while I was in the room and I managed to rescue the prints immediately so only one or two were damaged. Had I not realized until the next morning, every print would have been ruined.

Experience and instinct count for a lot when you make black and white prints. My early efforts were terrible because I didn't really know what I was doing. But the more time you spend in a darkroom, the more confident you become because you can predict the outcome of your actions – and even if you can't, you know that you've got nothing to lose by trying.

Based on how the first print looks, I may fine-tune it or take it in a completely different direction, perhaps increasing the contrast grade to produce a punchier, bolder photograph or exposing it

Castle Stalker, Scotland

These photographs show how a print tends to evolve – in my darkroom anyway! Having produced the test strips to determine exposure (see page 57), I made a proof print (top left) at grade III, exposing to record detail in the castle. The result, as expected, was rather boring as the photograph had been taken on a dull day and the negative was a little flat, but I knew that I could soon remedy that. Stage two was to make a further print, using the same base exposure and grade, but then to burn in the sky and foreground for an additional eight seconds (top right). This took me much closer to the feel I wanted, but it still wasn't dramatic enough. The solution was to burn in the sky for an additional 20 seconds and the foreground for 12 seconds, resulting in a much darker and mysterious print.
Camera Hasselblad Xpan panoramic set to 35mm mode Lens 45mm Filter Orange Film Ilford FP4 Plus

through a soft-focus filter to add atmosphere.

There's no right or wrong, so I do whatever I feel I need to do to achieve the desired end result. As I usually don't know what that is when I start printing, it's often a pleasant surprise.

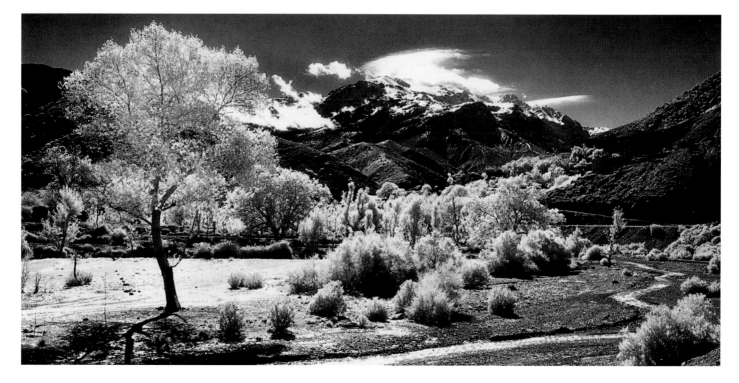

Tizi n' Tichka Pass, Morocco

Black and white prints usually require localised control to make some areas lighter and others darker than they would record on a 'straight' print. In this case the photograph was taken on infrared film and printed at grade IV to produce rich blacks and glowing highlights. To achieve the desired result I had to dodge the tree and the middle distance for part of the exposure, then burn-in the top left corner and the cloud on the top of the mountain. It took several attempts to get it right, but once I had found the solution I made three prints one after the other.

Camera Hasselblad Xpan Lens 30mm Filter Red Film Konica 750 Infrared

Dodging and burning in

It's rare that you will make a straight print from a negative and find that everything is perfect.

A more likely scenario is that you will need to lighten or darken certain areas in order to record detail that can be seen on the negative – in the highlights and shadows – but that the print can't show in a single exposure.

Sometimes you may also want to make areas in a print much lighter or darker for creative effect. A dark sky is more dramatic than a light one, for example; a distracting element can be played down if it's darker; and something you want to stand out can be made more prominent if it's lighter.

To do this, two techniques are employed: first 'dodging', where areas of the print are blocked for part of the exposure time so they come out lighter; and second 'burning in', where areas are given more exposure so they come out darker on the final print.

Burning in

For this, I have a sheet of black card with a few holes cut in – one centrally, then others closer to the four edges of the sheet. The holes are roughly cut so they don't have clean edges – this gives a more subtle effect – and they are no more than 30cm in diameter.

Four of the holes are always covered with oversized discs of black card, which I keep in place with small balls of Blu Tac. The hole I use depends on which part of the print needs to be burned in. I can also vary the size of the area being affected by moving the card closer to or further away from the enlarger lens. The closer it is to the lens, the bigger the hole and the softer the edge, while the closer it is to the printing paper, the smaller the hole and the harder the edge.

When I need to burn in an area on a print, I tend to cover the hole in the card that will be used with another piece of card so the whole sheet of printing paper is covered. The enlarger is then turned on so the image from the negative is projected onto the card. I can then determine where the card needs to be held and how far above the enlarger baseboard so that light hits the required area. Having established that, the piece of card blocking the hole is removed and burning in commences. After the required time, the hole is quickly covered to end the exposure and the enlarger is turned off.

To avoid there being any sign of burning in, the card mask should be gently moved throughout the

exposure – up and down and side to side by a few millimetres is sufficient. Otherwise, there's a chance that a line or edge will be visible on the print.

When I'm burning in the sky and there are features such as hills to work around, I often dodge those areas for part of the initial exposure. This means that during burning in I can allow light onto the dodged areas to avoid producing a 'halo' effect, without them coming out too dark because they have received too much exposure. This type of manipulation can be tricky, but with experience you will know what to do.

If you bend a sheet of card the edge will form an arc, which can be useful when you're burning in the sky in a photograph.

Dodging

To dodge smaller areas I have half a dozen 'tools' made from lengths of fine wire with pieces of card held on the end using Blu Tac – a couple of circles, ovals and triangles, each a different size. Again, the effect they produce can be varied by moving them closer to or further away from the print, and angling them to change the shape.

To avoid tell-tale signs, keep the dodger moving by vibrating the wire a few millimetres in all directions. Don't move it over too wide an area or the central part of the print being dodged will come out lighter than the edges. Keeping the tool moving also prevents the shadow of the wire recording as a lighter line on the print.

For larger areas close to the edges of the print, hands make great dodging tools – it's amazing how many different shapes you can create simply by bending your fingers or placing your hand at different angles. I also keep sheets of card handy in the darkroom so that if I need to cut a mask to dodge or burn in a specific area, I can.

Your test strip may tell you how long certain areas need to be dodged or burned in, while the first proof print will show which areas need attention but not tell you how much the exposure should be increased or reduced by.

When I'm faced with this dilemma, I usually make another test strip to cover larger areas, while with smaller areas I use my experience and guess. I don't always get it right, but the next print takes me a step closer to where I need to be and from there I can usually pull it all together.

What you may find surprising is that when you are burning in small areas you need to give the area more exposure than expected. This is

Localized exposure control

These four photographs show common dodging and burning techniques that can be used to provide localized exposure control during printing. A hole cut in a sheet of black card is ideal for burning in small areas. Cover that hole and the same sheet of card can be used to burn in the sky. Small pieces of card on lengths of wire are perfect for dodging small areas, while your hands can be used to dodge larger areas.

because you are constantly moving the card so not all the light falls on the area. If your test strip suggests that an extra ten seconds is required, you may need to give it 15 or even 20 seconds.

The key is remembering which areas you need to dodge and burn and for how long. When you have half a dozen different actions to take on a print, mistakes are easily made. The best way around this is to sketch the image and mark plus and minus times on the areas that require work so you can refer to it as you go. I used to do this, but these days I just work from memory.

Washing and drying

Resin-coated paper requires little effort in this department – a wash under running water for no more than five minutes will rid it of all fixer traces, and if pegged to a line it will dry perfectly flat in an hour or two.

Unfortunately, the same can't be said of fibre-based papers. They absorb a lot of liquid, so thorough and prolonged washing is essential.

I do this using a Nova archival print washer. This holds each print in its own slot so a dozen can be washed at the same time. No two prints

come into contact with each other, so complete washing is guaranteed. That said, I still subject each print to a 45-minute wash with the water constantly running through the archival unit, as it's the only way to remove all traces of harmful fixer, prolong the life of the print, and reduce the risk of staining during toning.

Once the prints have been washed, I remove them one at a time from the washer, drain the excess water, then peg the print to a line from one corner. This aids further draining. After a few minutes, I peg a second corner so the print is held on the line by two corners, and hang pegs on the free bottom corners to add weight and reduce curl. A better way to reduce curl is by drying FB prints back to back. I use plastic clothes pegs bought from a hardware store. Wood pegs can be used too, but they tend to absorb moisture and can stain the corners of the print.

If I do an evening printing session, I leave the prints on the line overnight. By the next morning they should be 95% dry, though they almost always show a fair degree of curl. To remedy this, the prints are carefully sandwiched between sheets of card then weighted down with books and print boxes for 24 hours.

If you catch the prints before they're completely dry, the fibres in the paper will still be a little flexible and this makes it easier to flatten the prints – though they will never be 100% flat. Care is required, however, because if the prints are too damp before you flatten them, there's a danger of the emulsion side sticking to whatever it's in contact with.

Archival washer
I used to labour long and hard over washing fibre-based prints, but then I invested in a Nova archival washer and never looked back – though expensive, it's invaluable if you want consistent quality.

Re-touching

Once the print is flat and dry your work is almost done – unless you decide to mount and/or frame it.

The only thing you may need to do prior to this is re-touch the print to get rid of any unwanted blemishes. If you wash and dry your films carefully after processing, handle and store the negatives properly and clean them prior to printing, any blemishes such as hairs and dust spots should be minimal. That said, often you will notice a few small white dots of the print caused by dust on the negative.

To cover these dots I use a set of Spotone re-touching dyes. There are six bottles of dye in

the set, each a different colour – sepia, selenium, neutral, blue-black, olive and brown – so you can match the colour of the dye to the colour of the print. Two or more dyes can be mixed if necessary to achieve an unusual colour, though I rarely need to do this.

To re-touch a print, a tiny amount of dye is placed on a saucer. Using a very fine paintbrush, I then apply it to the area concerned using the very tip of the brush. If the blemish appears in a dark area of the print, the dye is used neat, while for lighter-toned areas I dilute it with water to achieve the required shade.

Testing this either on the print border or a sheet of white paper will determine if it's too dark. It doesn't matter if the density of colour is too light because you can apply it more than once and build up the tone gradually until it matches that of the print and the blemish disappears. This is the best way to work as the dye is absorbed into the print very quickly, making mistakes difficult to rectify.

If there are lots of blemishes when I make the first print, the negative is removed from the enlarger, cleaned, and then another print is made straight away, so it rarely takes more than a few minutes to re-touch a print.

You may think this stage is unnecessary, and that tiny white dots on the print won't be seen. Unfortunately, you're wrong – it's surprising how distracting even a few tiny dust spots can be when a print is viewed from close quarters, and how much better it looks if they are removed.

the digital darkroom

In the last few years, digital technology has had a massive impact on the photographic world and there are now probably more photographers using a computer, scanner and inkjet printer to produce black and white prints than an enlarger and traditional 'wet' processes.

People are often surprised when they realize that I haven't gone down the digital route, but having tried it, I feel that the process is too clinical and detached for my liking. Yes, it is possible to do everything – and more – digitally that you can achieve in a darkroom, without the mess, smells, lack of light and risk of making expensive mistakes. But it's all these things that attract me to printing. I love the dim glow of the darkroom safelight and the musty smell of chemicals. I get immense satisfaction from waving my hands or bits of card around under the enlarger to control the fall of light on the printing paper to ensure the final photograph says what I want it to say. Every print is a challenge because it's so easy to make mistakes, and the final product is an original piece of art.

Don't get me wrong – I'm not against digital manipulation and printing. And far from being easier than traditional printing, in many ways I feel it's more difficult. However, having tried it from time to time, no matter how good the end result is, I never feel as satisfied as I do when I emerge from the darkroom clutching a batch of fibre-based prints that I have made with my own hands and fairly basic equipment.

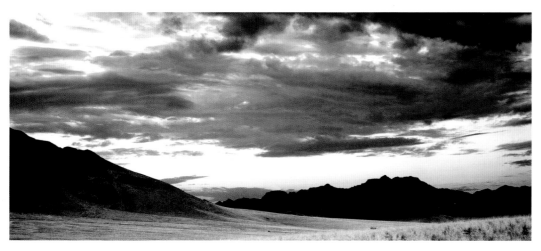

Namib Rand, Namibia
This print was made very quickly and easily by scanning the original colour slide, converting to greyscale, adjusting contrast and brightness in Adobe Photoshop, then outputting an inkjet print.
Camera Fuji GX617 panoramic **Lens** 180mm **Film** Fuji Velvia colour slide film

Toning prints

Although I love working in black and white, many of the prints that I make are toned rather than left as pure black and white.

Some might argue that if I feel the need to do this, I'm defeating the object of shooting black and white in the first place. However, 'colourful monochrome', as toning has been described, is a highly effective technique that can enhance a photograph no end and help you capture the mood you have in mind, regardless of the subject.

An added benefit, in most cases, is that a toned print is more archivally permanent than an untoned one, so long-term it will be less likely to suffer colour changes, staining or fading due to inadequate fixing and washing.

Your knowledge of toners may go no further than adding an 'olde-worlde' sepia tint to prints. However, that's just the tip of the iceberg, and the aim of this chapter is to show you just what can be achieved. There are numerous different colours of toners available, and you can create a wide variety of different effects from a single toner. Further effects can be achieved by toning the same print more than once in different toners. Best of all, toning can take place in daylight, allowing you to see exactly what's happening to the print and control the final result.

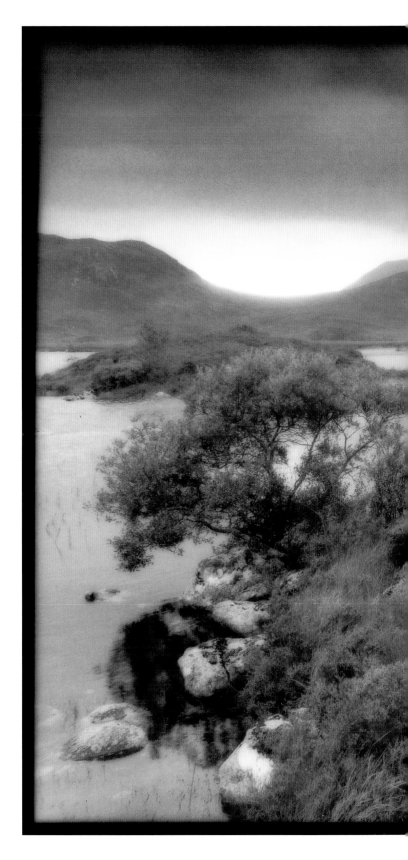

Lochain Na h'Achlaise, Rannoch Moor, Scotland

The main reason why I tone prints is that it allows me to create an atmosphere and mood that black and white alone isn't capable of. Warm tones are soothing and tranquil. They can also imply romance and intimacy, and generally encourage a more positive response from the viewer than the colder pure tones of a straight black and white print. For this print, I used a combination of three toners: sepia, gold and blue. First, the print was partially bleached and split sepia-toned so the highlights were warmed up. After washing, it was then immersed in gold toner, which turned the sepia highlights a more reddy colour. Finally, after yet another thorough wash, it was briefly blue-toned to cool down the midtones and shadows.

Camera Nikon F90x Lens 28mm Filter Orange Film Agfapan APX 400 Toning Sepia, gold and blue

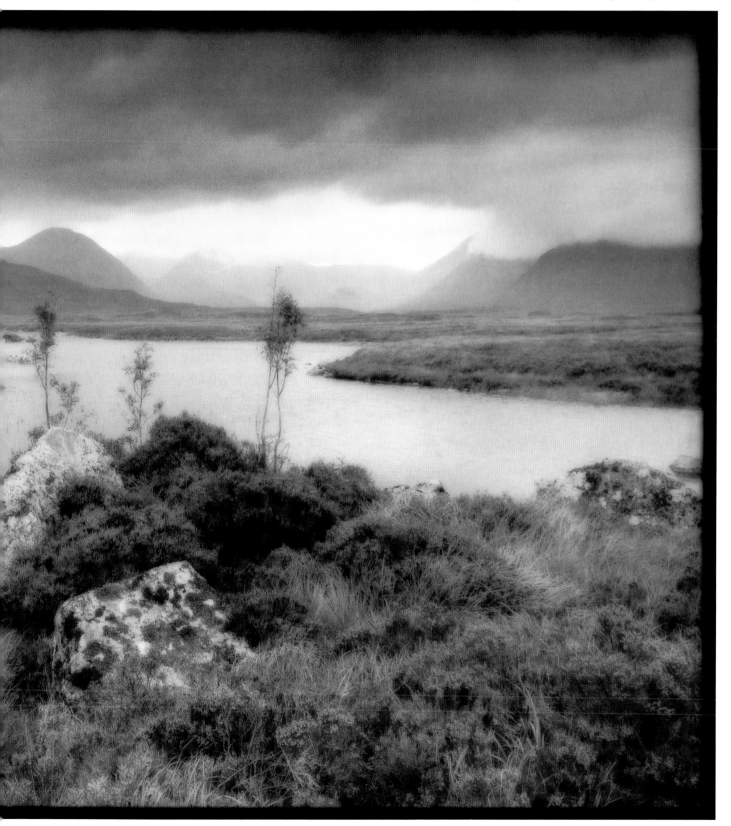

Types of toners

The main toners used for black and white prints are sepia, selenium, blue, gold and copper. All but sepia are one-step processes in that you work with a single bath. Sepia toning is a two-bath process: the print is first immersed in bleach to fade the image and then toned to bring the image back with its characteristic warm colour.

The effect you get depends on paper type, toner dilution and how long the print is toned for. Chlorobromide (warmtone) papers show stronger results with selenium toner than standard bromide papers, for example, while most papers will show a stronger tone colour if the dilution of the toner is higher and/or the toning time is longer – and vice versa. In terms of archival performance, selenium, sepia and gold are the three toners to use.

It's relatively straightforward to make your own toners from raw chemicals. However, this is something I have never tried myself, preferring instead to buy the standard toner solutions that are available from all good photographic retailers and darkroom suppliers.

As with most darkroom and print techniques, the key to success is keeping things as simple as possible, especially when you first set out.

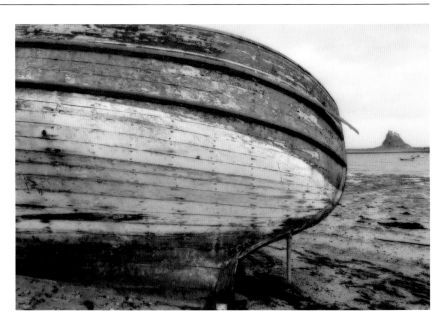

Lindisfarne, Northumberland, England
You can be as subtle or as bold as you like when sepia toning prints. If you prefer softer tones, you should dilute both the bleach and toner much more than recommended so the effects are slowed down and made more controllable. For this photograph, I partially bleached the print for around 30 seconds then, after a 20-minute wash, the print was immersed in the toner bath for one minute. The result is an attractive split between the lighter tones, which have been warmed by the toner, and the darker tones, which have been left unchanged.
Camera Nikon F5 Lens 28mm Film Ilford HP5 Plus Toning Partial bleach and sepia

Sepia toning

Sepia is the first toner that most photographers try, mainly because it's readily available, easy to use and the effect is very familiar, especially if you've ever looked through an old black and white photo album.

Due to its popularity, sepia toner has a reputation for being a bit downmarket (some printers and photographers refer to it as thiocarbamide toner because it sounds more impressive!). However, nothing could be further from the truth. It's my favourite toner by a wide margin, and though you might think that it's only capable of producing a single 'look', the effect is in fact infinitely variable.

This variety is mainly due to the fact that most sepia toners now use thiocarbamide in their make-up (rather than smelly sulphide) and come with a special additive, which, when added to the toner bath, allows you to vary the depth of colour of the tone, from a tint that's hardly discernible, through traditional sepia to dark chocolate-brown. Sepia toner is also archival, so any prints treated in it will become archivally permanent.

I use sepia on any print that I feel will benefit from the addition of subtle, warm colouring. This includes landscapes, still-lifes, nudes and the occasional portrait. I rarely use the technique to impart an old-fashioned feel, but simply to enhance the image – I prefer warm photographs to cold ones. If you intend to hand-colour a print, it's also a good idea to sepia-tone it beforehand as the coloured dyes or oils used tend to work better against a warm background.

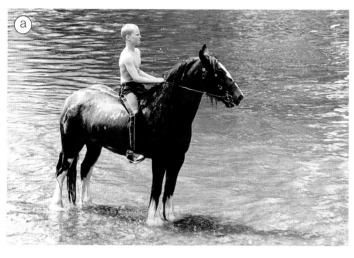

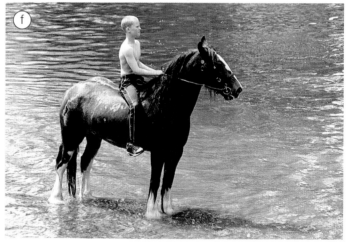

Gypsy on horseback

This set of prints shows how versatile and effective sepia toner can be. Each print was made to look exactly the same, but I then subjected them to various bleaching and toning exercises using Fotospeed sepia toner.

The first print (a) shows what the untoned original looked like. Next is a print (b) that has been partially bleached to illustrate how the image fades. Full bleaching and toning with only a small quantity of toner additive gives a delicate tone (c), while increasing the amount of additive darkens the image colour (d). I generally prefer to partially bleach and split-tone the print as the effect is more subtle (e), while full bleaching, followed by partial toning then redevelopment, gives an interesting mix of sepia tones and black and white (f).

Camera Nikon F90x **Lens** 80–200mm zoom **Film** Ilford HP5 Plus

Toning prints

Bleaching the print

As already mentioned, sepia toning is a two-bath process where the image is bleached back in a weak potassium-ferrycyanide solution, thoroughly washed, then toned so the bleached image redevelops with sepia's characteristic warm tone.

The extent to which you bleach the image can drastically affect the final result, and this is part of what makes sepia toning so appealing. Bleaching attacks the highlights of the image first before progressing through the midtones to the shadows. If you fully bleach the print, the image will almost disappear. On toning, all the tones, from highlights to shadows, will react to the sepia toner. However, by only partially bleaching the print, you can create interesting split-toned effects where the lighter parts of the image are toned and the darker parts are left untoned.

The key to success here is slowing down the process so you can stop it when the desired effect is achieved. That means diluting the bleach much more than recommended – if the instructions say 1:9, try diluting it anything from 1:20 to 1:50.

I find that 1:20 is fine for general use where I want to tone the highlights and lighter midtones, but I will dilute further if I want the effect to be even more subtle – if you remove the print from the bleach before you can actually see the effects of the bleach, it's possible to create a beautiful, delicate warmth in the highlights.

Before bleaching, fibre-based prints should always be soaked in water for a minute or two. This facilitates even coverage of the bleach and prevents streaks or patches. Constant agitation of the print tray is also required.

I carry out toning on my kitchen worktop, which is easy to wipe clean afterwards. I have three print trays lined up: the first contains water for soaking the print; the second contains bleach; and the third holds more clean water. I soak one print at a time; if you put more than one dry print in the water, there's a danger that they will stick together. After bleaching, the print goes into the third tray, containing clean water. Once I have bleached a batch of prints, they are transferred to an archival print washer in the bath and washed for 20 to 25 minutes in cold water to remove all traces of bleach.

Toning bleached prints

Once the bleached prints are washed I prepare to tone them, again using a three-tray set-up. The first contains the washed prints in water; the second the toner; and the third clean water.

Most sepia-toner kits recommend that you dilute the toner solution 1:9 with water, though, as explained above, I tend to make the bath weaker than this. This means that the toner becomes exhausted more quickly, but the toning process is slowed down so I can pull the prints when I'm happy with the effect. Having this degree of control is vital when your aim is subtle split-toning.

Once the toner is mixed, the final stage is to pour in the additive that controls the depth of colour – sodium hydroxide. The more you add, the darker the sepia colour will be, so check the instructions that come with the kit. I favour a more subtle tone, so I rarely add more than 10 to 15ml of additive to one litre (two pints) of working solution. If I find that the effect is too subtle, I simply add a little more.

With the solution ready, I begin toning the prints one at a time. Sometimes it takes just a few seconds for the desired effect to be achieved, but at other times it may take several minutes. The beauty of toning is that you can watch the effect and then, when you're happy with what you see, pull the print and immerse it in water, to halt further toning.

One thing you will notice is that sepia-toned prints tend to be a little lighter in appearance than they did before toning. This effect is especially noticeable if you bleach the print heavily and then fully tone it, while partial bleaching and split-toning will barely affect image density.

Experiments with sepia

There is no right or wrong when sepia toning, so don't worry about trying to get everything absolutely precise. If you bleach and/or tone a little too much or not quite enough, you can still end up with some beautiful results. In fact, some of my better results have come from experimentation where I didn't really know what the final outcome would be, so I would always encourage you to take a step into the unknown.

Here are a few ideas to start you off...

• If you partially bleach and split sepia-tone a print, you can tone it again in a different toner such as blue, gold or selenium (see Multiple toning on page 76).
• If you bleach the print and like the effect that

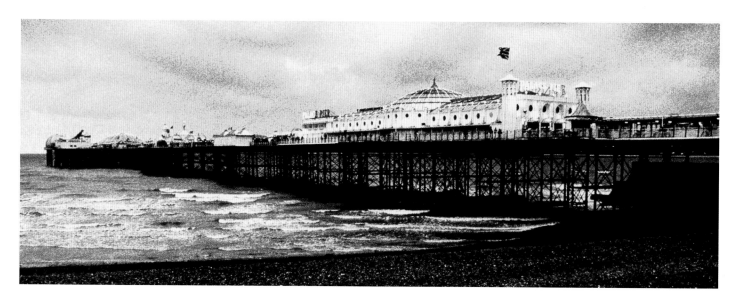

bleaching alone creates, don't bother toning it – just wash the print, refix it and wash it again.

• Bleaching is a great way to rescue prints that are too dark, especially lith prints that were snatched too late (see chapter seven). Just immerse the print in the bleach bath, agitate continually and when the image density is better, remove, wash and fix it.

• If you over-bleach a print, don't panic – just redevelop it in print developer and the original image will be restored.

• If you partially bleach and split-tone a print in sepia, the highlights and lighter tones affected by the bleach and toner will be immune to further change. This means you can re-bleach the print and re-tone it in sepia toner that has more additive in it so the colour is deeper. This will give two different colour bands in the highlights and midtones plus black shadows. Alternatively, after the second bleach, wash and fix the print so the midtones are lighter but untoned. By playing around you can create some fascinating effects.

• Try fully bleaching a print but then only partially toning it in dilute toner. Next, wash the print and then redevelop it in print toner so some tones are warm and others are left as black and white.

• If you fully bleach a print, redevelop and then sepia-tone it (remembering to wash it thoroughly between each stage), the midtones and shadows will be affected by the toner but the highlights will remain unchanged.

Brighton Pier, Sussex, England

Sepia toner works well when combined with other toners, as it allows you to create more than one image colour on the same print. In this case, the print was first partially bleached and sepia-toned. It was then transferred to gold toner after washing, which turned the sepia highlights a pinky-red colour.

Camera Hasselblad Xpan Lens 45mm Filter Orange Film Fuji Neopan 1600 Toning Partial bleach, sepia and gold

Selenium toner

Selenium is perhaps the most subtle toner of all those discussed in this chapter, but it's also the most common among experienced printers. There are two main reasons for this:

• Selenium toner has excellent archival characteristics, so you can make a print archivally safe without having to inherit an unwanted tone.
• Shadow density (D-Max) is enhanced by selenium so the darker tones appear richer. As a result, contrast is slightly increased and print quality improved.

If all you want to do is enhance D-Max and make a print archivally safe, use a weak solution of selenium – perhaps 1:20 dilution with water – and tone for 15 to 20 minutes. If you also want a colour change, use a stronger dilution of, say, 1:5, though don't expect miracles – with some bromide papers you may not see any change to image colour at all, and if you do it may only be a slight cooling of the image or marginal warming, depending on how long the print is toned for. Chlorobromide papers react better to selenium toner. Initially, the image colour may appear cooler, before going an inky purple-black or a dark brown. Any of these variations can work well,

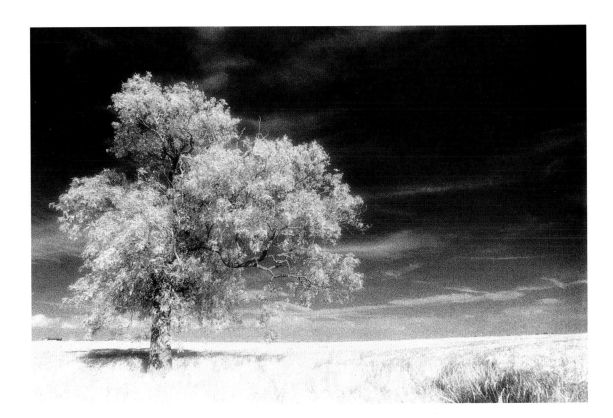

Tree in wheat field
The effect that you get from selenium toning depends on the paper type used, the strength of the toner and how long you tone the print for. This infrared photograph was printed on chlorobromide (warmtone) paper then toned for 15 minutes in selenium diluted 1:5 with water to produce a reddish-brown image colour.
Camera Olympus OM2n Lens 28mm Filter Red Film Kodak High Speed Toning Selenium

though what you get will depend on the dilution of the toner, how long the print spends in it and the paper type. Lith prints can also produce superb results in selenium (see page 86).

A popular use for selenium is in split-toning. It affects the darker tones first, so if you partially tone a print in selenium it will make the shadows and lower midtone values immune to further change by any other toner. You can then re-tone the print in, say, sepia.

The final effect will depend on whether there is any colour change caused by the selenium. If not, then the darker tones will remain as black and grey while the areas not affected by the selenium will be warmed by the sepia, producing a duotone effect. Where there is a change to image colour in the darker tones caused by the selenium – if you use a chlorobromide paper, for example – the effects can be even more attractive.

One of the great things about selenium toner is

that it lasts for ages, so you can make up batches at different dilutions and pick and choose which one you want depending on the effect required. This makes it an economical toner to use.

Be warned that selenium isn't nice stuff, so always take care when handling selenium toner, particularly at strong dilutions or if you ever try to use it undiluted. The room in which you work must be adequately ventilated, and you should wear gloves to avoid it coming into direct contact with your skin. If you do splash your skin with it, wash it immediately.

Blue toner

I probably use blue toner on its own less than any other colour, as my preference is usually for warm prints. However, the cold blue colour it creates can work well on some prints, so I do use it occasionally. I also like the effect of toning a print in sepia and then in blue to achieve warm highlights and cold shadows.

Different brands of blue toner produce different results in terms of image colour, so, if this type of toning suits your style, it's worth experimenting with a number of brands to determine which you prefer. Variations are also possible from any one brand of blue toner.

Factors to consider are as follows:
• Soak the print in water before toning to avoid

streaking. Blue toner is a one-bath process. Once the print is in the toner bath, agitate gently but continually until the desired effect is achieved.

• If you mix up a batch of blue toner with the intention of reusing it until exhaustion is reached, the blue colour will be deeper when the solution is fresher and will gradually become paler.

• If you prefer the effects achieved using partially exhausted blue toner, you can take the solution to this point by using rejected prints in it initially.

• Another way to soften the blue tone is by placing the toned print back in weak print developer (1:25 or weaker) and pulling it when you're happy with the effect.

• If you don't like the effect you get by blue toning, redevelop the print and it will go back to its untoned state.

• Redevelopment can be used to make the blue more intense. After toning, wash and redevelop the print in print developer so it goes back to black and white, then wash and re-tone in blue toner for a second time. You can redevelop, wash and tone again if you wish. Each time you do this, the colour will become more intense.

• Blue toner works better on bromide papers than on warm-toned chlorobromide papers.

• When you blue-tone a print, contrast and image density both increase, so if you make a print with blue toning in mind, print it slightly lighter and softer than you normally would.

• Once toning is complete, the highlights may have a yellow appearance. This usually clears on washing, but don't over-wash the print as you will reduce the depth of colour as well. The print should be handled carefully after washing and should be air-dried.

Princess Pier, Torquay, Devon, England
This picture was taken on a damp, drab day – as dull as weather can probably ever get. Blue-toning the print enabled me to recreate the atmosphere of the location – and my feelings at the time.
Camera Olympus OM1n Lens 28mm Film Kodak T-Max 400 rated at ISO1600 and push-processed two stops Toning Blue Print Filter soft focus

Sally in leathers
I tend to use blue toner when I want to give a print a more sombre, mysterious feel, so it was perfect for this low-key portrait. I wasn't happy with the initial toning, so I redeveloped the print to take it back to its original state then re-toned in blue to produce a deeper image colour. The blue tone isn't extensive, but it's enough to do what I wanted it to do.
Camera Olympus OM4-Ti Lens 85mm Filter Red Lighting Studio flash Film Kodak High Speed Mono Infrared Toning Blue

Gold toner

Gold is the most expensive toner that you're likely to use. It is supplied in bottles of working-strength solution that require no further dilution – you simply use the toner as required, then pour the liquid back into the bottle for future use.

The capacity of gold toner is quite low compared to other types of toner. This, combined with its high cost, means that you must use it carefully to get the most for your money, making sure prints are properly washed to avoid contamination from fixer or other toners.

You might think that gold toner produces a very warm effect, but in fact it does the opposite. On normal bromide papers you may not notice any change and, if you do, the effect will be no more than a cooling down of the image colour. This effect is more obvious with warm-toned chlorobromide papers, however, which come out blue; the warmer the print, the bluer the gold-toned version will be. Lith prints also go blue in gold toner, though it's a very subtle, watery blue rather than an intense tone. Whatever type of paper you use, gold toning is also excellent for archival purposes.

My favourite way to use gold toner is in combination with sepia-toned prints. If you partially bleach and split sepia-tone a print, when you then immerse it in gold toner the sepia highlights turn anything from pink to red – depending on the paper used and the extent of bleaching and sepia toning – while the midtones and shadows cool off to a gentle blue. This warm/cool split can look amazing, creating a sunrise or sunset effect on a black and white print.

Loch Linnhe, Scotland

If gold toning follows sepia toning, the areas affected by the sepia tone turn a reddish, pinky or orange colour, depending on the toners, the level of sepia toning, the paper and the length of gold toning.
Camera Hasselblad Xpan Lens 45mm Filters Red and polarizer Film Ilford HP5 Plus Toning Partial bleach, sepia and gold

Splashing water

Gold toner will cool down a previously untoned print, rather than warming it up. In this case, the slight cooling of the tones adds to the impact of the shot.
Camera Nikon F90x Lens 105mm Lighting Studio flash unit fitted with softbox Film Ilford FP4 Plus Toning Gold

Copper toner

Copper is perhaps the least popular of the mainstream toners, but it can yield surprisingly good results. The image colour can be anything from a pink to a red, depending on the type of paper you use, the brand of toner and the length of time the image is toned for. Both bromide and chlorobromide papers respond well, and the colour becomes brighter the longer you leave it in the toner bath.

Copper toner usually comes in the form of two concentrates that are combined and diluted with water to make a working solution. One of the concentrates is a bleach, but unlike sepia toning where the print is bleached first, with copper bleaching and toning both occur in a single bath and the print is pulled when the desired image colour is reached.

An easy way to make the colour richer is by redeveloping it in print developer, washing and then re-toning. This process can be repeated if desired. A bleaching stage can also be introduced after the first or second toning stage – for example, tone, develop, wash, tone, wash, bleach, tone. Doing this to a print that has already been partially bleached and split sepia-toned is another variation worth trying, or you can use blue as the final toning stage. Note that image solarization may occur with repeated toning and redevelopment, though the effect can look good if it remains fairly subtle.

It's also worth noting that copper toner tends to lighten an image, so you should ideally begin with a print that's slightly darker than you would normally make if it were to be left untoned.

Careful handling is necessary, as the surface of a copper-toned print is easily damaged. If you hold the print at an angle to the light, you may notice that some areas have a duller finish. This is caused by copper ferricyanide molecules breaking through the emulsion of the paper, especially in the shadows and darker tones. To remove these areas and make the print less prone to damage,

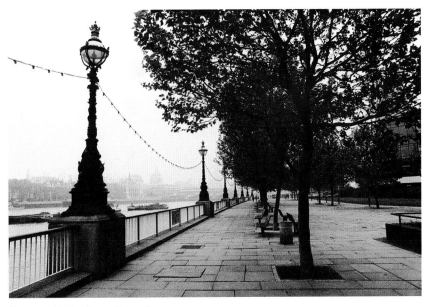

Thames Embankment, London

Copper toner can produce colours from pale pinks and soft browns to rust and rich red, depending on how you treat the print. This image's colour was created by toning the print for a few minutes in Fotospeed Copper toner diluted to normal strength. Camera Olympus OM4-Ti Lens 28mm Film Fuji Neopan 1600 Toning Copper

wipe the surface over with cotton wool or a soft cloth while it's still wet. Laying it on a flat surface is recommended, as the ridges in the bottom of a print tray may cause lines on the print.

Live band

This print was darker than I wanted, but by copper toning I was able to lighten the image and rescue it. The warm colour created by the toner also enhances the photograph, which was taken in a dark concert hall. Camera and lens Konica Big Mini compact camera with fixed 38mm lens Film Kodak T-Max 400 rated at ISO1600 and push-processed by two stops Toning Copper

• It is very important to wash prints thoroughly if you want to avoid staining and streaking when you tone. This is particularly important with fibre-based printing papers. If in doubt, especially if you decide to tone a fibre-based print that you made some time ago, rewash it for 45 minutes in running water. An archival washer offers the most efficient solution, allowing you to wash a dozen or so prints at a time.

• Handle prints carefully during toning – the toner chemicals can stain printing paper if it's on your fingers when you pick a print up.

• Wear rubber gloves to keep toner chemicals off your skin – some can be harmful or cause irritation.

• Remember that sepia and copper toning makes prints slightly lighter, while blue toning makes them slightly darker. Build in a suitable factor when you make the prints to compensate for this.

• Prints that have been fully developed tone the best.

• Experiment! You never know what you might discover.

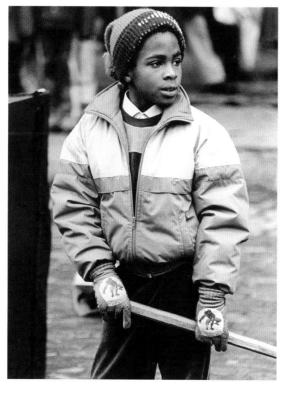

Covent Garden, London

Combination toning can produce an infinite number of effects, so it's always worth experimenting. One of my favourite techniques is to partially bleach and sepia-tone a print, wash it, and then transfer it to blue toner to produce warm highlights, blue shadows and greenish midtones.
Camera Olympus OM1n Lens 135mm Film Ilford HP5 Toning Partial bleach, sepia and blue

Multiple toning

Having mastered the use of individual toners, you can take things a step further by using two or more toners on a single print so their effects are combined or new ones created.

This idea has already been described above in the section on gold toner, where the gold is used as a second toner after bleaching and sepia toning so the sepia areas turn a pinky or reddy colour.

Another popular technique is to partially bleach and sepia-tone a print so that only the highlights and possibly the lighter midtones are affected. After thorough washing – this is essential to ensure even toning – the print is then blue-toned. Doing this creates blue shadows, warm sepia highlights and blue/green midtones where the two toners merge.

If you use the same technique with copper toner instead of blue, the shadows will be pink or red and the highlights sepia. If you use selenium as the second toner, a duotone effect will be achieved with warmtone papers.

Selenium and blue toners can be combined successfully. If you tone in selenium first, followed by blue, the result will be brown shadows and blue highlights. If you use copper instead of selenium, followed by blue, you will get blue shadows and reddy highlights.

These are just a few suggestions, but more can be created by experimenting. I often make several prints at a time from the same negative so I have plenty of spares with which I can try different toning techniques.

Digital toning

Digital image manipulation is something that I've often considered getting more involved in, but really I'd rather spend my time in a traditional wet darkroom than sitting at a computer.

That said, one technique that I have experimented with a little is the digital toning of black and white photographs.

I still prefer to tone my prints chemically, but one of the benefits of digital toning is that you can achieve effects that could never be created conventionally, simply by tweaking a few controls in Adobe Photoshop (a popular photo-editing software program). Any mistakes can also be rectified immediately, without wasting expensive paper or toners.

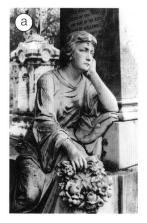
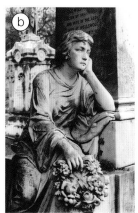

Headstone, Torquay, Devon, England

This set of pictures shows just a few of the many toning effects that can be achieved using a computer rather than chemicals. The first picture shows what the original, untoned image looked like (a). Sepia toning is shown in (b); copper toning (c); blue toning (d); green toning (e); and split-toning in sepia and blue (f). Finally, I took the effects to a more extreme level by making more dramatic adjustments to the colour channels and also increasing saturation (g and h).

Camera Olympus OM1n Lens 50mm Film Ilford Pan F

Here's how I achieved the toning effects seen in this set of comparison pictures.

Having scanned the original negative, adjusted contrast and Levels and cleaned up the image to get rid of dust spots and other blemishes (using the Rubber Stamp tool), I made an identical copy on which to work.

Toning is done by going to the Image menu in Photoshop and selecting Image > Adjust > Curves. Different toning effects are then achieved by adjusting the channel of specific colours.

Digital sepia toning

Select the blue channel and push the curve into the yellow side to give the image a brown colour until you're happy with the level of tone. You will find this image looks a little green, so select the green channel and move the curve into magenta side. Now select the red curve and push the curve into the red. This should give you a good sepia-tone effect.

Digital copper toning

Repeat the steps for sepia toning but simply push the red curve further into red to create a copper-tone effect.

Digital blue toning

Select the blue channel in Curves, then pull the curve into the blue area – the more do this, the bluer the tone.

Digital green toning

Select the green channel in Curves, then pull the curve into the green area.

In each case, you can adjust the depth of colour by going back to the Image menu and selecting Image > Adjust > Hue/Saturation, and then tweaking the Saturation slider.

Digital multiple toning

It's also possible to create split sepia/blue, sepia/gold and other dual-toned effects with your computer. With the image you have already sepia-toned, for example, you can create a split sepia/blue-tone effect by selecting the blue channel then pegging the curve in the highlights and the lighter midtones. Next, pull the darker midtone and shadow part of the curve into the blue to get the split-toned effect – sepia highlights, blue shadows and blue/green midtones.

For effects that could never be created conventionally, all you have to do is play around with various curves until you're happy with the result.

Lith printing

It took me years to pluck up the courage to try my hand at lith printing. I had seen enough superb examples of the technique to convince me that the process was worth investigating, but the whole thing seemed so riddled with potential problems, and mistakes seemed so easy to make, that I never actually tried it for myself.

All that changed a few years ago. Equipping myself with the necessary paper and developer, I decided it was a case of now or never. When I emerged from my darkroom at the end of my first lith-printing trial run, not only did I have one or two prints that I was really pleased with, but I also wondered what all the fuss was about and regretted not trying the technique much sooner.

It soon became clear to me that while lith printing is time-consuming and often highly frustrating, it's also a very easy technique to grasp – provided you are willing to forget much of what you already know about conventional printing, as lith prints require a rather different method. Because of this, beginners to darkroom work often take to lith printing more readily than experienced printers, who find it hard to relinquish the control they're used to having and leaving more to chance.

Dunstanburgh Castle, Northumberland, England

One of the things I love about lith printing is its ability to give photographs an ancient, antique feel. This scene, not far from my home, hasn't changed in centuries, and certainly not since the birth of photography, so I used the newer version of Kentmere Kentona paper to make a print that reflected its timelessness. The original print was over-developed so that it came out too dark. I then bleached it back in sepia bleach to enhance the antique look of the image.

Camera Nikon F5 **Lens** 20mm **Filter** Red **Film** Ilford HP5 Plus

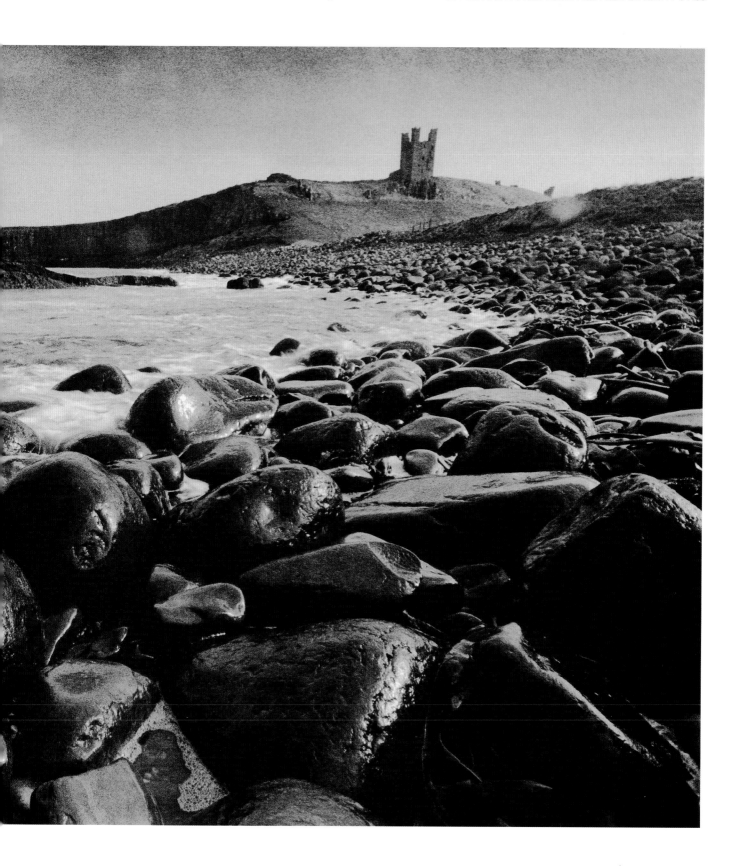

The principles of
lith printing

The basic idea behind lith printing is that a heavily overexposed print is processed in dilute lith developer and, instead of being developed for a specific length of time, it is 'snatched' or 'pulled' from the developer when image density reaches the desired level.

This sounds straightforward enough, but you should be aware that lith developer works rather differently from conventional print developer. The darker tones develop much faster than the lighter tones, and as their density increases so the rate of development is accelerated, until density in the

Bexhill-on-Sea, Sussex, England

This print was made on Kentmere Kentona (the old version) and the rich pinky-red tone is entirely natural. Compared with the panoramic shot on the opposite page, it shows how you can achieve completely different colours and feels using one type of paper, simply by varying the print exposure and development time. It also illustrates that lith printing doesn't have to be very dark and sombre: lighter, more delicate effects are also possible. I used the cropping blades in my enlarger's negative carrier to create the soft border and the print was snatched after about 15 minutes, soon after the emergence of the first blacks in the shadows.
Camera Nikon F90x Lens 20mm Filter Red Film Ilford FP4 Plus

shadows builds up so quickly that sometimes you have only a few seconds in which to remove the print from the developer and get it into the stopbath before the image goes black. This process is known as 'infectious development'. While the darker tones are racing ahead, the lighter tones and highlights in the print are much slower in developing. If you pull the print at the right time, you will end up with darker tones that are cool in colour and coarse-grained, and lighter tones that are much warmer in colour and finer-grained. This combination can be highly effective, allowing you to combine delicate highlights with dark, contrasty shadows.

Another appealing factor of lith printing is that you can achieve a wide range of image colours, especially in the highlights, varying from pink or peach through to cream or brown, depending on the paper that you use, the state of the developer, the exposure used for the print, and the length of time that the print has been developed before being snatched.

Toning and bleaching back (see page 70) creates even greater colour variations.

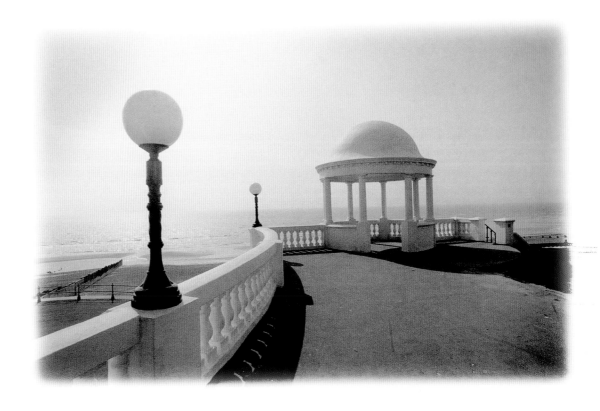

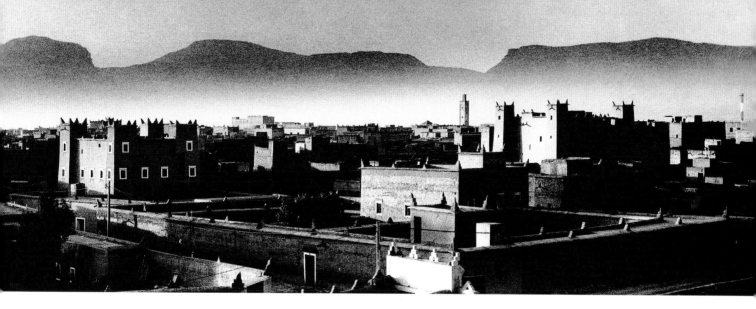

Paper for lith printing

In order to produce successful lith prints, you need the right kind of paper and developer.

Fotospeed FB Lith (previously known as Sterling Premium F Lith, Process Supplies Lith Paper and Fotospeed Lith) is a paper that is specially manufactured for lith printing and one that is well worth trying.

My favourite paper, however, and the one used for all the prints in this chapter, is Kentmere Kentona, which is a glossy fibre-based paper. Kentmere Art Classic and Fotospeed Tapestry, both fibre-based art papers with a textured surface, can also produce superb results. Other papers to consider are: Oriental Seagull G and VC; Ilford Multigrade Warmtone; Agfa Classic MCC FB; Forte Polywarmtone FB; and Forte Fortezo Museum.

Try to avoid the trap of thinking that you need to experiment with lots of different papers, however. They might all offer their own unique characteristics, but unless you're really serious and have money to burn you could pick just one

Nkob, Morocco

I was staying in Nkob in an old Kasbah that had been converted into a wonderful small hotel. Early on the first morning, I decided to check out the view from the roof terrace. This is the scene that greeted me: the town stretching into the distance, mountains rising from the mist and a single minaret breaking the skyline. I knew the picture would make a great lith print. The high contrast and grain suit the simple starkness of the scene and help to emphasize the main elements. There was no planning involved when I made the print – I guessed an exposure of 80 seconds and this was the result. Varying the exposure and development time would have produced a print with a completely different feel, but I was happy with this.
Camera Hasselblad Xpan Lens 45mm Filter Orange Film Agfapan APX 400

paper and stick to it. That's pretty much what I did. I started out using Kentmere Kentona and I'm still happy with the results I get from it, so I see no reason to change. I also use Fotospeed Tapestry for conventional printing, so I always have a second paper with a different surface finish at my disposal that responds well to lith development.

I suggest you do the same, at least in the beginning. Stick to a paper that works well for lith printing – either Fotospeed FB lith or Kentmere Kentona – and see how you get on.

Chemicals for lith printing

Lith developer

One of the great things about lith printing is that the image colour can vary quite significantly from one print to the next, depending on how much exposure you give it, how long it's developed for and how many prints have already passed through the lith developer you're using.

There are various makes of lith developer available, but unless you intend to get seriously

into lith printing, any one will do. Fotospeed LD20 Lith Developer is the one I mainly use, for no other reason than it's convenient and easy to get hold of. It comes in liquid form in one-litre (two-pint) packs, so it's good value if you only make a few lith prints every now and then. I also sometimes use Forte Lith Developer, which comes as a liquid concentrate in a two-litre (four-pint) pack.

Lith printing

Champion Novalith is a well-known brand, available in two-litre (four-pint) liquid packs or five-litre (eight-and-a-half pint) powder packs. Kodalith liquid concentrate is also well-known, though it's only available in ten-litre (twenty-pint) packs so would be unsuitable for occasional use.

Stopbath and fixer

In addition to lith developer, you need stopbath and fixer. In both cases you can use conventional brands, though I would advise you to dilute both more than normal. I often use water instead of stopbath to arrest infectious development, and usually dilute the fixer with double the usual quantity of water (1:18 instead of 1:9). I fix lith prints for only a minute or so as over-fixing can bleach the delicate highlights (a problem you don't get with conventional printing). As lith prints tend to exhaust the fixer more rapidly than normal prints, especially if they contain mainly light tones, it's important to replace it with a fresh mix more frequently than you might usually.

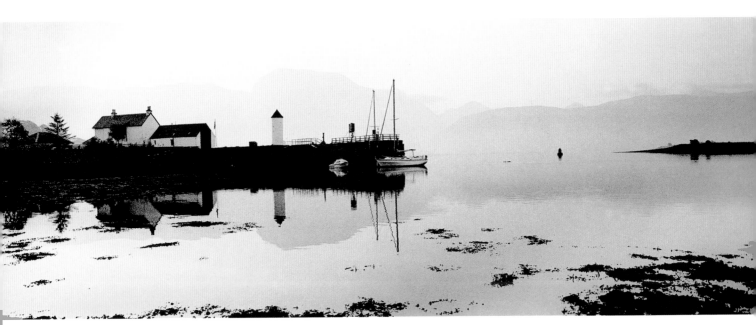

Developer dilution

Once you have your chemicals and paper and have selected a few negatives with which to make your first lith prints, the next step is to mix up the lith developer. This comes as two parts, A and B. The dilution you use is up to you. The manufacturer's instructions may suggest one part A and one part B with nine parts water, but this is a pretty strong mix and I would recommend a more dilute solution.

Initially I suggest you mix 100ml (one-eighth of a pint) of part A and 100ml (one-eighth of a pint) of part B with three litres (five pints) of water. If you want a smaller quantity, mix 50ml (one-sixteenth of a pint) of part A and the same amount of part B with 1.5 litres (two-and-a-half pints) of water.

Once you get the hang of things, you can vary the developer dilution. The weaker it is, the longer the print will stay in it, but you will get better separation between warm and cold tones. The stronger the mix is, the shorter the development time and the higher the contrast, in some cases. I normally use a solution diluted as above, which tends to give development times of 10 to 15 minutes, though I have halved it and diluted 50ml (one-sixteenth of a pint) of parts A and B with three litres (five pints) of water, which extends development times to 20 to 30 minutes.

Loch Eil, Corpach, Scotland

I arrived at this location at dawn to find perfect conditions: the loch was flat and calm, mist had turned the distant mountains into a hazy cutout, and the scene was mirrored in the glassy water. In reality the colours were much colder – blues, mauves and lilacs – but the warmth of the lith print looks natural and suits both the calmness of the scene and the time of day at which the photograph was taken.

Camera Hasselblad Xpan **Lens** 45mm **Film** Agfapan APX 400

Maturing the developer

It is important to note that lith developer tends to give better results when it has already received a few prints. To reach this stage straightaway, you can add some exhausted lith developer (commonly known as 'Old Brown' due to its colour) held back from your last printing session to freshly made developer. Instead of using three litres (six pints) of water, for example, you would use 2.5 litres (five pints) of water and 500ml (one pint) of Old Brown, or, if you're only mixing half that volume, use 1.25 litres (two-and-a-quarter pints) of water with 250ml (half a pint) of Old Brown.

Obviously, when you embark on your very first lith-printing session, you won't have any Old Brown, but a shortcut is available. Make up a batch of lith developer as explained above, then expose two or three sheets of printing paper by turning the darkroom light on for a few seconds, put the prints in the lith developer and leave them

for a while. This will age the developer for you. Once your first printing session is over, or when this first batch of developer becomes exhausted, decant a litre (two pints) of it into a storage bottle and put it to one side for later use as Old Brown.

Another factor to consider is that by diluting the developer and adding Old Brown, there won't be that much active developer in the tray from the outset, and with each print you make you will be exhausting what little there is. This means that you must replenish or replace the developer at regular intervals. When I'm working with 40x30cm (16x12in) paper, I expect to get no more than four or five prints from two litres (four pints) of diluted developer, and I always keep some fresh developer handy so I can replenish it quickly, especially if the developer I'm using expires mid-print, which can be highly frustrating.

Exposure for lith prints

When you make a lith print, you will need to overexpose it by two or three stops, so getting the exposure exactly right isn't necessary – there's no such thing as 'correct' exposure with this process.

Because of this, I don't bother making any kind of test strip – I just use a starting exposure of 80–100 seconds and then assess the first print I make and take things from there. If you want to be a little more controlled than this (after all, it is a rather lazy approach!), I suggest that you make an exposure test strip using conventional printing paper and developer, establish what exposure you would use for a normal print (for the midtones and highlights) then increase it by three stops to calculate the starting exposure for your lith print. For example, if the test strip shows correct exposure at 15 seconds, a one-stop increase would be 30 seconds, two stops 60 seconds and

Speaker's Corner, London

This set of photographs shows how you can vary the contrast of a lith print quite significantly by adjusting the exposure used to make the print and then either reducing or increasing the development time so the print reaches the same density. The basic rule is: reduce exposure/increase development to give higher contrast, and increase exposure/reduce development to give lower contrast. In this case, picture A was exposed for 20 seconds at f/8 on Kentmere Kentona paper; picture B was exposed for 40 seconds at f/8; and picture C for 80 seconds at f/8. In all three cases, the print was pulled from the developer when blacks had emerged on the man's shirt and down the left-hand edge of the print. Of the three, I prefer the contrastier version, though such contrast wouldn't suit all subjects so it makes sense to experiment. Camera Nikon F90x Lens 80–200mm zoom Film Ilford HP5 Plus

three stops 120 seconds. This final figure is your starting exposure for the lith print.

All you have to do then is expose your first sheet of paper, gently slide it into the lith developer and start agitating the tray. Depending on the developer dilution, it may take five or ten minutes for any image to appear on the print, and then it will be very light. Image density will then

begin to build gradually. You will see black dots appear in the shadows and these will increase, spread and group together to form darker areas. This is infectious development occurring before your eyes, and the darker the shadow areas become, the faster density increases.

You need to pull the print when the most important shadow areas are as dark as you want them to be. When that point is reached, speed is of the essence if you don't want the crucial moment to pass. Don't bother carefully draining the print of excess developer as you would normally do, but slide it straight into the stopbath to arrest development.

Assessing the print during development

Assessing the print during development isn't easy because lith developer tends to go murky quite quickly. Combine this with working under safelight conditions, and assessing the image becomes a tricky business. Not only that, when you finally snatch the print and it goes into the fixer tray, the image will lighten a little. When deciding if a print has reached the snatch point, you must therefore compensate for this and wait until the print density is quite a lot darker than required, or it will end up too light. Don't overcompensate though, because the print will then darken down a little as it dries. Experience is your best gauge.

Another way of gauging the snatch point is to use a darkroom torch so you can check the print in better light. I made my own by taping a red filter over the lens of a small Maglite torch. Once the print gets to a time where the snatch point is approaching, I lift it from the developer and examine it with the torch.

You need to take care when doing this that you only flash the torch on the print for a few seconds, otherwise fogging may result. However, the risk of fogging is reduced compared to normal printing because the rate of development is so slow initially – it may take several minutes for the evidence of fogging to show on the print, by which time it has already been snatched and fixed.

If using a torch doesn't help, another option is to flick on the main light in your darkroom for a second or two. I would advise against doing this until you're very close to the snatch point though, as the risk of fogging will be significantly increased.

If your early efforts are disappointing, don't worry – once you get used to assessing the prints in less-than-ideal conditions and being able to predict the snatch point, the quality of your lith prints will improve overnight. I myself tend to go on gut feeling and hope for the best. Often I wait until the very last moment, when the image is on the verge of racing away with itself, and generally this seems to work – though I often have to make two or three prints from the same negative before I get it right.

Controlling the effects of lith printing

Once your first print is developed and fixed, you can assess it and see if you need to change the exposure or development time. When doing this, consider the following factors:

• If the image is too contrasty, reduce contrast by increasing exposure time. Try an increase of one stop initially. This will reduce the development time before the snatch point is reached.

• If image contrast is too low, reduce the exposure time by half or one stop and extend development.

• If overall image density is too dark, you may have missed the snatch point. Try again, pulling the print before image density reaches that level.

• The highlights in the print are controlled by the exposure time. If they're too light, increase exposure by 1/2 stop and try again. If the lighter tones are too dark, reduce the exposure by 1/2 stop.

• Extending or reducing development time to affect highlights isn't practical because it will affect the darker tones at a different rate – they may be too light if you shorten the development but much too dark if you extend it. Remember – expose for the highlights and develop for the shadows.

• Image colour, contrast and grain size are affected by how long the print remains in the developer. If you snatch the print early, not only

a

b

c

d

will the tones be lighter, but contrast will be lower, grain will be finer and colours generally warmer. This high-key effect can produce beautiful results. The more you delay the snatch point, the more image density, grain size and contrast increase, while image colour becomes colder to produce darker, more sombre prints.

The reality of lith printing is that, with so many variables affecting the outcome of a print, your best bet is to experiment and see what happens.

Seahouses, Northumberland, England

After exposure, the other main factor that you can control during lith printing is the snatch point. You can see from these prints how delaying the snatch point has a significant effect on the density of the image and the feel of the final print. Print A was pulled before any true blacks appeared, so the tones are quite soft; contrast is fairly low; grain is fine; and the photograph has a delicate, high-key feel. Print B was pulled when blacks had emerged in the hull of the boat. I prefer this one – it's darker and more dramatic, but not over the top. The last two prints, C and D were pulled progressively later to illustrate how infectious development works, with the blacks gradually creeping from the shadows into the midtones.

Camera Nikon F90x Lens 20mm Film Ilford HP5 Plus

Test prints

I've never been a great one for conducting tests; I prefer to jump in and see what happens. However, the more tests you conduct with lith printing, the more you will understand how to take advantage of all the variables involved. You can then exercise control and, to a certain extent, predict the outcome of your actions.

In particular, I would advise you to produce a series of prints from the same negative to explore the effects of delaying snatch point and varying exposure, as these are the two main controls you have. Note how contrast, image density, image colour and grain size are affected.

Another test worth trying is to make two prints from the same negative, using the same exposure,

then develop one in very dilute lith developer (50ml/one-sixteenth of a pint of part A and part B in three litres/six pints of water and one litre/two pints of Old Brown) and one in very strong lith developer (100ml/one-eighth of part A and the same of part B in one litre/two pints of water plus 250ml/half a pint of Old Brown).

Whatever you do, you should keep an open mind. Lith printing can never be an exact science as there are too many variables involved, so if you try to make it one you will only be disappointed. One of the reasons why I love lith printing is that I never quite know what's going to emerge from the developer, but whatever does come out is always a surprise.

Toning lith prints

A basic lith print will always have a colour. This can be anything from yellow to peach to pink to brown, depending on the paper type, the strength and maturity of the developer, the contrast of the image, when the print was snatched from the developer, and so on. This colour will also change as the print dries.

If you then want to take the print one step further and create a different colour, toners are well worth experimenting with, especially gold, selenium and sepia.

Gold toner

Gold toning cools down lith prints to a shade of blue. The strength of colour depends on the paper type and the contrast and density of the print. Other colours may also be created prior to the blue, so keep an eye on the print – you may prefer the effect of only partial toning. Gold toner affects the highlights first and shadows last, so if you snatch it early you may be able to maintain the

warmer tones of the lith print in the shadows contrasted with the cooler highlights.

Selenium toner

As always, results depend on the paper type. The older versions of Kentmere Kentona and Document Art were capable of multicoloured effects when pulled early. Since the removal of cadmium from the emulsion, however, this is no longer the case and the prints now cool off to a blue-grey tone. Other papers turn various shades of brown and red-brown.

Sepia and gold toner

Partially bleach the lith print in dilute bleach first so that only the highlights are affected. Then, after washing, tone in sepia. The colour change you get is widely variable. After thorough washing, place the print in gold toner. This tends to turn the warm highlights pinky or peachy while the shadows cool down, creating an attractive contrast. As with all aspects of lith printing, experiment!

Bleach and redevelopment

A final technique worth experimenting with is to bleach back lith prints in dilute sepia bleach, then partially redevelop them in lith developer. You can do all this in daylight. I mix the bleach in two or three times the volume of water recommended to produce a more dilute and slow-acting solution. For the lith redevelopment, I generally use 50ml (one-sixteenth of a pint) of part A and 50ml (one-sixteenth of a pint) of part B in two litres (four pints) of water with no Old Brown added.

If the print to be worked on is already dry, soak it in water for a minute or two so as to ensure even bleaching. And experiment with different levels of bleaching – if you bleach until all highlights and midtones have faded, the results will be different from bleaching only the highlights. Make sure you agitate the tray of bleach continually to avoid streaks.

The colour change you get will vary depending on which printing paper you're using, how far it's bleached back and how long it spends in redevelopment. I just watch the image re-form and/or change colour and when I'm happy with the effect, I remove it from the developer and place it in water.

I find this technique particularly useful for rescuing lith prints that were snatched too late

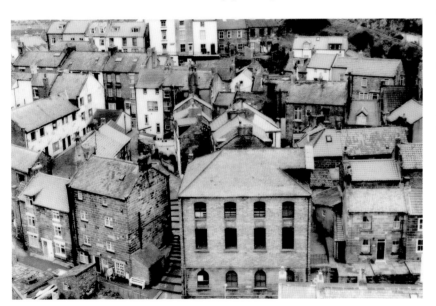

Staithes, North Yorkshire, England
This is the kind of effect you can achieve by toning a lith print in gold toner. Many photographers assume that gold toner always creates a warm colour. This is the case with conventional prints if they have already been partially sepia-toned, but with lith prints a cooler blue tone results. When I initially toned this print, I was disappointed as the wonderful yellow colouring of the original print disappeared before my eyes. Once over the initial shock, however, I was happy with the change.
Camera Nikon F90x Lens 80–200mm zoom Film Agfapan APX 400 Toning Gold

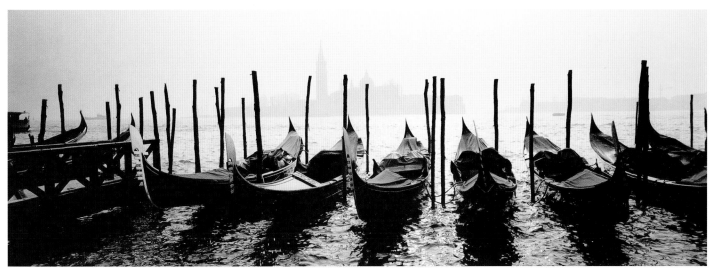

Venice, Italy

This lith print was made on the old version of Kentmere Kentona paper and then selenium-toned. The darker tones were affected first, turning a blue-purple colour. This colour gradually crept into the midtones, but I pulled the print before it was fully toned so the highlights retained the warm peachy colour – this warm/cold colour mix works well.

Camera Hasselblad Xpan Lens 45mm Filter Orange Film Ilford FP4 Plus Toning Selenium

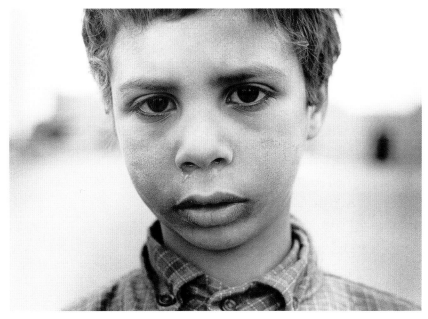

Boy in Hassi Labiad, Morocco

This portrait was originally rather flat. However, by partially bleaching and then redeveloping it in lith, not only did I manage to increase apparent contrast by lightening the highlights in the background, but a soft red-pink tone was added as well.

Camera Nikon F90x Lens 80–200mm zoom Film Ilford HP5 Plus Toning Partial bleach

the first time round and are too dark. Instead of discarding these prints I put them to one side and occasionally use bleaching and redeveloping to see if I can give them a new lease of life.

Bleaching lightens the print, affecting the highlights first, and as redevelopment in lith is carried out in daylight you can remove the print and arrest further development when you're happy with the effect – before it goes too dark again.

This technique is also ideal for prints that have been developed in 'normal' print developer rather than lith. I have produced some interesting results by lightly bleaching Ilford Multigrade IV fibre-based paper so only the highlights are affected, then redeveloping in lith. This adds a subtle peach-pink tone in the highlights. More extensive bleaching followed by redevelopment can create an almost solarized effect where the lighter tones are coloured and the midtones come out grey.

After redevelopment, the print should be fixed. The problem is that by doing so the colours may change again or disappear altogether. If I end up with a print that I really like, I miss the fixing stage. In the long-term, silver staining is likely, but I usually re-photograph the print on colour transparency film so that I have some high-quality copies, just in case that does happen.

Diffusing the image

Black and white photographers tend to fall into one of two distinct categories: purist or artistic.

If you're a purist, chances are you like to create prints that are technically perfect, pin-sharp and full of detail. You may use slow film for optimum image quality, experiment with special developers that increase sharpness and reduce grain, and only produce prints that are pure black and white.

If you see yourself more as an art photographer, the opposite will almost certainly apply. You don't mind grain – the coarser the better; you have no particular preference over film choice; and your pictures are rarely pure black and white because you love to experiment with toning and lith printing.

If this sounds like you – it certainly sounds like me – another technique you may find interesting is print diffusion. I love to produce prints that have a dreamy, romantic feel to them – that's how I often see the world when I shoot in black and white – and, although some purists may argue that diffusing a print is merely an excuse for hiding sloppy printing, there's no denying that the results can be beautiful when used on the right subject.

Nude

I have made numerous different prints from this negative – the simple composition lends itself to experimentation. This is one of my favourites. I wanted to degrade the image as much as possible without destroying the outline of my subject's body and to take the resulting image as far away from conventional photography as possible. I achieved this by making the print in contact with greaseproof paper but also placing two soft-focus filters beneath the enlarger lens to add diffusion as well as texture. The print was then bleached back a little before dilute sepia toning.

Camera Nikon F90x Lens 28mm Film Fuji Neopan 1600 Print Filter Soft-focus Toning Partial bleach and sepia

Soft-focus printing

You can add a soft-focus effect when the picture is taken by placing a suitable filter over the camera lens. However, a more effective way to add soft focus to a black and white photograph is by doing so at the printing stage. There are three good reasons for doing this:

1) The actual effect you get is different. When you add soft focus at the taking stage, the highlights bleed into the shadows. When you add it at the printing stage, the shadows bleed into the highlights. I use both techniques for colour and black and white respectively, but I have to say that I prefer the latter. With portraits and nudes, it adds a gentle glow that obliterates skin blemishes to produce perfect porcelain complexions, while landscape, still-life and architectural shots take on a dreamy, impressionistic quality.

2) By adding soft focus at the printing stage you have the option to make a straight and soft-focus-free print as well.

3) You can vary the degree of soft focus if you add it at the printing stage, by using different materials or subjecting the image to soft focus for varying amounts of time while the print is being exposed. This gives you lots of creative freedom and also allows you to tailor the effect to suit specific photographs, rather than being limited to one effect, which is what happens if you add soft focus when taking the picture.

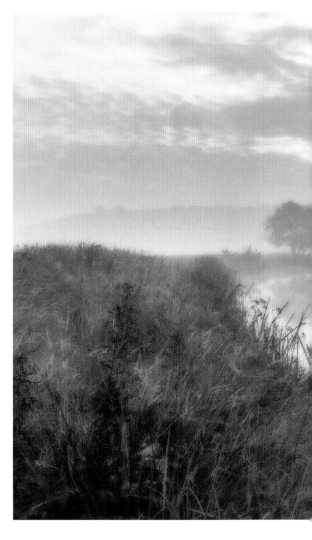

Soft focus effects

This set of prints shows how you can vary the soft-focus effect using different filters and materials. My personal favourites are the Cokin Diffuser 1 and the frosted polyester sleeve. The original shot was taken on an Olympus OM1n with a 50mm lens using Ilford Pan F film.

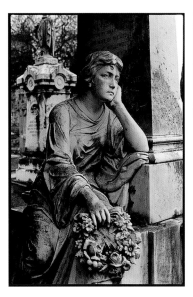

Straight print, no diffusion

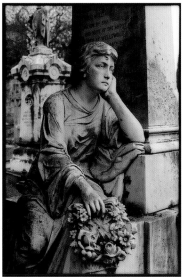

With Cokin Diffuser 1 filter

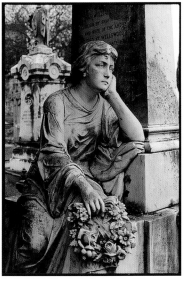

With hairspray on skylight filter

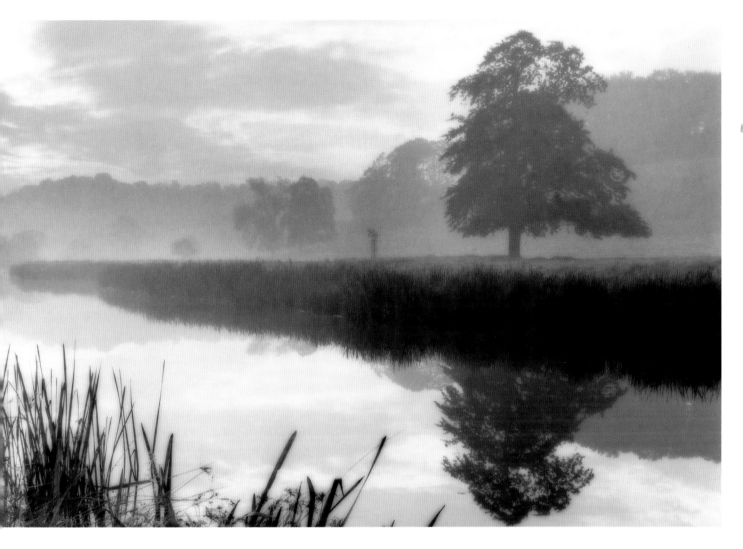

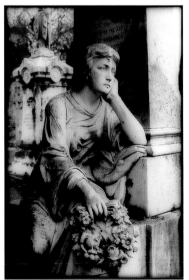

With frosted half of slide mask sleeve **With Vaseline on clear plastic**

River Aln, Northumberland, England

I headed to this location to photograph Alnwick Castle across the river, but the view along the river itself was more appealing. I was entranced by the delicate mist and soft light burning through the clouds, and felt that this atmosphere would be best captured by printing the negative through a soft-focus filter. The print was also partially bleached and sepia-toned.

Camera Hasselblad Xpan **Lens** 45mm **Filter** Orange **Film** Agfapan APX 400 **Print Filter** Soft-focus **Toning** Partial bleach and sepia

Adding soft focus

The procedure I use to make a soft-focus print is very straightforward. First, the negative is selected and cleaned, and the enlarger is set up as it would be for any printing session.

My Durst M670K enlarger has a swing-in red safety filter that can be positioned under the lens. However, the red filter pops out of its frame quite easily and this provides a perfect platform on which to rest a soft-focus filter.

Having selected the filter I want to use – I tend to use a Cokin P System Diffuser for general use (Code P830) – I place it on the swing-in filter frame so the negative is projected through it onto the masking frame. I then focus the image as normal using a focus finder and make a test strip to determine correct exposure.

What I have found when printing through a soft-focus filter is that image contrast is reduced a little – as you would expect – so to avoid wishy-washy prints I tend to increase the contrast grade by half, printing at 3½ instead of 3, for example.

Based on what the test strip shows I may even increase the contrast by a whole grade.

I like using the Cokin Diffuser 1 filter, as its effect is quite subtle and I can happily leave it in place for the whole print exposure. However, if you find that the effect you get from a filter is too strong, all you need to do is remove it part way through the exposure.

To gauge the effect of this, make a series of test strips, but instead of varying the exposure time, vary the length of time that the filter is in the enlarger's light path for each one.

For example, if from the first test strip you determined that the correct print exposure was 16 seconds, make a second test strip with the filter in place for the full 16 seconds; another where you remove it from the light path after 12 seconds; another where you remove it after eight seconds; and a final strip where you remove it after four seconds. From this set of four test strips you can choose the effect that you prefer.

Kitty's feet
My daughter was only a few weeks old when I took this photograph. She was fast asleep and perfectly still, so I decided to take some pictures of her delicate little feet resting on a duvet. It seemed natural to then diffuse the negative during printing to enhance the dainty feel of the picture. I also added a feeling of delicate warmth by partially bleaching and sepia toning the print.
Camera Nikon F5 Lens 105mm macro Film Fuji Neopan 1600 Toning Partial bleach and sepia

Variable soft focus

These prints show how you can vary the soft-focus effect by diffusing the print for all or just part of the exposure. I used a Cokin Diffuser 1 filter for the two diffused prints. The original shot was taken on a Nikon F90x with a 105mm macro lens using Ilford FP4 Plus.

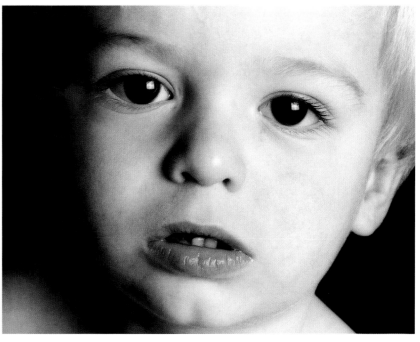

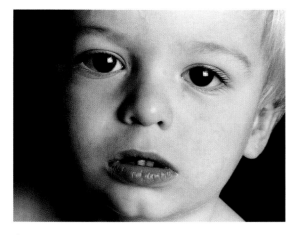

Straight print with no diffusion

Print diffused for half of total exposure

Varying soft-focus effects

The soft-focus effect you achieve can be varied by using different materials (see previous pages).

Purpose-made soft-focus filters are fine, but they're not cheap. One useful option is the Soft Focus filter set from Lee Filters. This comprises five 100mm polyester filters, each set in a plastic mount and offering a different level of diffusion so you can pick and choose depending on the effect you want, or combine more than one for a stronger effect.

A cheaper option is to make your own filter. A piece of black stocking material stretched over the enlarger lens or a card frame will give an attractive effect, as will a tiny amount of petroleum jelly smeared on an old clear filter (old warm-up filters are handy for this). The benefit of the latter technique is that you can create different effects by varying the way the jelly is smeared, though you need only a very small amount or it will obliterate the image.

Another idea worth trying is to apply some hairspray or spraymount adhesive to a clear filter, such as an old skylight filter or a small piece of clean glass. If you have several blank filters, vary the amount of spray on each to give different results.

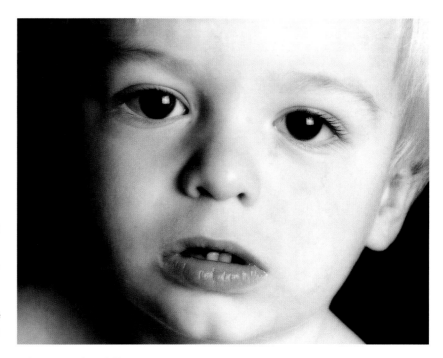

Print diffused for full exposure

I also like the effect created by the frosted half of an anti-Newton glass slide mount – the GePe 6x6cm mounts are ideal. The frosted back of a polyester slide mask sleeve gives a similar effect. In fact, if you have a look around your house, office or darkroom, you will probably find countless items that can be employed, each giving a slightly different effect.

Diffusing the image

Adding texture

The next technique I suggest you try is printing through tissue paper or a similar material. This works in a completely different way to soft-focus filters, as you will see from the pictures shown here, but the effects produced can be stunning.

The easiest way to begin is by laying a sheet of tissue paper over an unexposed sheet of printing paper, contacting the two with a clean sheet of glass and making your exposure as normal. I buy packs of white tissue paper from department stores that are about 40x50cm

(16x20in) in size. When you do this, the image is projected through the tissue paper before it reaches the printing paper, so you get the pattern and texture of the creases and fibres in the tissue paper recording on the print. The image is also diffused by the paper, which has a glassine finish.

It's also worth experimenting with other types of translucent paper. I love the effect created by household greaseproof paper, for example. The texture it adds has an ageing effect on the image, making prints look as if they are a hundred years

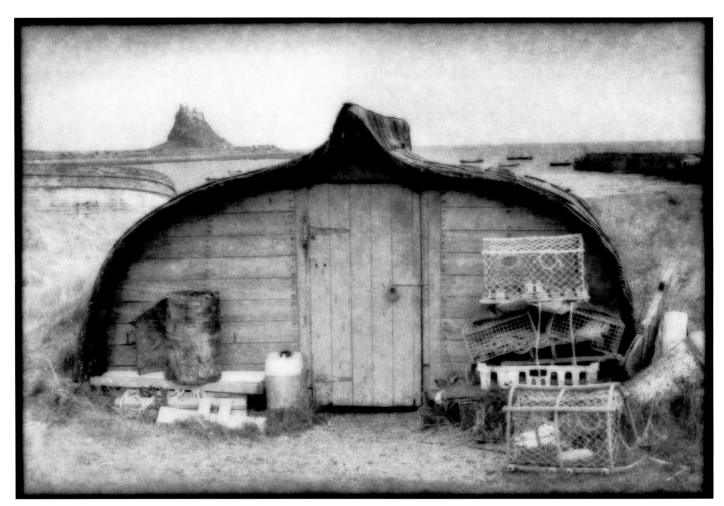

Lindisfarne, Northumberland, England
I've been fascinated by these old fisherman's sheds on Lindisfarne since my first visit there a few years ago. They were made from the upturned hulls of old boats that were retired from service when the herring fishing industry fell into decline, and some are more than a century old. I have photographed them on many occasions, but this view, with the dramatic Lindisfarne Castle looming up in the distance, is perhaps my favourite as it looks so timeless. To play on this mood, I exposed the image through a sheet of greaseproof paper that had been contacted with the print using a sheet of clean glass. The mottled pattern in the print is the texture of the greaseproof paper. To complete the effect, the print was partially bleached and then subjected to dilute sepia toner for one minute.
Camera Nikon F90x Lens 50mm Film Ilford HP5 Plus Toning Partial bleach and sepia

Straight print

Flat tissue paper contacted with glass

Flat tissue paper, no glass

Tissue printing variations
This set of pictures shows how you can vary the effect created by printing through tissue paper. Note how the more you distort the tissue paper, the more it degrades the image. The most effective method for general use is to screw tissue paper into a ball then flatten it again, so the paper has a pattern of intricate creases. These will record on the final print if you contact the tissue paper and printing paper with glass.

Screwed-up tissue paper contacted with glass

Screwed-up tissue paper, no glass

Wet tissue paper laid on print

old – especially if you tone the print in sepia as well.

As with most darkroom techniques, it's all about experimentation. Try tissue paper and greaseproof paper, but also look at other materials – kitchen roll, tracing paper, bubble wrap, and so on.

Ideally, the sheet size needs to be a little bigger than the size of the image you want to print, so that a single sheet will cover the entire image area. You can use two or more sheets by placing them side by side, but there's always a risk of getting a line on the print where the sheets meet, or, if the sheets overlap, you may get an area that's lighter

than the rest of the print because the double thickness of paper lets less light through.

You could make a feature of this effect, of course, by intentionally overlapping several sheets of paper. Another option is to wet the tissue paper so it sticks to the printing paper. You could then tear it to create ragged edges and overlap sheets of wet paper. It can be a messy business and you will need to clean up after each print, but sometimes you have to work hard for your art!

Diffusing the image

Using liquid emulsion

I started experimenting with liquid photographic emulsion only during the writing of this book, but from the very first print I was hooked and this technique now forms an important part of my creative repertoire.

The beauty of liquid emulsion is that it provides you with an easy way of creating original pieces of photographic art. Modern photographic printing papers are better than ever before, and with such a wide range available they offer something for everyone. Ultimately, however, they are mass-produced materials that roll off a factory production line, so the results you can achieve with them are predictable – a benefit most of the time, but sometimes a limitation – and there is little you can do to change their characteristics.

With liquid emulsion, it's a different story. Not only can you use it to coat and sensitize a variety of different base materials, including paper, wood, glass, canvas, metal and fabrics, it also enables you to fix photographic images on three-dimensional objects, or directly onto surfaces such as walls or ceilings. Applying the emulsion by hand adds a further creative variable to the equation: how you apply it, and the amount of emulsion applied, affects the final image, so every picture you make is a one-off original; a unique piece of art.

This image was made during my first attempt at working with liquid emulsion. I used Silverprint SE1 emulsion and Fabriano 5 paper, coating the emulsion with a Jaiban brush. The ragged edge of the image is characteristic of liquid emulsion applied with a brush. It is best revealed when the background is dark, as this maximizes the contrast between the brush strokes and the white or off-white of the base material.

Camera Nikon F90x Lens 50mm f/1.4 Film Ilford HP5 Plus

Liquid emulsion:
materials and subjects

Paper is the simplest base material to work with. It is available in a wide range of textures, weights, colours and qualities, so it offers plenty of scope for experimentation. Paper also provides a good surface for the emulsion to bond with due to its fibrous construction, which offers great benefits in terms of the long-term permanence and stability of the image.

You can produce good results using any high-quality handmade, mould-made or machine-made paper. Some commonly used brands among photographers include Fabriano Artistico and Fabriano 5 (which I used for the images shown in this chapter), Arches Aquarelle, Arches Platine and Cranes Parchment. These papers, and many more, are available from specialist paper suppliers. They usually come in large sheets of 55x60cm (22x30in) that can be cut down into smaller sizes. I normally cut each sheet into four 25x30cm (11x15in) sheets.

Handmade paper is generally more expensive than other types because it's more labour-intensive and time-consuming to produce. It also tends to have a coarser surface texture. This will affect the way photographic emulsion bonds to it, and the resolution of the final image.

Initially, it's probably best to use a hot-pressed (HP) paper, which has a smoother surface (all of the papers mentioned above are hot-pressed). I would also advise you to use papers that have a weight of at least 200gsm (grams per square metre) so they are robust enough to cope with being passed through photographic chemicals and then continually washed for 40 minutes or so.

You can use liquid emulsion with any subject matter. I have concentrated mainly on portraits, nudes and still-lifes, and these seem to benefit from the beautiful textural qualities of coated paper, but landscapes and architecture would also be suitable. The main thing to remember is that you may lose some fine detail, depending on the base material used and how carefully the emulsion is applied, so if an image relies on fine detail for its appeal it's probably not going to work.

Liquid emulsion:
what's available

The most popular emulsion in the UK is known as SE1. It is made by Kentmere Ltd for the London darkroom supplier Silverprint. SE1 is a general-use bromide emulsion with a contrast similar to grade III paper. It adheres well to papers and other materials, and responds well to toning. It can also be used for lith printing, although I have yet to try this. This brand of emulsion is available in the USA under the name Luminos Silverprint, and in Germany as Tetenal Work.

Fotospeed manufactures a liquid emulsion known as LE30, which has exactly the same characteristics as SE1, while Maco Photo Products of Hamburg, Germany, produces three different liquid emulsions that are available in the UK from specialist dealers such as Silverprint and Mr Cad and in Europe from Maco. Black Magic Normal is similar to SE1; Black Magic Hard is an extra-high-contrast emulsion; and Black Magic VC is the only variable contrast emulsion available – by using yellow and magenta filters on your enlarger, you can control image contrast in the same way that you can when using variable-contrast printing paper.

The nationwide UK dealer, Jessops, sells its own brand of liquid emulsion. Though not confirmed, I suspect this is manufactured by Maco and offers the same characteristics as Black Magic Normal.

Another product available in the US from Rockland Colloid Corp is Liquid Light. This is a slower emulsion than SE1 that copes better with poorer storage conditions and has a longer shelf-life once opened.

Nude

The delicate texture of coated paper is ideal for evocative images such as this subtle nude study. I wanted to keep the overall feel of the print delicate, so I printed it lighter than normal and exposed the image through a strong soft-focus filter. The slight imperfections on the print add to its handmade feel.
Camera Nikon F5 Lens 35mm Film Fuji Neopan 1600 Print Filter Soft-focus

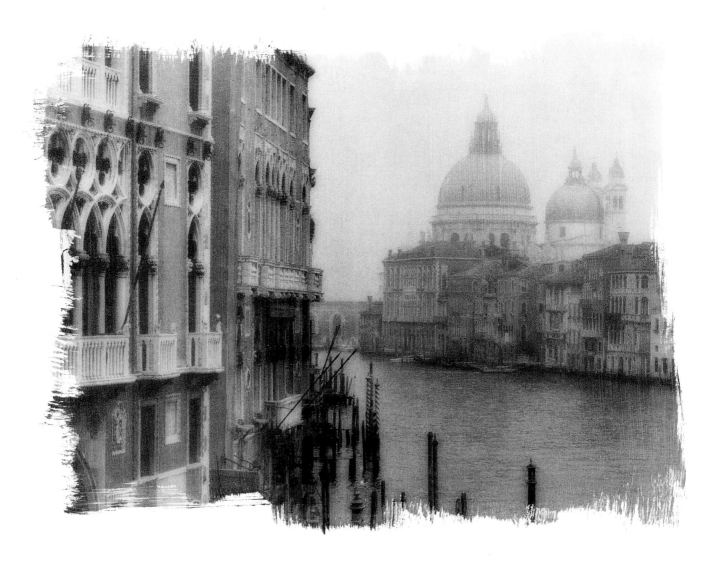

Della Salute, Venice, Italy
This view of Venice has been photographed a million times, so I thought I would try to create a different interpretation of it using hand-coated paper. The photograph was taken on a dull, misty day using fast, grainy film, and I wanted to produce a dreamy, high-key print. This aim was realized by exposing the image through two soft-focus filters so that it was heavily diffused, and keeping the print tones light. I then partially sepia-toned the print to add some nostalgic warmth.
Camera Nikon F90x Lens 70–210mm zoom Film Fuji Neopan 1600 Print Filter Soft-focus
Toning Partial sepia

Emulsion quantity and storage

For your first experiments with liquid emulsion, I would recommend that you buy a bottle containing no more than 250ml (half a pint). It's surprising how far such a small quantity can go if you are just coating paper. Another important reason for using small quantities is that, each time you heat up the emulsion to melt it, the level of base fog increases. Eventually, you may have to discard the remaining emulsion because the fog level is too high, rendering it useless.

One way to reduce the risk of wastage is by coating a number of sheets of paper during one session. This minimizes the number of times you need to reheat the emulsion. I tend to coat in batches of ten sheets, each measuring 25x30cm (11x15in), with the emulsion covering an area roughly 20x25–30cm (8x10–12in), depending on the film format I will be printing from.

A 240ml (half-pint) bottle of SE1 emulsion will coat at least 50 sheets of paper at this size, and, having reheated the same bottles of emulsion at least five times, I have yet to notice any loss of image quality due to the build-up of fog.

When it's not being used, you should store liquid emulsion in a refrigerator, or anywhere that provides a constant temperature of 10°C or lower.

Using liquid emulsion

Preparing the paper

If you're coating paper, the most convenient way to work is by setting up a production line so you can coat a number of sheets in one batch, let them all dry overnight, then use them the next day, or at a later date.

There's nothing to stop you coating a single sheet of paper, drying the emulsion with a hairdryer and then exposing it straightaway, but this is a very long-winded way to work. Instead, I coat up to ten sheets at a time using empty 40x30cm (16x12in) photographic printing paper boxes to store the coated sheets until they are dry.

The very first time I used liquid emulsion, I simply taped each sheet of paper inside one of these boxes, coated it, left it to dry overnight, then used it the very next day. I then repeated this procedure and coated my second batch of paper. However, I failed to realize that when I coated the first batch of paper, the dampness of the liquid emulsion caused the bottom of the box to bow upwards and the top of the box to bow downwards. This problem was exaggerated when the second batch of paper was coated, and the space inside the box was reduced so much that each sheet of coated paper stuck to the inside of the box lid and had to be discarded.

To avoid this happening again, I cut lengths of stiff card five centimetres (two inches) deep and stapled them to the inside edges of each box. This increased the depth of the box, ensuring that, no matter how much the top and bottom of the boxes bowed, the coated paper inside wouldn't make contact and be ruined.

When I'm planning to coat a new batch of paper, I first take each sheet and corner-mark the area where I want the emulsion to be applied. I use a hard-grade pencil for this, because if the markings are too faint, you won't see them under safelight conditions.

I always coat the paper well inside the corner markings so the markings don't encroach on the image area. Also, I know that if the image being printed extends to the corner markings, the whole of the coated area will be exposed – dry liquid emulsion is yellow in colour, but you can't actually see it on the coated paper so your corner markings are the only practical guide available.

Once the sheets are corner-marked, I tape them to the base of each box using masking tape, stack the boxes in my darkroom, then prepare the emulsion and coating tool ready for use.

Preparing the emulsion

Liquid emulsion is light-sensitive, so you must coat your base material under safelight conditions – a red or orange safelight is suitable – and allow the emulsion to dry in total darkness before exposing it under an enlarger.

When stored at a low temperature, the emulsion solidifies, so before each use you need to melt some of it so it can be applied to your base material. I do this in my darkroom, using a hot-water bath. I place the bottle of emulsion upside down in a jug of water heated to 60–70°C (60°C is the minimum required) so about one-third of the bottle is submerged. Don't fully submerge the whole bottle or leave it in the hot water until all of it has melted, as this will accelerate the development of base fog that eventually ruins the emulsion. Don't shake the bottle either, as this causes bubbles to form.

Next to this water bath I have another jug of hot water with a small glass bowl resting on top (like the bain-marie set-up that cooks use to melt chocolate). After five minutes or so, in safelight conditions, I open the bottle of liquid emulsion and pour some of the melted emulsion into the glass bowl. The hot water underneath it will keep the bowl hot and the emulsion liquid.

I pour only 10–15ml of liquid out at any one time to minimize its exposure to the safelight. If I'm coating a batch of paper, it's necessary to top up both water baths every few minutes with hot water from a kettle (I keep one in my darkroom for this purpose) or the emulsion will start to resolidify. This also means that as the emulsion in my bowl runs out I can pour a little more from the bottle.

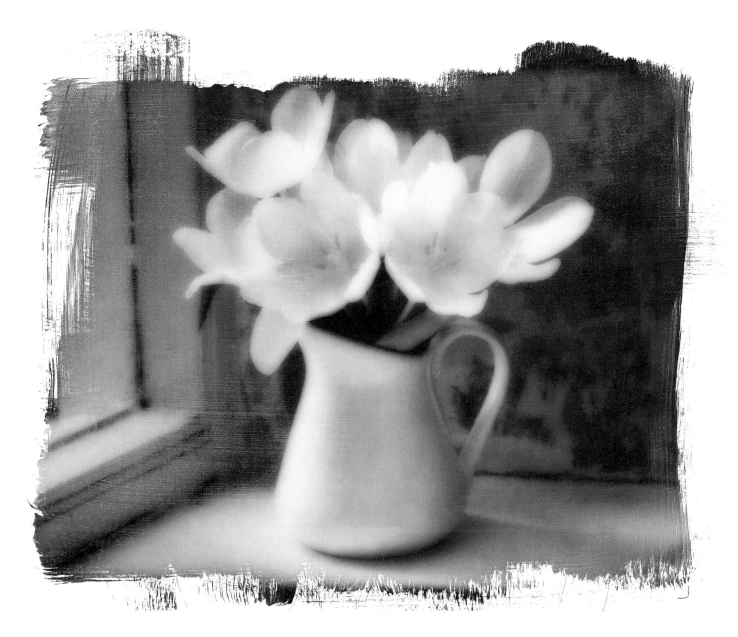

Tulips

I love photographing flowers, so when a friend bought
my wife these tulips I was itching to get some shots of
them. A few days later, when the flowers were fully
open, I saw my chance. I placed the arrangement on a
windowsill and photographed them in natural daylight. It
was a dull day and the light was soft, but I still placed a
reflector to the right of the tulips to bounce some light
back into the shadows and reduce contrast. During
printing, the image was exposed through the frosted
half of an anti-Newton glass slide mount, which makes
an excellent soft-focus filter. The print was made by
coating Fabriano 5 paper with Silverprint SE1 emulsion.
Camera Nikon F5 **Lens** 105mm macro **Film** Ilford HP5 Plus

Coating the paper

The easiest way to coat paper with liquid emulsion
is by painting it on. The best tool I have found for
this job is a Chinese Jaiban brush. These are
inexpensive and available from specialist darkroom
suppliers in a range of sizes. The goat's-hair
Jaiban brush is ideal because it contains no metal
parts that can rust and contaminate the emulsion,
and the bristles are coarse enough to give a good,
even coat of emulsion.

Before use, and especially when new, I give
each brush a good wash under warm running
water to remove any loose bristles. I never use
boiling water for this because it could melt the
glue holding the brush together.

Once your emulsion has been liquefied by

Using liquid emulsion

the water bath and a small quantity has been decanted into the glass bowl, you can then begin the coating.

To do this, simply dip your brush into the emulsion (which will be white in colour and resemble PVA glue), so no more than half the length of the bristles are covered, and start applying it to the paper.

If you have corner-marked the paper heavily enough, you will be able to clearly see the markings that denote the limit of the area you want to coat. As the brush will hold a fair amount of emulsion when first dipped, I start to apply it to the middle of the paper first, to avoid depositing too much emulsion at the edge of the area I want to coat, and work it out towards one edge. With the next dip, I work it out from the centre of the paper to the other edge.

Apply vertical brush strokes first and then work the emulsion in positive strokes until it begins to feel tacky. This will help to reduce the number of air bubbles.

Once you've done that, repeat the process with horizontal strokes. It's always better to finish on horizontal strokes as the eye doesn't notice unevenness in the strokes as easily as it does if the strokes travel vertically. For this reason, you need to decide before coating if you intend printing photographs that have been composed in landscape or portrait format. I tend to coat all the

sheets in a batch in the same way, then print negatives that are all composed in the same format.

When you coat your first batch of paper, try to be consistent and apply roughly the same amount of emulsion to each sheet. That way, when you print and develop this batch, you will be able to see whether you are applying too much or too little emulsion, and if your coating technique is okay. When applying emulsion to an area approximately ten by twelve inches, I dip a two-inch brush three or four times into the emulsion for the vertical strokes and the same for the horizontal strokes.

One of the great things about using liquid emulsion for me is that each sheet is slightly different. I don't try to be too neat about it – I like the fact that you can see brush strokes in the emulsion, and that the borders of the images are uneven and often quite ragged.

Drying and storage

Once you have coated a sheet, place the box lid over it then get to work on the second. Repeat this until you have coated every sheet in the batch – ten is a good number – then stack the boxes.

The next stage involves leaving the boxes in darkness overnight until the coated paper has fully dried. I do this by placing a number of boxes inside the lightproof changing bag I normally use on location to load and unload infrared film. It's quite a large bag and allows me to zip five of the extended boxes inside. The other boxes are wrapped in a large sheet of darkroom blackout material measuring approximately 3x2 metres (9x6 feet). I then place all the boxes inside a large cupboard in my darkroom.

The next day, once the sheets of coated paper are fully dried, I may use them straightaway to make prints. Alternatively, if I am planning a bigger

printing session, I remove the sheets from the box, place them all in one of the lightproof bags used to store factory-made printing paper, then coat another batch of paper with liquid emulsion. That way I can have as many as 20 sheets of coated paper to work with.

Printing with coated paper

Exposure test strips are coated the same way as full sheets; the only difference is that I take a sheet, cut it into three or four strips, then tape them to the base of one of my print boxes and coat them individually using both vertical and horizontal strokes. I mark the box 'Test Strips' so I know where they are. If I am coating ten sheets of paper, I will make six or eight test strips using two further boxes, and if I run out of test strips before I run out of full sheets, I simply cut up one of the coated sheets to create more test strips.

Paper coated with liquid emulsion can be treated in the same way as normal photographic printing paper in that it is placed under the enlarger in a masking frame, exposed, then subjected to developer, stopbath and fixer before washing.

In order to make sure the image to be printed is projected over the area of paper that has been coated with emulsion, place a sheet of coated paper on the enlarger baseboard under safelight conditions. With the enlarger's red safety filter swung over the enlarger lens, and that lens stopped down to f/11 or f/16, turn on the enlarger.

The projected image needs to cover an area that is larger than the area of paper covered by emulsion, otherwise you won't achieve the characteristic border effect showing brush strokes and the film rebate will be recorded.

I use the pencil corner-markings on the coated paper as guides – if the enlarged image extends to those markings or slightly beyond, I know the emulsion will be fully covered by the image as well. It's a simple test, but it works well.

Choice of negative is important if you're using a fixed-contrast emulsion such as SE1. I find SE1 to be harder than standard grade II paper and closer to grade III. This is fine for negatives with normal contrast and adds more impact to negatives that might be a little flat if printed on grade II paper.

I make exposure tests using one of the coated strips of paper. SE1 emulsion is quite fast, so I tend to expose the strip in increments of one or two seconds, depending on the density of the negative. If the required base exposure is brief and I need to dodge and burn the image, then I will close the lens aperture down by one or two stops to lengthen the duration of the exposure and make it easier to employ manipulation techniques.

Once the test strip is exposed I immediately develop and fix it, then turn on the main light in the darkroom to examine the strip and determine the required exposure.

A factor you need to consider here is that, as coated paper dries after exposure, development and washing, the image tends to darken by anything between 5 and 10%, depending on the paper used. I build in a dry-down factor when determining the working exposure, and make the print slightly lighter than I want it to be, knowing that by the time it's dry it should be perfect.

Processing, washing and finishing

Having exposed the coated paper under the enlarger, carefully slide it into the developer and start the timer. I use normal paper developer, usually Ilford Multigrade, diluted 1:9 with water, and develop the paper for a full two minutes before lifting, draining and sliding into a dish of stopbath for 30 to 60 seconds. Once the paper and emulsion are wet, you need to be careful as the emulsion is easily damaged.

The next stage, as usual, is to fix the sheet of coated paper. I use Ilford Hypam diluted 1:9 with water for four to five minutes, depending on how fresh the fixer is. An additional bath of hypo clearing is suggested, but I never bother and go straight from fixer to wash.

Washing is a vitally important stage. Paper is highly absorbent, so you need to make sure that all traces of fixer are washed away, otherwise it could affect the long-term stability of the image.

Yellow staining is a common long-term side effect of insufficient washing. To prevent this, I use a Nova 40x30cm (16x12in) archival washer. This holds each sheet of paper upright in its own slot so that fresh water continually passes over it. I leave the prints in the washer for 60 minutes.

Once washed, the wet sheets are pegged to a line, weighted down with a plastic clothes peg on the two free corners, and left to dry overnight. Paper with a weight of 200gsm or more should

dry reasonably flat. After drying, I sandwich the prints between sheets of card, pile books on top and leave them to flatten for a day or two.

You may find that there are white specks on the prints. These are usually caused by bubbles in the emulsion. If these fall in crucial areas, I retouch them using Spotone inks and a fine brush (00 size).

Finally, the prints are slipped into polyester archival print sleeves for protection when they're handled and viewed.

Pebbles from Alnmouth Beach

I took this photograph specifically with a liquid emulsion print in mind, using a black velvet background as I knew it would show off the brush strokes on the paper to maximum effect. The pebbles were arranged on the velvet next to a window in the dining room of my home so I could use the soft daylight flooding in to illuminate the still life. The paper used was Fabriano 5 and the print was partially bleached and sepia-toned.
Camera Nikon F90x Lens 50mm Film Ilford HP5 Plus Toning Partial bleach and sepia

Gallery

The journey's end for any black and white photographer is the final print. Sometimes that journey is short and sweet, but often it's a long and winding road that we must travel to reach our destination, and we don't always know where that destination is or what we will find when we get there.

In this chapter you will find some of my favourite black and white photographs. The subjects vary: landscapes take prominence, but there are portraits, candids, nudes, architecture shots and still-lifes too.

All these images were created using the techniques described throughout this book. Hopefully they demonstrate that black and white photography really can be a simple art – if that's what you want it to be.

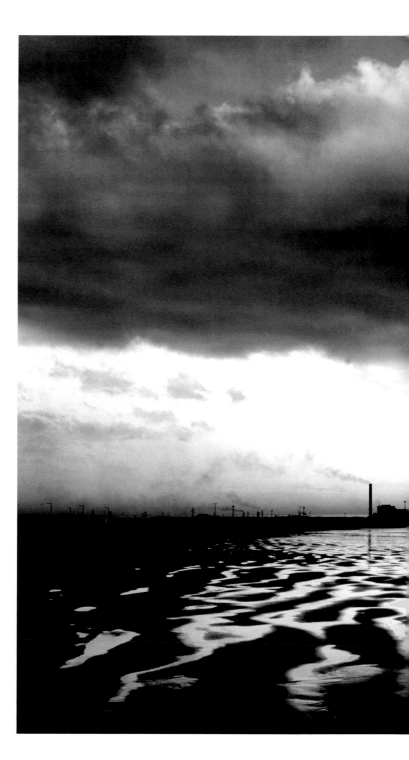

While exploring and photographing Northumbria for a book project in the mid-1990s, I visited the coastal town of Redcar. As is often the case when I'm on location, the weather was grey and overcast, so I decided to work in black and white rather than colour – always a good ploy when the weather is poor. Down on the beach, I looked along the coast and noticed an industrial plant in the distance, which seemed at odds with the beautiful natural surroundings. I realized this contrast would make an interesting photograph, so I shot a roll of film, using my camera's metering system to determine the correct exposure and bracketing up to +2 stops in full-stop increments. I wanted to print the image dark and dramatic. This involved working at grade IV to boost contrast; burning in the sky to emphasize the billowing clouds; and holding back the foreground to prevent the ripples in the sand going too dark. The end result is nothing like how the scene looked at the time, which was flat and grey – but the mood is more in keeping with the nature of the scene.

Camera Pentax 67 **Lens** 45mm **Filter** Red **Film** Ilford FP4 Plus

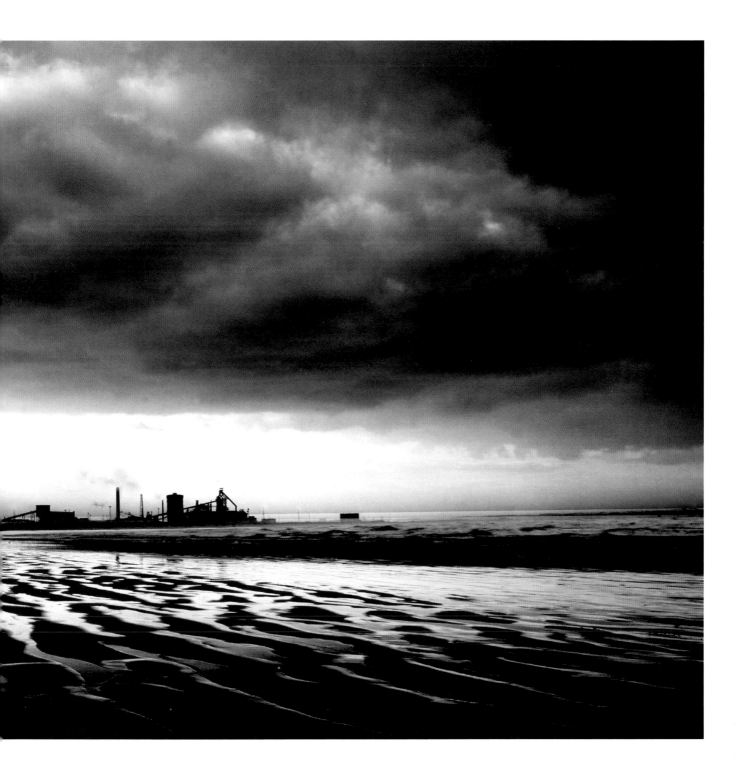

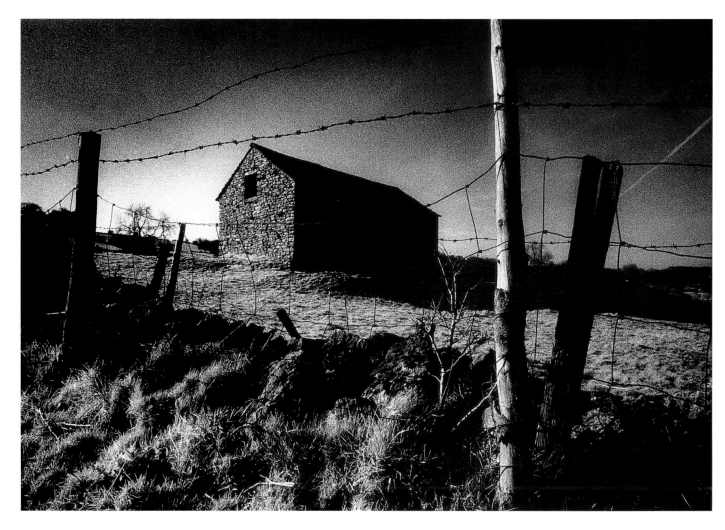

Peak District, Derbyshire, England

I was driving along a country road when I spotted this barn in the middle of a field – not an unusual occurrence in the Peak District, but I decided to stop anyway. I had no picture in mind as I peered through the fence, but then, in a moment of pure serendipity, I realized that that was it – the view through the fence was the picture.

Accident? Luck? Who knows, but as I framed the barn between the fence posts and barbed wire, a shiver of excitement ran down my spine. It was one of those rare moments when everything came together at exactly the right time.

The scene was captured on infrared and printed hard to grade IV. This enabled to me produce a dark, dramatic print and emphasize the light glancing across the gable end of the barn and the slender fence post.

Camera Olympus OM4-Ti Lens 21mm Filter Deep red Film Kodak High Speed mono infrared

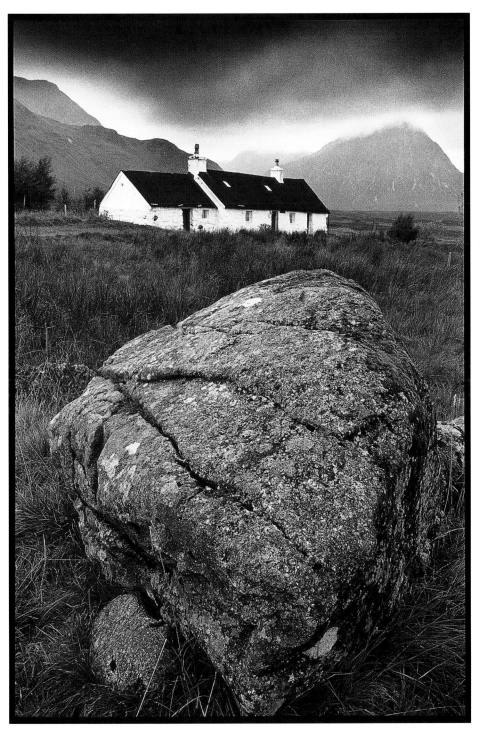

Black Rock Cottage, Scotland

This small cottage on Rannoch Moor has been photographed many times over the decades, so on my first visit a few years ago I was determined to come up with something different.

The weather was pretty dreadful on the day, but I saw that as an advantage – the soft light and atmosphere of dull days is ideal for black and white landscapes.

As I surveyed the scene, my eye was drawn to the large rock, which I knew would make ideal foreground interest and break up the empty expanse of grass in front of the cottage. Initially I exposed a few frames with the scene composed in landscape format, but when I turned the camera on its side and moved closer to the rock, the picture really came to life. The rock seems to dwarf the cottage, and in doing so adds depth and scale to the composition.

The print was made to grade III on Ilford Multigrade FB glossy paper (my standard choice). Because contrast was fairly low it needed little work other than burning in the sky. Finally, the print was partially bleached and sepia-toned.

Camera Nikon F90x Lens 28mm Filter Orange Film Agfapan APX 400 Toning Partial bleach and sepia

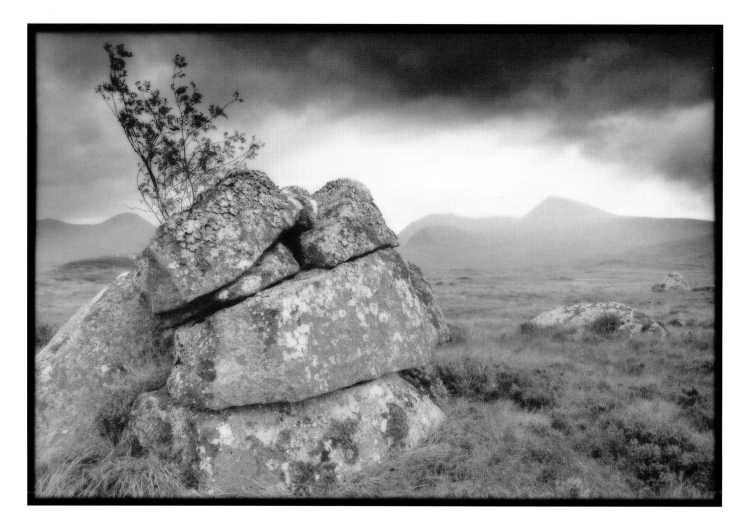

Black Mount Hills, Rannoch Moor, Scotland

I noticed this pile of rocks in the near distance as I drove across Rannoch Moor, so I decided to squelch across the soggy, spongy terrain and take a closer look. The light wasn't ideal at the time, with the sun behind the view and obscured by cloud, but the rocks and tree made great foreground interest in a view across the moor, so I took a few pictures anyway.

In the darkroom some months later, I started out with the intention of making a dark, dramatic print but was unhappy with the initial results. Then, out of curiosity, I exposed another print through a soft-focus filter. This did the trick, adding a dreamy diffusion to the print that helped to recapture the atmosphere of the scene as I interpreted it at the time. I also burned in the sky quite heavily to create a feeling that the sun was just about to burst through the clouds in the background. This mood was enhanced by partial bleaching and sepia toning to warm up the print, then gold toning to turn the highlights a reddy colour.

The appeal of this print for me has more to do with the feeling and emotion it generates than the actual subject matter.

Camera Nikon F90x **Lens** 28mm **Filter** Orange **Film** Agfapan APX400 **Print Filter** Soft-focus **Toning** Partial bleach, sepia and gold

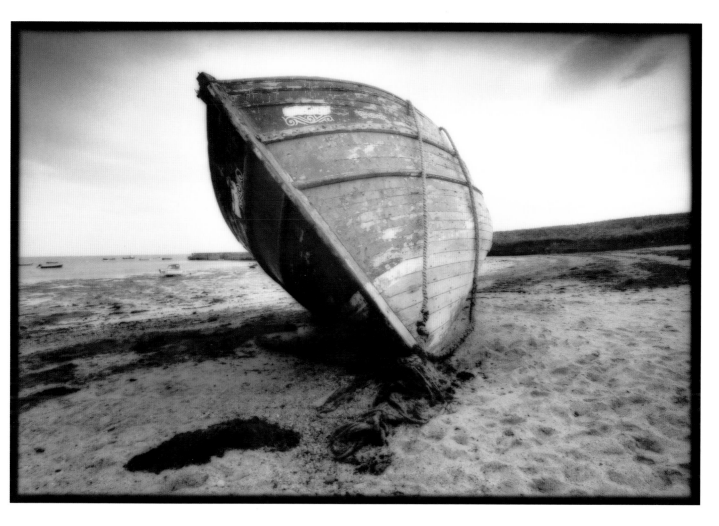

Lindisfarne, Northumberland, England

I was so pleased with the effect created on the previous print that I decided to try it on this shot. The original photograph had been taken a year or so earlier, but at the time I had no idea how I wanted to final print to look – I just liked the composition, and, despite photographing that same old boat on the beach at Lindisfarne many times before, I had never explored it from this angle.

Having completed the Rannoch Moor print, I realized that the same printing and toning techniques would work just as well here. As before, I exposed the print through a soft-focus filter (Cokin Diffuser 1), burned in the corners of the sky to frame the boat, then split-toned in sepia and gold to add warmth.

Camera Nikon F90x **Lens** 17–35mm zoom at 20mm **Filter** Orange **Film** Ilford HP5 Plus **Print Filter** soft focus **Toning** partial bleed, sepia and gold

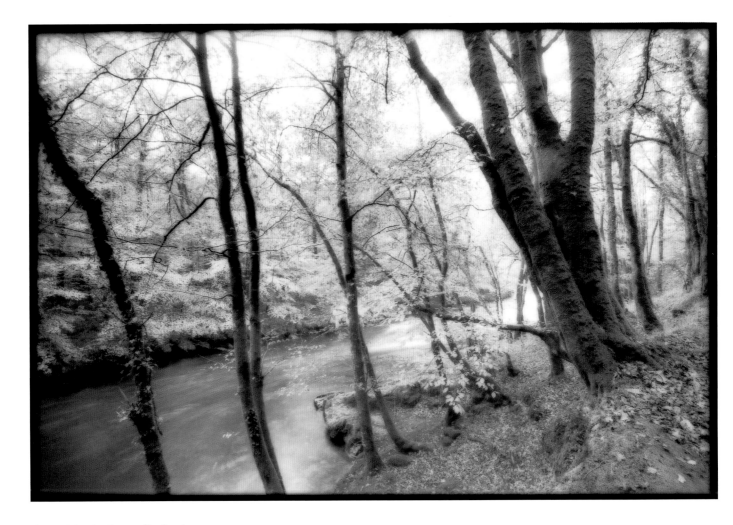

Chase Woods, Devon, England

This picture was taken during a monochrome workshop on Dartmoor for *Black and White Photography Magazine*. The weather on the moor itself was appalling, with mist so dense that we couldn't actually see the location we had planned to photograph. In desperation, I suggested that conditions might be better at lower altitude, so we headed into the wooded valley of the River Dart below the village of Buckland in the Moor. My hunch was right, although it was still damp, dark and uninviting in the woods, and for an hour or two I struggled to find an inspiring view. Luckily, as I headed out, I noticed this scene and made a two-minute stop to shoot it. What appealed to me was that the overcast sky outside the woods was very bright compared to the light levels inside, making it possible to produce a delicate backlit image. The light wasn't strong enough to give quite the effect I was after, but by exposing for the shadows when I recorded the scene, I knew that the sky would burn out and that I could enhance this effect in the darkroom. To do that, I printed for the shadows and let the highlights burn out. I also printed through a soft-focus filter to enhance the dreamy effect and warmed the image slightly by partial sepia toning.

Camera Nikon F90x **Lens** 17–35mm zoom at 24mm **Film** Agfapan APX400 **Print Filter** Soft-focus **Toning** Bleach and partial sepia

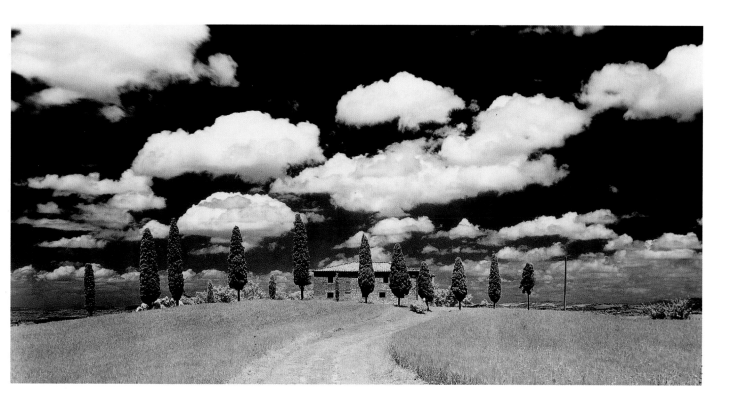

Barn and cypress trees near Pienza, Tuscany, Italy

I travelled to Tuscany in 2002 to shoot colour landscapes. I had already photographed this scene in colour, but decided that the amazing sky would work well in infrared too. In the darkroom, I cropped the composition a little as I felt there was too much empty foreground. Doing this also put more emphasis on the sky. Ironically, this shot has so far proved to be the most commercially successful photo of the trip, and has been published as a large poster for international sale.

Camera Pentax 67 Lens 45mm Filters Deep red and polarizer Film Konica 750 Infrared Toning Partial bleach and sepia

Cappella di Vitaleta, Tuscany, Italy

This small church can be seen perched on a hillside near the village of San Quirico d'Orcia in Tuscany. I had photographed it a couple of times before from the classic, distant viewpoint, but on a trip to Tuscany in 2003 I decided to find a way to the track that led right up to the church as I had never seen a close-up picture of it before.

It took me several hours of driving down farm tracks and country lanes before I finally discovered how to get there. I returned the next day late in the afternoon to get my shot. What I hadn't bargained on was the weather – a storm quickly rolled in and the most violent hailstorm I have ever witnessed battered my car for 30 minutes or more.

Fortunately, when the storm passed over, clear skies followed and eventually the sun came back out, lighting up the church against the dark sky now hanging over Pienza. It looked spectacular, so without hesitation I waded into the (now very wet) field opposite the church to get my picture.

Taking this picture was immensely satisfying, not only because I had finally found a way to the church but also because the light was so stunning. Such moments of sheer photographic joy are rare and can't be predicted, which makes the taste of victory even sweeter – you really do need to be in the right place at the right time.

I took the shot using my 6x17cm panoramic, setting the tripod low in the field so I was able to hide a plough next to the church. The negative was much too big for my modest medium-format enlarger, so I scanned it into my Apple Macintosh computer. My knowledge of digital imaging is minimal, but I managed to create the feel I wanted simply by tweaking brightness and contrast in Photoshop and cropping either end of the image to simplify the composition.

Camera Fuji GX617 panoramic Lens 90mm Film Ilford FP4 Plus

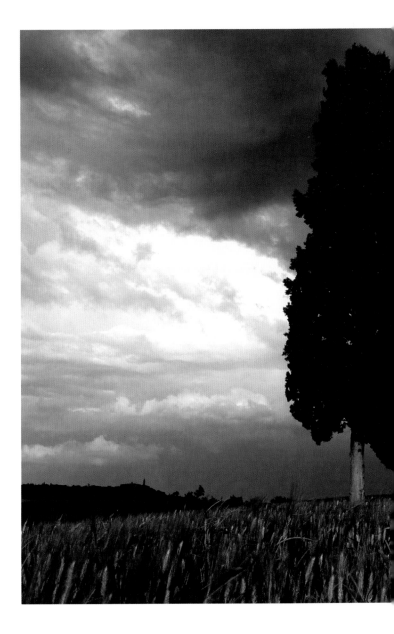

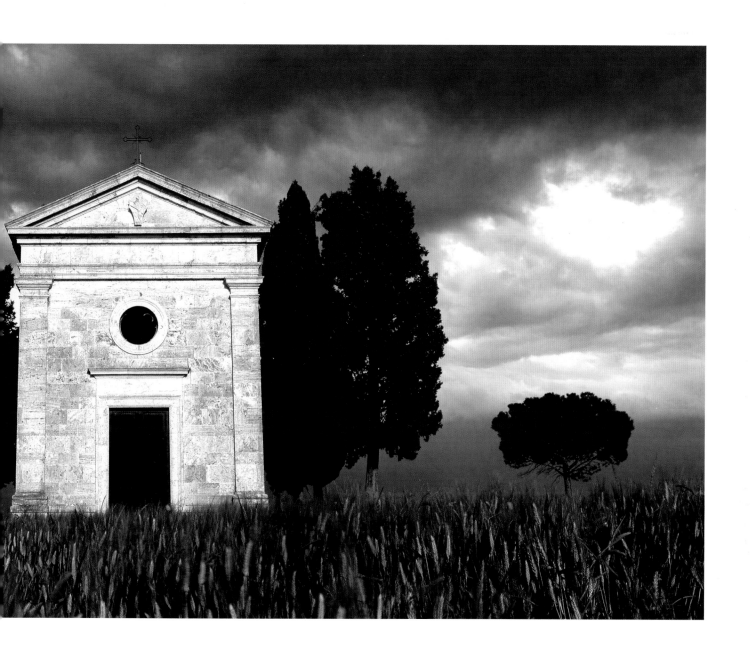

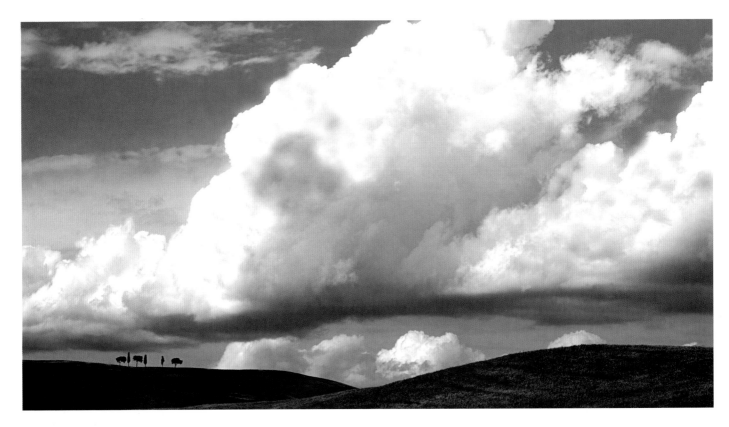

Cypress trees, Tuscany, Italy

I was on location in Tuscany, sheltering under a bridge during a storm and waiting for the light
to improve so I could photograph a famous group of cypress trees in the middle of a field.
While I waited, I happened to glance in the other direction and saw this amazing sky. Initially I
wasn't sure how to make a feature if it, but then I noticed the tiny trees on a distant ridge and
realised that I didn't need anything else – their size would lend a strong sense of scale to the
scene and dramatize the skyscape. A deep red filter was used to accentuate the clouds and
darken the green fields and trees. I also adjusted brightness and contrast after scanning the
negative, before outputting a print on inkjet paper.

Camera Fuji GX617 panoramic camera **Lens** 180mm **Filter** Red **Film** Ilford FP4 Plus

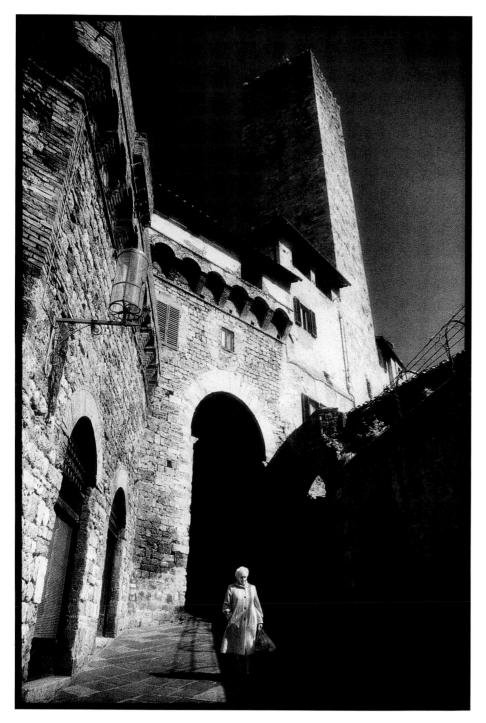

San Gimignano, Tuscany, Italy

The medieval walled town of San Gimignano is famous throughout the world for its huge stone towers, which were built by local families to show off their wealth – the richer you were, the bigger your tower. Today it's a popular tourist destination, and throughout the spring and summer the town's narrow streets and small courtyards are packed with hundreds of visitors. This makes photography at street level very difficult. If you visit outside busy tourist times, however, it's almost deserted and the mood changes completely.

I took this picture in March, when the town was so quiet I felt I had it almost to myself. I had walked through the archway a minute or two earlier and turned to admire the view back. As I raised the camera to my eye to take a picture, the woman walked out of the shadows and for just a couple of seconds passed through a pool of sunlight. She was just what I needed, adding both a human element and a bright focal point to the otherwise dark, shady foreground.

To boost contrast and make sure the highlights were nice and bright, I printed to grade IV – my standard choice for infrared film.

Camera Olympus OM4-Ti **Lens** 21mm **Filter** Red **Film** Kodak High Speed mono infrared **Toning** Selenium

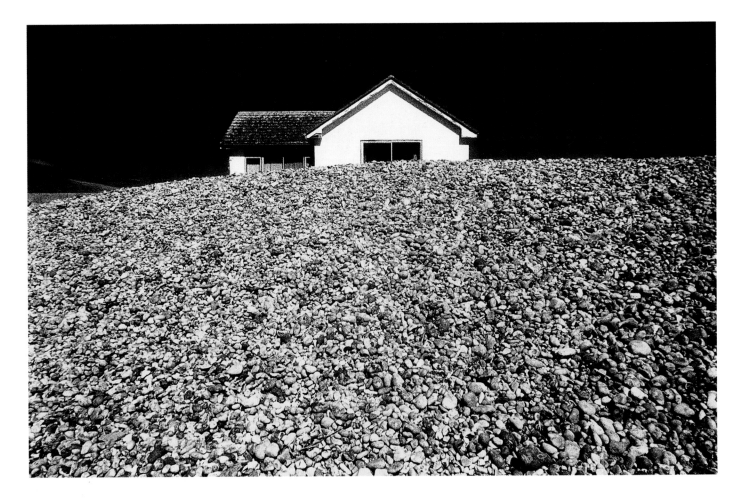

Winchelsea Beach, Sussex, England

I travelled to this location to meet three readers of *Black & White Photography* magazine who were taking part in a monochrome workshop with me. I had never been to Winchelsea before, and on arrival my heart sank – all I could see was an endless expanse of shingle beach and some wooden sea defences that were partially submerged by the tide; it was not the most inspiring location.

Fortunately, while wandering along the beach, I noticed this house set a little way back from the beach and I knew I had the makings of a picture. All I had to do was decide how best to record the scene.

In the end I went for this viewpoint, with the house peeping over the shingle bank and set against clear sky. I wanted to keep the composition simple and uncluttered, so I shot from a low angle to keep telegraph poles and any other distracting elements out of frame. I loaded my camera with mono infrared film, knowing it would maximize contrast between the blue sky and white house and produce a very stark, graphic image.

Camera Nikon F90x **Lens** 18–35mm zoom **Filter** Red **Film** Kodak High Speed mono infrared

Brighton Pier, Sussex, England

When the sun is shining, I love nothing more than loading a roll of infrared film into my camera and going for a wander. I rarely set out with preconceived ideas about the pictures I might take and open my mind to any opportunities that present themselves. If I'm using Kodak High Speed mono infrared, I tend to dispense with a tripod as the film is fast enough to shoot handheld, even with a light-sapping red filter on the lens.

On this occasion I was in Brighton, exploring the pier and promenade in bright sunlight and basically taking snapshots. Seaside towns are ideal for this relaxed approach to picture-taking because there's always something to catch your eye.

While walking along Brighton Pier, I noticed the helter-skelter ride and strolled over to take a closer look. Peering through my camera's viewfinder with a wide-angle lens attached gave a distorted perspective of the scene and I knew that, combined with the graphic qualities of infrared film, it would make a good shot. One of the things I like most about infrared film is that you can print it so the highlights begin to burn out and bleed into the darker tones.

Camera Nikon F5 Lens 18–35mm zoom Filter Red Film Kodak High Speed mono infrared

Trees in snow, Cambridgeshire, England

In the early part of my career, I lived in Peterborough and worked as a journalist on various photographic magazines. It wasn't the most inspiring place for a photographer, but I did manage to take a decent picture occasionally.

This is one of my favourites. Snow had been falling all morning, so I decided to go for a stroll along the nearby River Nene during my lunch break. It was there that I discovered these trees. Because the snow-covered ground and washed-out sky merged into one, all sense of perspective had been destroyed and the trees appeared to be floating in space. I seized on this illusion, realizing it would make a very simple, graphic picture.

Two important steps were necessary to achieve the desired result. First, I knew that all the whiteness would fool my camera's metering system, so I overexposed by two stops. Second, the negative was printed to grade IV to boost contrast and make sure that no tones were recorded in either the sky or the ground.

Camera Olympus OM4-Ti **Lens** 28mm **Film** Fuji Neopan 1600

Blackpool Pier, Lancashire, England

I was in Blackpool for one day, leading a monochrome workshop, and despite it being the middle of summer the weather couldn't have been worse. I suggested to the participants that we take shelter under the pier for a while until the torrential rain eased off, and that's where I took this picture.

I wanted to make a feature of the pattern of bold supports and criss-crossing struts that had kept the pier standing for a century or more. The presence of a large pool of water under the pier helped as the reflection in it added symmetry to the scene. I also liked the way that the side of the pier and its reflection created converging lines that directed the eye towards the end of the pier in the far distance. The figure in silhouette was an added bonus, though I had to wait a while for the man to be in the right position.

By exposing for the highlights (setting my camera to Aperture Priority AE mode) I knew no shadow detail would record on the negative. This meant I could print it at grade II but still produce a strong silhouette. I also cropped the image a little at the top and bottom to improve the composition. Other than that, it's a straight print.

Camera Nikon F90x Lens 28mm Film Fuji Neopan 1600

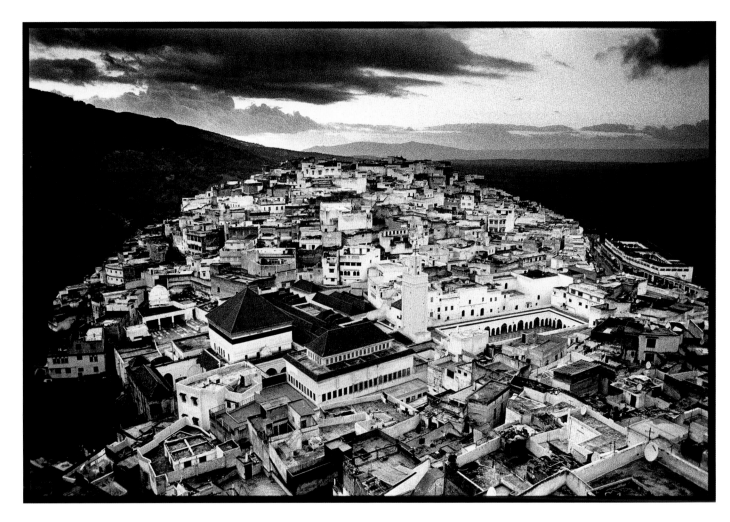

Moulay Idris, Morocco

Moulay Idris is Morocco's holiest town. It is the resting place of Moulay Idris I, the man responsible for creating the first Arab dynasty in Morocco and for founding the imperial city of Fez. The town is essentially a shrine to its namesake and enjoys a dramatic hilltop position with whitewashed houses spilling down in all directions.

I came to the town for the first time one evening while en route to Meknes, and wanted to find a high viewpoint over the town. With minutes to spare – the sun had already set – I managed to locate a café with a terrace that gave me the perfect view, so I ordered a cup of coffee and set to work. The picture composed itself – I just selected my widest lens and started shooting, knowing there was no time to lose.

In the darkroom, I wanted to make a print that captured the dying light and warm tones that I remembered. I also wanted the town to look holy and ancient. I achieved the effect I wanted by printing quite dark and burning in the sky.

Camera Nikon F90x Lens 20mm Film Ilford HP5 Plus Toning Partial bleach and sepia

Interior, Tangier, Morocco

During a trip to northern Morocco in 2003 I stayed for one night in the old Hotel Continental, which overlooks the port and medina in Tangier. These days it's a little frayed around the edges, but it used to be the city's most fashionable hotel and was one of the locations used in Bernardo Bertolucci's film *The Sheltering Sky*, based on a novel by American writer Paul Bowles. Arriving late at night, I saw little of the hotel, but the next morning I was directed upstairs for breakfast and it's there that I saw the building's amazing interior, complete with the intricately carved plaster detailing that is typical of traditional Moroccan architecture. Capturing this on film wasn't easy. The interior lighting was poor, with open courtyards flooding some areas with daylight and sending contrast through the roof. Unsure how best to deal with this, I bracketed exposures widely and hoped for the best.

This picture was one of the better compromises, though I had to dodge and burn various areas to balance the tones. I'm sure a more skilled printer would have done a better job, but I was happy with my effort and feel that it captures the grandeur of a wonderful old building.

Camera Nikon F5 **Lens** 20mm **Film** Ilford HP5 Plus

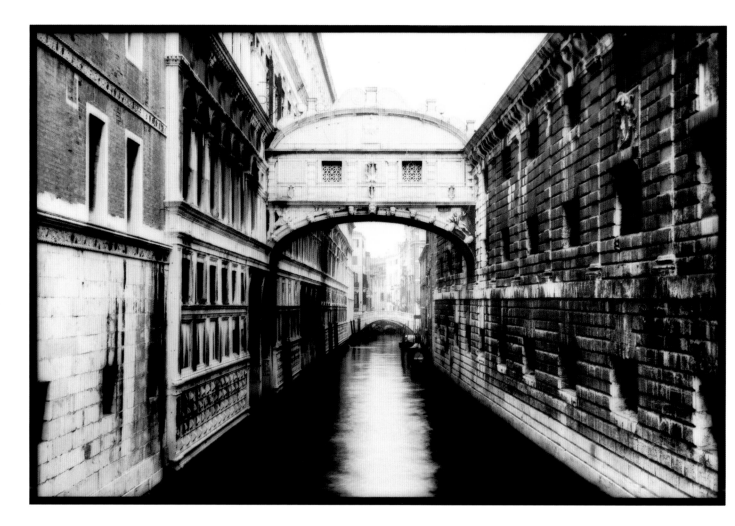

Bridge of Sighs, Venice, Italy

Venice's biggest attraction is that it has remained virtually unchanged for hundreds of years – stand on the Rialto Bridge or Academia Bridge and the scenes you witness look pretty much today as they did when the likes of Bellini and Canaletto were committing them to canvas in the 16th and 18th centuries.

The Bridge of Sighs is one of the city's most famous landmarks. So named because prisoners (the most famous being Casanova) were taken across it to be incarcerated in the prisons, it's quite small and easily missed, though a throng of tourists wielding cameras is a sure sign that you've found it.

When I arrived to wield my own camera, there was a builder's boat tied up near the bridge and laden with sacks of cement, so I had to return the next day when the canal was clear. The weather was overcast, which created perfect light for me to capture a gentle, romantic image of the bridge. During printing, I burned in the distant buildings seen through the bridge and dodged the wall on the right, which was darker and shadier than the wall on the left. I also printed through a soft-focus filter and split-toned the print in sepia and then in blue.

Camera Nikon F90x **Lens** 50mm **Film** Ilford HP5 Plus **Print Filter** Soft-focus **Toning** Partial bleach, sepia and blue

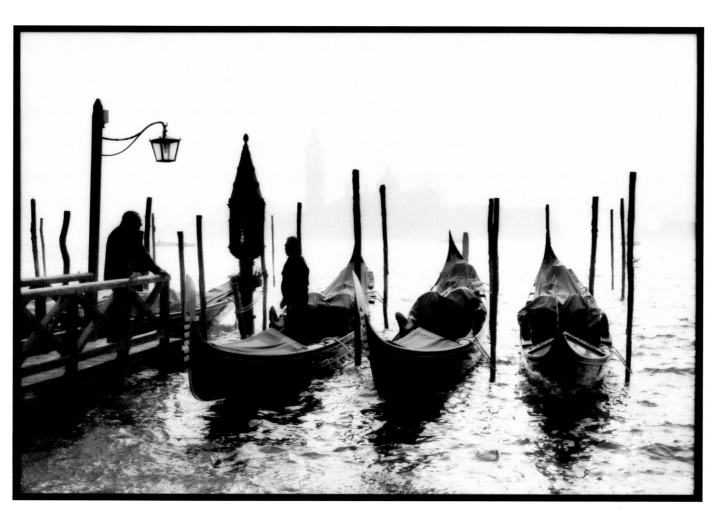

Gondolas on the Bacino, Venice, Italy

I don't work to any specific plan when I visit Venice – I just turn up and go with the flow,
visiting locations I know like old friends and others that I've never been to before. I usually
set out from my hotel at dawn and stay out until nightfall, just wandering around, looking,
watching, waiting and drinking in the beauty of the place.

This shot was taken into the light on a bright but hazy morning. I was wandering along and
saw these two men chatting, so I started shooting. I bracketed a series of frames in aperture
priority mode: metered, +1, +2 and +3 stops. I printed the frame at +1 stop, which gave me
more shadow detail in the gondolas while still recording detail in the highlights – though I had
to burn in the background quite heavily in order to show a faint outline of San Giorgio
Maggiore.

Camera Nikon F90x Lens 28mm Film Ilford HP5 Plus Print Filter soft focus Toning Partial bleach, split
sepia and blue

Three Gondoliers, Venice, Italy

Gondoliers have been carrying people along the waterways of Venice for centuries, and, with their stripey tops and straw hats they remain one of the city's most romantic symbols. With this is mind, I set out to take a photograph that was equally symbolic. I knew of a location not far from St Mark's Square where gondoliers tended to ply their trade on a bridge over a narrow canal. A little further down the canal was another bridge that would give me a perfect view, so I headed there one day to get my picture – though this was easier said than done. In the end it was a further two years before I got the shot I wanted – on previous attempts, the gondoliers would either be huddled together chatting; there would only be one or two whereas three is a more balanced number; there would be people passing in the background; or the gondoliers would all be dressed differently. On this occasion, I waited for about two hours, and suddenly everything fell into place for just a few seconds, as if it had been set up just for me. Fortunately, I was ready and waiting with my camera on a tripod, the scene composed and the lens set to a wide aperture to throw the background out of focus. The print was made on Fotospeed Tapestry paper which has a textured surface and responds well to toning.

Camera Nikon F90x Lens 80–200mm zoom Film Ilford HP5 Plus Toning Partial bleach and sepia

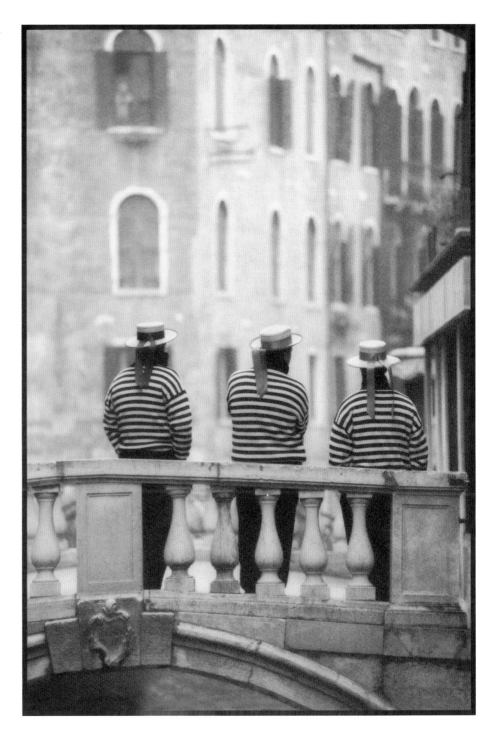

Father and son, Torquay, Devon

This picture was taken almost 20 years ago. I hadn't been interested in photography for very long, but my family had recently moved from Yorkshire to Devon, and I found living by the sea incredibly inspiring – everything was new and fresh. I spent every spare minute exploring the coastline of south Devon, and particularly enjoyed wandering along Torquay's seafront with a camera in my hand, photographing anything that caught my eye.

A newly acquired 300mm telephoto lens made this shot possible. I noticed the man and his young son walking along the beach and thought they would make an interesting silhouette against the sea. It was only when I raised the camera to my eye that I realized I could also include the hazy outline of a distant ship on the horizon.

My knowledge of exposure was limited back then, so I just left the camera on automatic and took the shot. In my innocence, I did exactly the right thing, as the camera biased the exposure towards the highlights, recording the two figures in silhouette. This gave me a negative that was easy to print – I set my enlarger filtration to give contrast grade III and no manipulation was necessary.

Camera Olympus OM2n Lens 300mm Film Ilford HP5

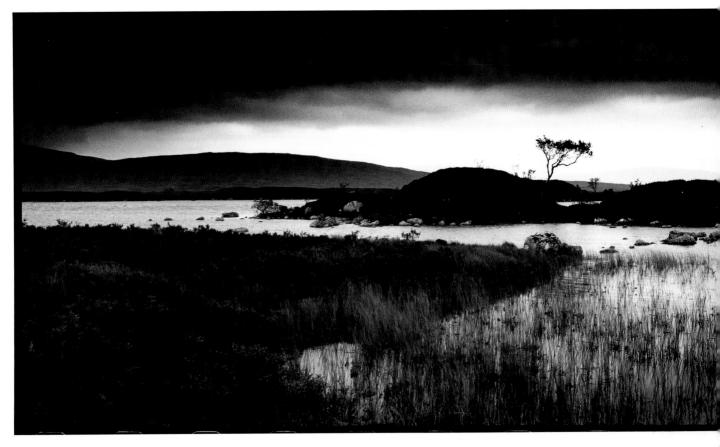

Lochain Na h'Achlaise, Rannoch Moor, Scotland

Rannoch Moor has some of the most dramatic scenery in the UK. It's a
bleak, desolate expanse of boggy ground, ringed by mountains and
punctuated by mysterious lochs and lochains. Ironically, a major trunk
road crosses the moor, and it's not uncommon to have articulated
lorries whistling by at high speed as you photograph the wild scenes
that stretch away in all directions.

This photograph shows Lochain Na h'Achlaise and the dark peaks of
the Black Mount. I had photographed the scene before, in colour, but
on this occasion the dull, grey weather inspired me to reach for black
and white film instead. It was also the first time I had taken my newly
acquired Hasselblad Xpan on location for black and white work.
At the time I didn't do anything out of the ordinary – as usual, I put the
camera on a tripod, composed the scene and let the camera's integral
metering system determine 'correct exposure'. It was in the darkroom,
however, that the photograph came to life. I wanted to recapture the
darkness and mystery of the place, so I printed hard and burned in the
sky quite heavily. I also sepia-toned the print, going for a darker tone
than normal as I felt it would enhance the mood of the scene.

Camera Hasselblad Xpan **Lens** 45mm **Filter** Orange **Film** Agfapan APX 400
Toning Partial bleach and sepia

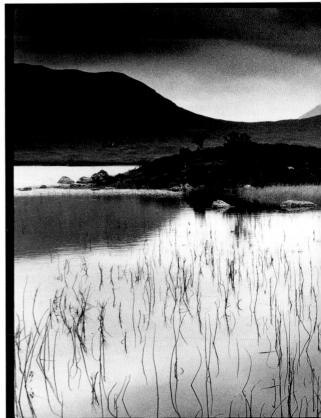

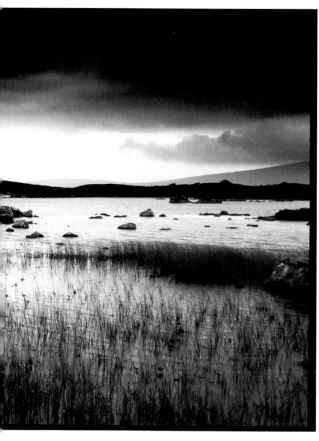

Lochain Na h'Achlaise, Rannoch Moor, Scotland

This is the same location that features in the photograph below, but from a different viewpoint. It was the single tree that attracted me here. Without it, the scene would appear rather empty and flat, but the addition of a single striking element, no matter how small, can make all the difference as it provides a focal point to draw the viewer's eye.

The sky was a blanket of grey cloud that obscured the sun and reduced contrast, so a straight print from the negative would have given me a fairly ordinary print with a washed-out sky and detail in the darkest shadows. I changed that in the darkroom, however, by printing to a higher contrast grade and using dodging and burning to provide localized exposure control. I burned in the sky but left a bright band across the centre of the composition where the tree was located. It wasn't like this in reality, but the effect is natural and can often be seen when the sun is about to appear below stormclouds and brightness towards the horizon is increased. I used darkroom techniques to put that 'band of gold' where I wanted it.

Camera Hasselblad Xpan **Lens** 45mm **Filter** Orange **Film** Agfapan APX400 **Toning** Partial bleach, sepia and gold

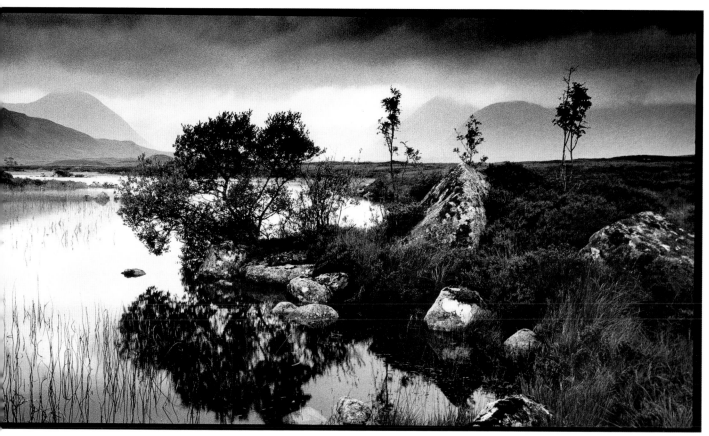

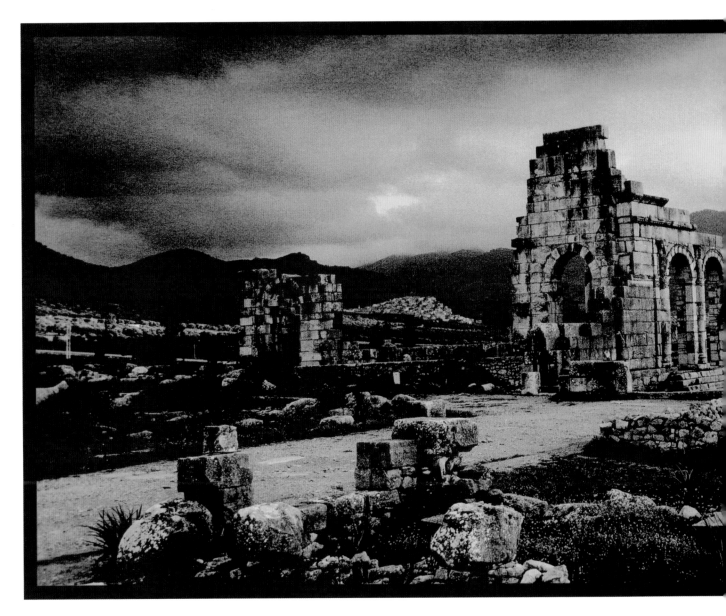

Volubilis, Morocco

With the exception of a site on a small island off the Moroccan port of Essaouira, Volubilis was the Roman Empire's most remote outpost. The intention was always to push south and penetrate the Atlas mountains, but the determination of the southern Berber tribes thwarted these plans, and by 245 BC the Romans were gone, leaving behind a legacy in the form of this striking town.

I'm not one for spending hours wandering around archaeological and historic sites, and when I visited Volubilis in 2003, I doubted that it had much photographic merit. However, after an hour or two my feelings changed. There was a storm brewing, which made the place far more dramatic than blue sky and bright sunshine ever could. It was also very quiet, with only a handful of other people around. It was on my way out that I came across this scene. As I stood admiring it, the sun broke through cloud and illuminated the main building against a dark, gun-metal-coloured sky. I grabbed my camera, jumped onto a low wall to gain a little height and started shooting. It was only when the roll ended that I realized it was loaded with colour film; this was not a problem as the results were stunning, but I was eager to photograph the scene in black and white as well. By the time I managed to do this, the sun had disappeared behind cloud again and failed to come out for the rest of the day.

In the darkroom, I wanted to attempt to capture the drama of the light that I'd missed, so I decided to make a lith print from one of the black and white negatives. My first attempt was too contrasty, and the sky was completely blown out. Increasing the print exposure to 120 seconds from 80 seconds (at f/8) lowered contrast. I also burned in the sky heavily by opening up the enlarger lens aperture to f/2.8 and giving it an additional 60 seconds (which equates to 480 seconds at f/8, two stops more than the main exposure). The second print was better but I needed to monitor the snatch point and get it perfect.

Eventually, after four or five attempts and about three hours, I pulled this print from the fixer. I rate this as my favourite lith print to date – if only because it took so much effort to create!

Camera Hasselblad Xpan **Lens** 45mm **Film** Ilford HP5 Plus

Gallery

Hadrian's Wall, Northumberland, England

It's complete coincidence that I chose this print to follow the one of Volubilis on the previous page when both happen to be significant Roman relics. In fact, they're the only two Roman relics that I have ever photographed, though this one is much closer to my home than the last! Hadrian's Wall was built between 122 BC and 130 BC and ran across northern England from the Solway Firth to Newcastle-upon-Tyne. The intention was to keep marauding bands of Scots from coming over the border to pick fights, although within a decade of its completion Emperor Hadrian was dead and the wall was abandoned.

Today, it's a shadow of its former self, but enough remains to give visitors a haunting sense of what life must have been like for the Roman troops stationed there who braved the isolation and weather to defend another corner of their empire.

This photograph shows a location along the wall known as Sycamore Gap. The scene is revealed at its best when viewed side-on, with the single sycamore tree nestling between the slopes rising either side. I used a panoramic camera so I could capture this without having to include too much foreground.

The end result was a simple, graphic composition that I decided to emphasize by making a lith print. For once, this came together quite painlessly – I 'guessed' an exposure of 80 seconds at f/8 and the first print was perfect apart from a thumb print in the sky – no doubt caused by handling the unexposed paper when my fingers were contaminated with fixer. After washing to make sure this didn't happen again, I repeated the process and ended up with the print you see here.

Camera Hasselblad Xpan Lens 45mm Filter Red Film Ilford FP4 Plus

Gallery

Damon

I've never been heavily involved in studio portraiture. However, back in my days as a staff journalist on photographic magazines I occasionally made use of the company studio, and that's how this portrait came about. Damon was the designer of *Photo Answers* magazine at the time (I was assistant editor). After work one day, I asked him if he'd mind sitting for a few portraits, and he agreed.

Given my limited knowledge and experience of studio lighting, I kept things very simple – one studio flash head fitted with a softbox was placed at 90 degrees to Damon, on my right, and I used two further flash heads fitted with basic reflector dishes to light the white background. I also set the background lights to overexpose by one stop and ensure that the white came out pure white.

Camera Pentax 67 **Lens** 165mm **Film** Ilford FP4

Andy

Encouraged by the portrait of Damon, I decided to pick on another colleague, who also
happened to be a magazine designer by day (and a drummer in a rock band by night).
Andy was a great character, always laughing and joking, but I knew he had a deeper,
more serious side too, which I wanted to capture.

I decided to use infrared film for this portrait as I felt its stark characteristics suited Andy's
personality better than conventional film would.

Of the 20 or so frames exposed, this was my favourite. Andy's eyes, blackened by the infrared
film, appear menacing and suit his rock star appearance. He was happy with the results too.

The print was made on Ilford Multigrade FB paper, printed to grade IV to increase contrast.

Camera Pentax 67 Lens 165mm Filter Red Film Konica 750 infrared

Steve

This is my middle brother, photographed as a teenager in my mother's dining room. Before I had access to studio lighting, I always used windowlight for portraiture, and actually prefer it: I feel it's more natural, easier to work with, and most people feel less intimidated when they're sitting by a window than they do surrounded by high-powered flash units.

Steve was probably 15 at the time and finding his way in life. On this day, he wasn't really in the mood to be photographed, so I worked quickly, exposing no more than half a dozen frames. We said nothing to each other. He looked into the camera and I fired the shutter. It was all over in a minute, but I feel this portrait captured a truth about him at that time in his life. The print was made on art paper that had been coated in liquid emulsion (see chapter 9).

Camera Olympus OM2n Lens 85mm Film Fuji Neopan 1600

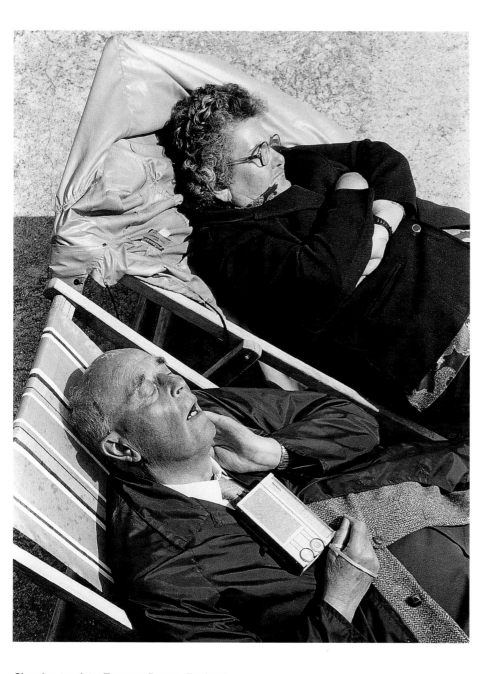

Sleeping tourists, Torquay, Devon, England

When I first became interested in photography, I loved the idea of taking candid shots. However, I didn't have the nerves to match my enthusiasm and always chickened out at the last minute, worried that I might be spotted by my subject. The solution was to photograph people who couldn't catch me out, and there's no better way to do that than by waiting until they're fast asleep!

This unlucky couple became my victim as I walked along a wall above Torquay's main beach – I looked down and there they were. Not the most dignified pose, but in a second it was all over – I had my picture and they were none the wiser!

Camera Olympus OM1n Lens 135mm Film Ilford FP4

Shopkeeper, Marrakech, Morocco

Whenever I'm in Marrakech I always head for the souks in its ancient medinas, where a maze of narrow alleys, busy streets and small, sunlit squares create endless potential for great pictures.

One of my favourite spots is a small square known as Rahba Kedima, one side of which is occupied by apothecary and herbalist shops selling all manner of lotions, potions and concoctions.

Initially I was fascinated by the skins and furs of dead animals hanging above the doorway of this shop, and the shelves inside lined with jars of herbs and spices. Then the owner came out to see what was going on and the picture was complete. I asked him if he minded being photographed – this is preferable to shooting first as it avoids offending anyone. He didn't mind, so I quickly took a few shots with the shop entrance and everything around it framing him. My only regret is that he was wearing modern training shoes. Without those, the picture could have been taken a century ago. I did think about cropping them out, but then I decided that they added a humorous twist to the portrait and should stay.

Camera Nikon F90x Lens 28mm Film Ilford HP5 Plus

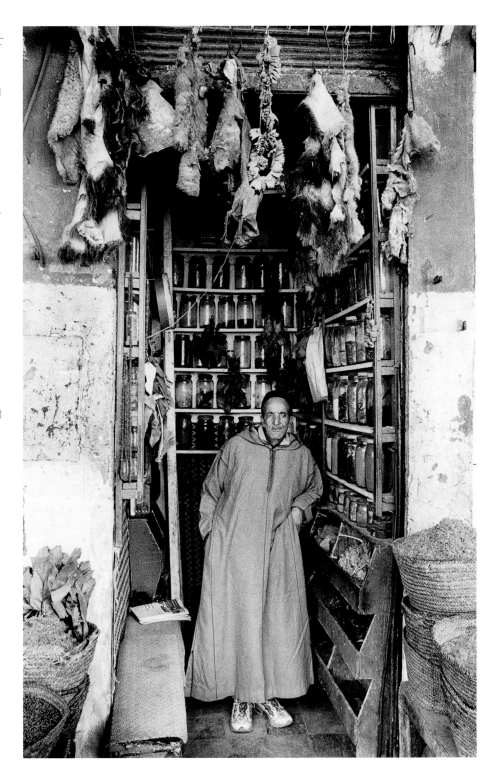

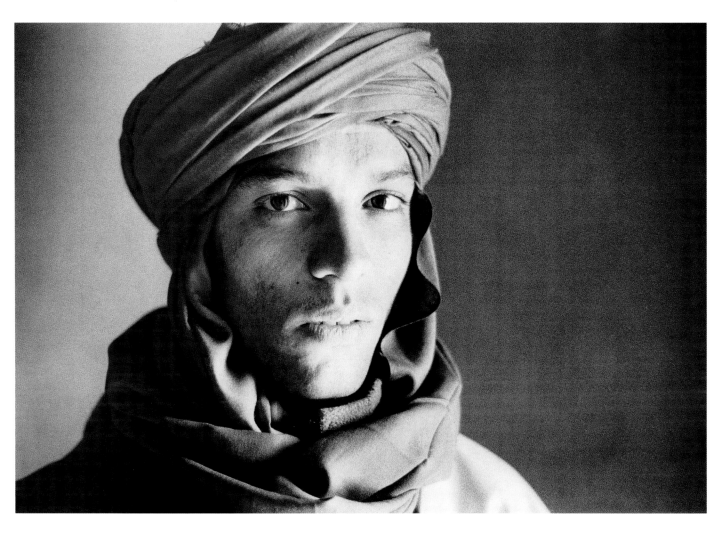

Hamid, Hassi Labiad, Morocco

Every year, I lead photographic holidays in Morocco and travel down to the Sahara Desert near Merzouga. In the village of Hassi Labiad, where we stay, there's a Berber artisan centre selling carpets and other local artefacts. Hamid is one of the men who runs it. I first met him a few years ago and thought he would make a great portrait subject. Initially, I photographed him in colour, using daylight flooding through an open door to light his face and a mud wall as the background. I was happy with the results, but when I returned in 2002, I decided to photograph him in black and white as I felt that colour took attention away from his bold features. The shoot was impromptu and lasted no more than two minutes, but I knew as soon as I looked through the viewfinder that I was going to get the shot I wanted this time. I was right.

After making the print, I partially bleached it in sepia bleach then redeveloped it in lith developer. This added a very delicate warmth to the image.

Camera Nikon F90x Lens 50mm Film Ilford HP5 Plus

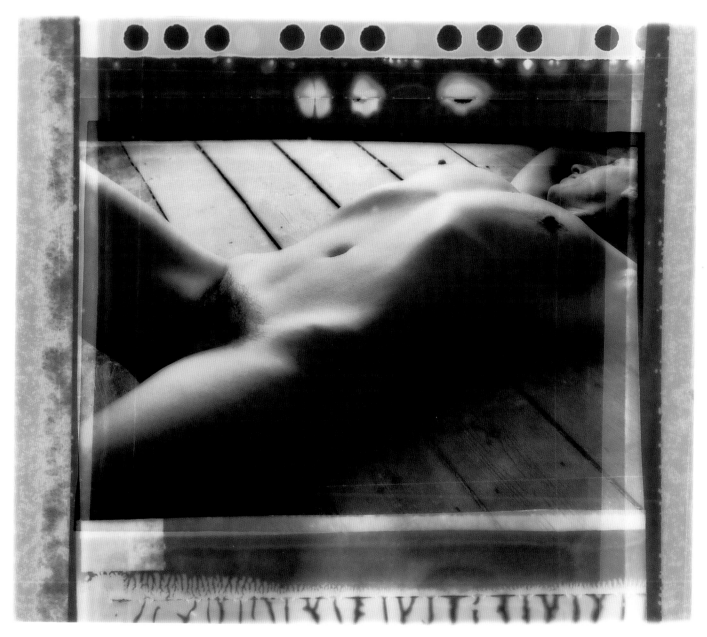

Nude 1

The female nude is a subject that has fascinated me for as long as I have been interested in photography. The female form offers great potential for creative and artistic interpretation. I have always admired photographers who create images that are sensual and romantic rather than blatant and explicit; images that celebrate and revere the beauty of the female body rather than using it as an object of cheap glamour or tacky voyeurism. I have attempted to achieve the same in my own work.

The photograph shown above started life as a 35mm negative, and initially it was printed in a fairly conventional way. However, after seeing the work of Turkish photographer Umit Ulgen I was inspired to try something new. Umit uses Polaroid Type 55 film to produce beautiful fine-art prints of nudes and flowers, and one photograph in particular caught my eye. Umit had cut the distinctive rebates from a 5x4in Type 55 negative and attached them to a smaller format

negative using pieces of sticky tape. I was keen to try the technique myself, so Umit kindly offered to send me one or two rejected Type 55 negatives. As soon as they arrived, I got to work, cutting the rebates off the original 35mm negative then carefully taping lengths of the Type 55 rebates around the edge. The new composite negative was then taped inside the aperture of a medium-format card transparency mask so I could place it in the negative carrier of my enlarger and make prints. I wasn't too precious in the preparation of the negative, as I wanted the two types of film to overlap in places, and for the pieces of sticky tape to be visible.

Printing was then relatively straightforward. The image was exposed through a soft-focus filter onto Ilford Multigrade FB paper then partially bleached and sepia-toned.

Camera Nikon F90x **Lens** 28mm **Film** Fuji Neopan 1600 **Print Filter** soft focus **Toning** partial bleed and sepia

Nude 2

For this image, I posed my subject against a bare plaster wall and photographed her from close range with a wide-angle lens in available windowlight. The photograph itself was straightforward, but in the darkroom I enhanced it by first contacting the printing paper with a sheet of greaseproof paper to degrade the image and add texture. I also exposed the negative through a soft-focus filter to further the effect, then bleached the print until the highlights began to fade. This step created the image colour; no toning was used.

Camera Nikon F90x **Lens** 28mm **Film** Fuji Neopan 1600 **Print Filter** Soft-focus

Hiking boots

This is one of the first still-life photographs I ever took. I noticed a shaft of sunlight coming through the window of the garage at my mother's house one evening, and looked around for something to place in the light and photograph. My old hiking boots were sitting in a corner gathering dust. I decided they would be as good as anything and laid them on the old floorboards to form a simple composition. It took no more than a minute to set up the shot. This is how I still like to work today – I see an opportunity and seize it with the minimum of fuss. Some time later I made a print from the negative, and in the 18 years since I have printed it another two or three times. This is my latest effort, using Fabriano paper coated in SE1 liquid emulsion (see chapter 9). The contrast of the emulsion allowed me to create a simple, graphic photograph with good shadows and crisp highlights.

It's nice to revisit old negatives every now and then, and in this case reaffirmed that even back then, as a novice, I was still capable of taking a good picture – even if it wasn't very often!

Camera Olympus OM1n **Lens** 50mm **Film** Ilford FP4

Old forks

I photographed these old forks a long time ago, but the negative remained unprinted for years until I was writing a magazine article on printing negatives through tissue paper and needed some new pictures to illustrate it.

Thumbing through my negative files, I discovered the sheet containing this picture and decided to experiment. The soft, dreamy feel to the image is typical of what you can achieve if you screw up a sheet of tissue paper, roughly flatten it out and then lay it over the printing paper before exposure but without contacting the two together with glass (see chapter 8). By doing this, some parts of the image are rendered relatively sharp, but others are blurred and distorted. It's hit and miss, but good fun. The key is to choose a negative that contains bold shapes rather than fine detail, as much of the latter will be lost.

After washing the print, I partially bleached it back in dilute sepia bleach (diluted 1:20 with water) for about 20 seconds, so the highlights faded a little. I did this with the intention of sepia toning the print, but I liked the effect of bleaching alone so I didn't bother with the final stage.

Camera Nikon F90x Lens 105mm macro Film Fuji Neopan 1600

Index